VIEWING
PITTSBURGH'S
TROLLEYS AND INCLINES

*Best wishes
to*

*Kenneth C. Ainsworth
November 25, 2022*

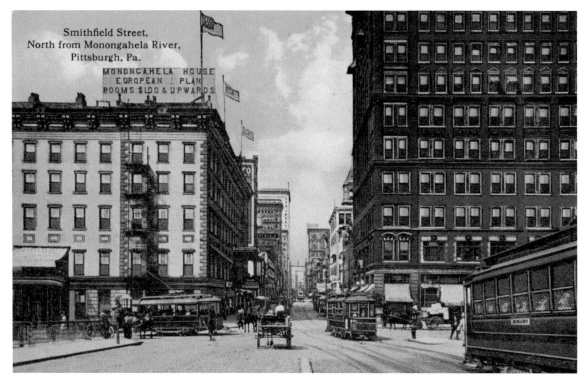

Smithfield Street, north of the Monongahela River in downtown Pittsburgh, is shown in this postcard scene with horse drawn carriages, pedestrians, and trolley cars before the advent of the automobile. In 1916, Pittsburgh Railways Company (PRC) fleet of motorized trolley cars peaked at 1,662, and in 1918, its number of trailer cars peaked at 394. The last day of trolley car operation over Smithfield Street and the streets of downtown Pittsburgh was July 3, 1985. Following a three-day celebration, the new light rail subway opened on July 7, 1985.

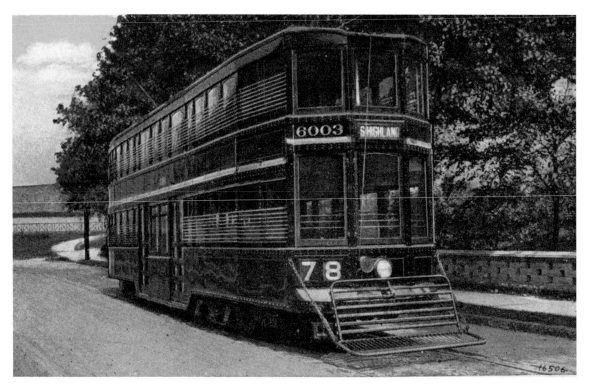

Pittsburgh Railways double-deck trolley car No. 6003 in the Highland Park section of Pittsburgh in an early postcard view is waiting for departure time. This was one of five double-truck, double-end, and double-deck cars Nos. 6001–6005 built by St. Louis Car Company in 1913. Weighing 48,000 pounds, these cars seated 60 passengers downstairs, 52 passengers upstairs, and with standees could handle 210 passengers.

VIEWING
PITTSBURGH'S
TROLLEYS AND INCLINES

KENNETH C. SPRINGIRTH

AMERICA
THROUGH TIME®
ADDING COLOR TO AMERICAN HISTORY

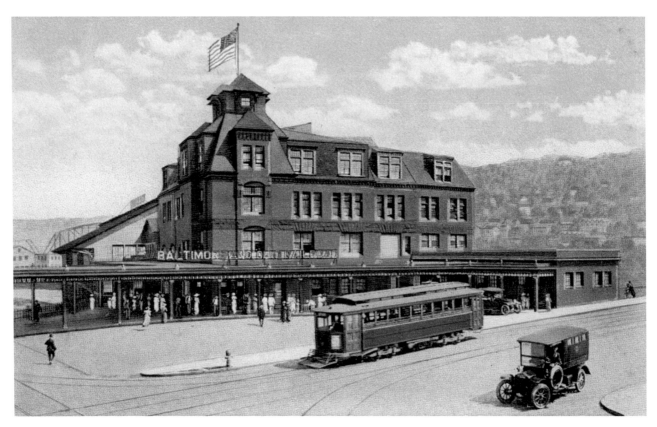

A Pittsburgh Railways trolley car is passing by the Baltimore & Ohio Railroad (B&O) station on Smithfield Street at Second Avenue in downtown Pittsburgh next to the Monongahela River in this 1910 postcard scene. This station opened in 1887 and was demolished in 1955 to make room for Interstate 376. A new station was built on Grant Street at Fort Pitt Boulevard which opened in 1957 to serve B&O commuter rail service. This was the last privately owned common carrier passenger train station built in Pennsylvania.

On the top portion of cover: Pittsburgh Railways Company (PRC) President's Conference Committee (PCC) car No. 1684 is southbound on Route 35 (Library) near the Mesta stop on June 11, 1961. This was one of twenty-five PCC cars Nos. 1675–1699 built by St. Louis Car Company and delivered during October-November 1945. Seating 54 passengers, each car was powered by four General Electric motors. (*Kenneth C. Springirth photograph*)

On the bottom portion of cover: With the skyline of downtown Pittsburgh in the background, Port Authority of Allegheny County (PAT) car No. 1758 is southbound on Smithfield Street crossing East Carson Street on Route 47S (South Hills Village via Overbrook) on July 5, 1985. Powered by four Westinghouse type 1432 motors, this car was one of seventy-five PCC cars Nos. 1700-1774 delivered to PRC between December 1947 and May 1948. The traditional trolley pole had been replaced by a pantograph during the rebuilding to a light rail system. (*Kenneth C. Springirth photograph*)

Back cover: As the Duquesne Incline car nears the Grandview Avenue upper station on June 12, 2019, the view of the Point Bridge over the Monongahela River is phenomenal making it easy to see why the Duquesne Incline is one of Pittsburgh's most popular tourist attractions. The Duquesne Incline carried 517,183 passengers in 2012 which was 2.5 percent higher than in 2011. (*Kenneth C. Springirth photograph*)

America Through Time is an imprint of Fonthill Media LLC
www.through-time.com | office@through-time.com

First published 2021

Copyright © Kenneth C. Springirth 2021

ISBN 978-1-63499-371-5

Typeset in Utopia Std
Printed and bound in England

Published by Arcadia Publishing by arrangement with Fonthill Media LLC
For all general information, please contact Arcadia Publishing:

Telephone: 843-853-2070
Fax: 843-853-0044
E-mail: sales@arcadiapublishing.com
For customer service and orders:
Toll-Free 1-888-313-2665

www.arcadiapublishing.com

Contents

Acknowledgments

Excellent reference sources were *Electric Railways of Northeastern Ohio* by Central Electric Railfans' Association; *McGraw Electric Railway List* August 1918; *McGraw Electric Railway List* 1924; *Passenger Transport October 10, 1975* American Public Transit Association; *Pittsburgh's Inclines* by Donald Doherty; *Pittsburgh Inclines* by Samuel R. Ohler; *Pittsburgh Inclines* in ERA Headlights Vol. 18 No. 4 April 1956; *Pittsburgh Inclines and Street Railways* by Howard V. Worley, Jr.; *Review of West Penn Railways 1889-1952* by Pittsburgh Electric Railway Club; *Steubenville, East Liverpool and Beaver Valley Traction* by Joseph M. Canfield in Electric Traction Quarterly Fall 1967 Issue Volume 6 Number 1; *The Electric Interurban Railways in America* by George W. Hilton and John R. Due; *The Street Railways of Pittsburgh, 1859-1967* by Tom E. Parkinson; and *Transit in the Triangle* Volume I by Blaine S. Hays and James A. Toman. Bob's Photos, Harold Geissenheimer (former director of PAT Transit Operations), W. J. B. Gwinn, and B. H. Nichols were a source of pictures. Picture was taken by Carl H. Sturner in a postcard that was *Used with permission from Audio-Visual Designs* (www.audiovisualdesigns.com).

This book is dedicated to the author's sons, Philip Springirth, Peter Springirth, and Timothy Springirth, because of their devotion to their family, their proficiency at work, and their ability to help the family in this age of technology.

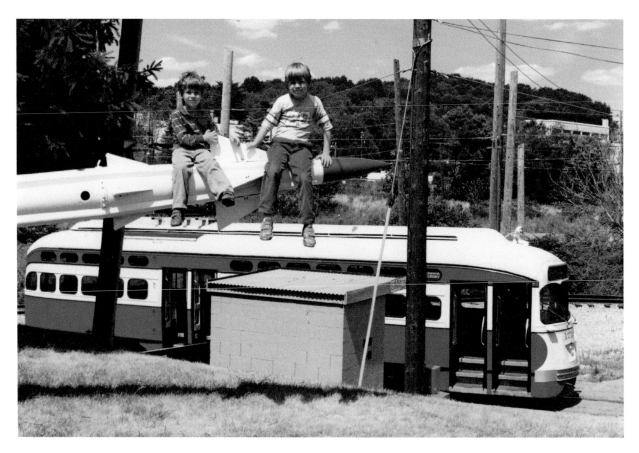

At the Simmons Loop, southern terminus of Route 35 (Library), on July 2, 1988 with a 1700 series Port Authority of Allegheny County (PAT) trolley car waiting for departure time, two of the author's sons (*from left to right*: Philip Springirth and Peter Springirth) are resting on a demilitarized Nike Ajax anti-aircraft missile from the Cold War era while their dad is photographing trolleys. (*Kenneth C. Springirth photograph*)

Introduction

Pittsburgh Railways Company (PRC) once operated a major trolley car system in the City of Pittsburgh plus lines that served Wilmerding, Trafford, McKeesport, Washington, Monongahela City, Roscoe, and Charleroi. The *McGraw Electric Railway List* August 1918 noted PRC operated 1,339 motorized passenger cars and 605 miles of track. World War I, with many employees going into the military, resulted in a shortage of workers which drove up wages. In addition, increases in the demand of coal drove up its price, which increased the cost of power generation. PRC filed for receivership, and trustees were appointed on April 23, 1918. Cuts were made and the *McGraw Electric Railway List* 1924 showed PRC had 592.92 miles of track and 1,219 motorized passenger cars.

In addition to Pittsburgh being a major trolley car system, it was possible to make a trip from Pittsburgh to Elkhart Lake, Wisconsin by trolley car as follows:

Pittsburgh, Harmony, Butler, & New Castle Railway—Pittsburgh to New Castle, Pennsylvania.

Mahoning & Shenango Railway Light Company (which later became Penn-Ohio System)—New Castle, Pennsylvania, to Leavittsburg, Ohio.

Cleveland, Alliance & Mahoning Valley Railroad—Leavittsburg, Ohio, to Ravenna, Ohio.

Northern Ohio Traction & Light Company—Ravenna, Ohio, to Silver Lake Junction, Ohio.

Northern Ohio Traction & Light Company—Silver Lake Junction, Ohio, to Cleveland, Ohio.

Lake Shore Electric Railway Company—Cleveland, Ohio, via Lorain and Sandusky to Fremont, Ohio.

Fostoria & Fremont Railway Company—Fremont, Ohio, to Fostoria, Ohio.

Toledo, Fostoria & Findlay Railway Company—Fostoria, Ohio, to Findlay, Ohio.

Western Ohio Railway Company—Findlay, Ohio, to Lima, Ohio.

Fort Wayne, Van Wert & Lima Traction Company—Lima, Ohio, to Fort Wayne, Indiana.

Fort Wayne & Wabash Valley Traction Company—Fort Wayne, Indiana, to Peru, Indiana.

Winona Interurban Railway Company—Peru, Indiana, to Goshen, Indiana.

Northern Indiana Railway Company—Goshen, Indiana, via Elkhart to South Bend, Indiana.

Chicago South Shore & South Bend Railroad Company—South Bend, Indiana, to Chicago, Illinois.

Chicago North Shore & Milwaukee Railway—Chicago, Illinois, to Milwaukee, Wisconsin.

Milwaukee Electric Railway & Light Company—Milwaukee, Wisconsin, to Sheboygan, Wisconsin.

Wisconsin Power & Light Company—Sheboygan, Wisconsin, via Plymouth to Elkhart Lake, Wisconsin.

With the exception of about a 1-mile gap between Edgeworth, Pennsylvania, and Sewickley, Pennsylvania, it was possible to travel by trolley car from Pittsburgh via Wheeling, West Virginia, to Moundsville, West Virginia, as follows:

Pittsburgh Railways route 23 (Coraopolis-Sewickley) to Sewickley loop and walk about one mile to Edgeworth, Pennsylvania.

Beaver Valley Traction Company from Edgeworth, Pennsylvania, via Rochester to Beaver, Pennsylvania.

Steubenville, East Liverpool, & Beaver Valley Traction Company from Beaver, Pennsylvania, to Steubenville, Ohio.

Wheeling Traction Company from Steubenville, Ohio, via Wheeling, West Virginia, to Moundsville, West Virginia.

The above-noted 1-mile gap was intended to be bridged.

On July 4, 1885, the Beaver Valley Street Railway Company opened a horsecar line from the Pennsylvania Railroad depot in New Brighton to 8th Avenue and 27th Street in Beaver Falls. The horsecar line was purchased by the Beaver Valley Traction Company and was changed over to electric trolley car operation on December 5, 1891. People's Electric Street Railway on August 13, 1892 opened their trolley car line serving Freedom, Rochester Township, Rochester, and Bolesville. The Riverview Electric Street Railway connected Beaver Falls with New Brighton around 1898. College Hill was connected with Beaver Falls by the College & Grandview Electric Street Railway which opened on July 31, 1893. The Rochester & Monaca Electric Street Railway connected Rochester with Monaca plus Beaver was connected to Vanport by the Beaver & Vanport Electric Street Railway. On October 1, 1900, all of these lines were consolidated into the Beaver Valley Traction Company. On January 29, 1908, the Philadelphia Company, a large utility company that owned Pittsburgh Railways, organized the Pittsburgh & Beaver Street Railway to build a trolley line connecting Baden with Emsworth. Two companies (Ambridge & Baden Street Railway Company and Ambridge, Leetsdale & Edgeworth Street Railway Company) constructed the line. The Beaver Valley Traction Company was contracted to operate the

line. In March 1922, the Philadelphia Company purchased Beaver Traction Company with the intention of closing the gap between the Beaver Valley Traction Company and Pittsburgh Railways but never closed the gap. The Beaver Valley Motor Coach Company began feeder bus operation in February 1924, and the last day of trolley car service was August, 10, 1937.

Connecting at Beaver, Pennsylvania, was the Steubenville, East Liverpool & Beaver Valley Traction Company. Operation began as a horsecar line in Steubenville, Ohio, that was converted to an electric overhead trolley system in 1888. By 1900, the line was extended along the Ohio River to Freemans' Ferry which was two miles north of Toronto, Ohio. Electric trolley service began in East Liverpool, Ohio, in 1892 by the East Liverpool & Wellsville Railway. A line was built across the Ohio River from East Liverpool, Ohio, to Chester, West Virginia, serving a race track and amusement park. In 1905, the Ohio River Passenger Railway constructed a standard-gauge line in Beaver, Pennsylvania, that connected with the broad-gauge Beaver Valley Traction Company line in Beaver. Following bankruptcy, these companies were reorganized and merged into the Steubenville, East Liverpool & Beaver Valley Traction Company (SELBVT) in 1917. The SELBVT called itself the "Streamline" and its schedules noted connecting railroad service. For example, its December 26, 1926 schedule showed connections for Columbus, Ohio, by the Pennsylvania Railroad at Steubenville, Ohio; connections for Lisbon, Leetonia, Youngstown, Salem, and Canton by the Youngstown & Ohio River Railway at East Liverpool, Ohio; and connections for Wheeling, West Virginia, by the Wheeling Traction Company at Steubenville, Ohio. When the State of Ohio needed the trolley car right of way to improve highway 7, the SELBVT in December 1938 only retained trolley service between East Liverpool and Wellsville along with East Liverpool city service which ended in April 1939.

West Penn Railways, at its peak, operated 339.47 miles of track. It consisted of six operations:

Allegheny Valley Railway operated from 1906 to 1937. It connected with Pittsburgh Railways at Aspinwall and operated about 23 miles along the north bank of the Allegheny River to Natrona.

Coke Region (named for the region's ability to produce coke from coal needed in the making of steel) began with the line connecting Greensburg with Uniontown in 1903. It became a large network of trolley lines that extended from Pittsburgh Railways connections at McKeesport (until 1938) and Trafford (until 1942) to Greensburg and south to Connellsville, Uniontown, Fairchance, Martin, and Brownsville. A line operated to Latrobe. Two lines operated between Greensburg and Scottdale, and two lines operated between Connellsville and Uniontown. Less than desirable roads in this area resulted in a lower percentage of automobiles, and trolley car ridership held up until the 1950s. Improved roads resulted in more automobiles and decline in trolley ridership. Trolley service in the Coke Region ended when the last car left Connellsville for Uniontown at 11:30 p.m. on August 9, 1952.

Wheeling Traction Company of West Virginia was controlled by West Penn Railways from 1912 to 1931. Trolley service operated on the east side of the Ohio River from Wheeling south to Moundsville and from Wheeling north to Weirton. On the west side of the Ohio River, a line operated from Shadyside via Bridgeport to Rayland, a branch from Bridgeport to Barton, and a connection from Bridgeport via a bridge over the Ohio River to Wheeling. There also was a line connecting Brilliant with Steubenville with a connection from Steubenville to the Wheeling Weirton line. On July 21, 1933, the Wheeling Traction Company was sold to company employees who had organized Cooperative Transit Company. The system was converting to bus operation, and the flooding Ohio River ended Wheeling's trolley car service on April 14, 1948.

Cowanshannock-Kittanning-Lenape Park from 1899 to 1936 operated as an isolated line from Cowanshannock to Kittanning to Lenape Park, an amusement park built and operated by the company. This isolated line was built as a standard-gauge 4 feet 8.5 inches. The other West Penn lines were built to a 5-foot 2.5-inch gauge.

Apollo-Leechburg operated as an isolated line from 1906 to 1936 along the north bank of the Kiskiminetas River from Apollo to Leechburg.

Oakdale-McDonald operated as an isolated line from 1907 to 1927 parallel to the St. Louis line of the Pennsylvania Railroad at the west end of Pittsburgh's suburbs.

The Pittsburgh & Butler Street Railway began trolley service on April 24, 1907 from downtown Pittsburgh using Pittsburgh Railways route 2 to Etna and headed north via Gibsonia, Mars, and McCandless. This was the east line to Butler. During 1908, the Pittsburgh, Harmony, Butler & New Castle Railway Company (PHB&NCR), using Pittsburgh Railways route 10 trackage on East Street, completed the west line via Ingomar, Wexford, and Evans City to Butler with a branch from Evans City via Harmony and Ellwood Junction to New Castle. At New Castle, it was possible to connect with the Pennsylvania Railroad to Erie, Pennsylvania, or to get off at Linesville, Pennsylvania, for the Northwestern Pennsylvania Railway trolley line for Meadville, Cambridge Springs, Edinboro, and Erie. In January 1915, the PHB&NCR opened their line from Ellwood City via Morado to Beaver Falls where connection was made with Beaver Valley Traction Company trolleys for Beaver a connection point with the SELBVT. Butler Railways Company, which provided trolley car service in the Butler area, became the city division of the Pittsburgh & Butler Street Railway (P&BSR) in 1914. The P&BSR failed in 1917 and reorganized as the Pittsburgh, Mars & Butler Railway. In 1918, the east and west systems came under the control of a holding company (Pittsburgh, Butler & Harmony Consolidated Railway & Power Company) which was succeeded in 1928 by the Harmony Short Line Railway Bus & Land Company. The Pittsburgh via Mars to Butler line made its last trolley run on April 22, 1931. Trolley service on the Beaver Falls–Ellwood City–New Castle section ended June 15, 1931; and trolley service on the remaining portion of the Harmony Route ended August 15, 1931.

The trolley routes were replaced by Harmony Short Line buses. Butler Railways Company ended trolley service on January 30, 1941.

The Mahoning and Shenango River Valleys of western Pennsylvania and eastern Ohio were served by local trolley car systems and interurban lines that in 1905 were unified into the Mahoning & Shenango Railway & Light System. In 1920, it became the Penn-Ohio Electric System. Its line from New Castle, Pennsylvania, via Youngstown, Ohio, to Warren, Ohio, opened in 1902 and closed in 1932. The line between Warren, Ohio, and Leavittsburg, Ohio, opened in 1901 and closed in 1931. At Leavittsburg, the Cleveland, Alliance & Mahoning Valley Railroad operated via Newton Falls to Ravenna, Ohio, where connection was made with the Northern Ohio Traction & Light Company (NOT&L) via Kent to Silver Lake Junction, Ohio, where it was possible to go south via NOT&L to Cuyahoga Falls and Akron or north via NOT&L to Cleveland, Ohio.

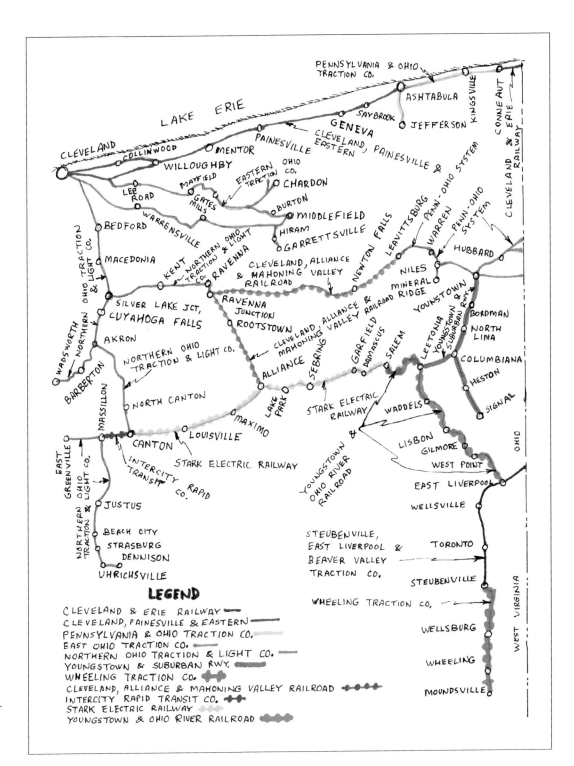

As noted on the above map, there were significant interurban trolley car connections from the Pennsylvania-Ohio state line to Cleveland, Akron, and Canton, Ohio.

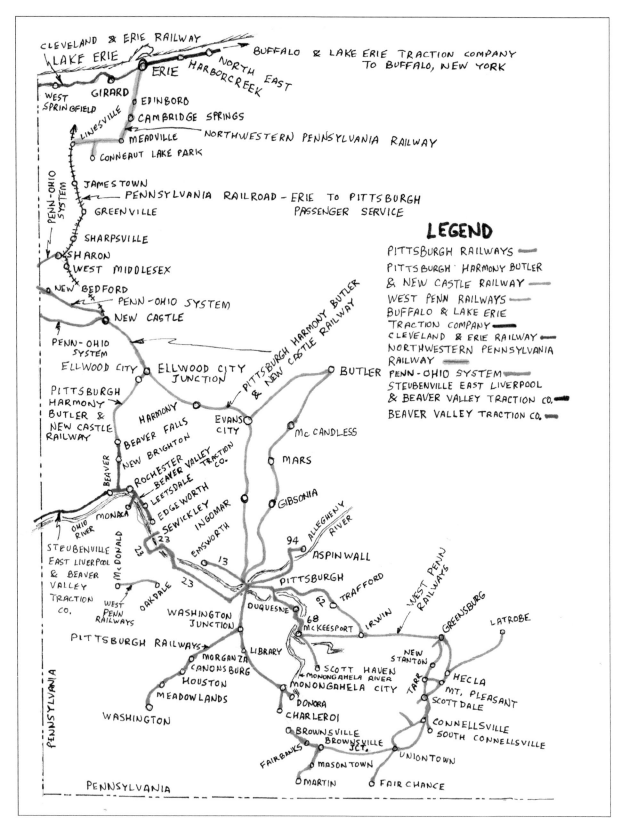

With the exception of about a 1-mile gap between the Pittsburgh Railways Company route 23 terminus at Sewickley, Pennsylvania, and the Beaver Valley Traction Company terminus at Edgeworth, Pennsylvania, it was possible to travel by trolley car from Pittsburgh via Wheeling, West Virginia, to Moundsville, West Virginia, as shown on the above map. There was a direct connection by Pennsylvania Railroad to Erie, Pennsylvania, or the Pittsburgh Harmony Butler & New Castle Railway could be taken to New Castle, connect with the Pennsylvania Railroad to Linesville, and then take a Northwestern Pennsylvania Railway trolley car to Meadville and transfer to a Northwestern Pennsylvania Railway trolley car to Erie or numerous points along the way.

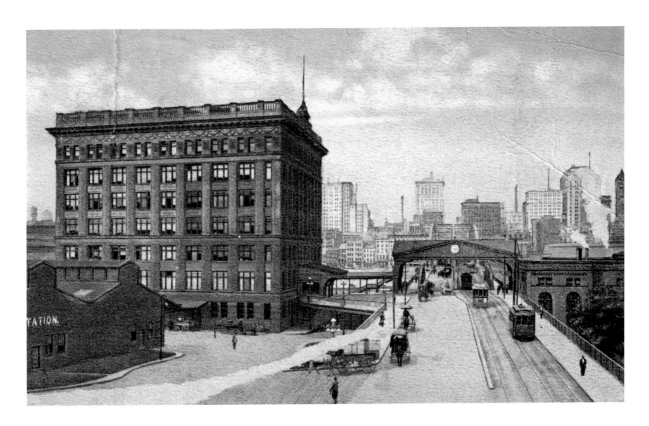

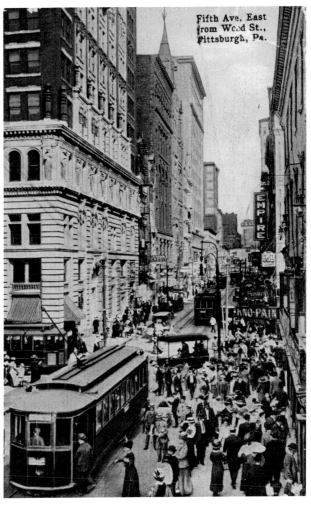

Above: In this 1910 postcard scene, numerous Pittsburgh Railways Company (PRC) trolley cars serving many communities are passing by the Pittsburgh & Lake Erie Railroad on Smithfield Street in downtown Pittsburgh.

Right: Fifth Avenue, east of Wood Street in the heart of Pittsburgh, is a store owner's delight with sidewalks filled with people that arrived by the many PRC trolley cars shown in this 1915 postcard view.

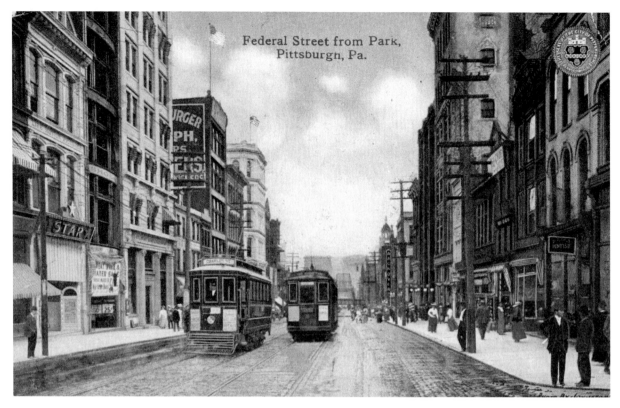

Federal Street on Pittsburgh's North Side was used by PRC trolley car Routes 8 (Perrysville Avenue) and 21 (Fineview) plus as noted by this postcard postmarked July 29, 1912 had a nice amount of pedestrians passing through the business district.

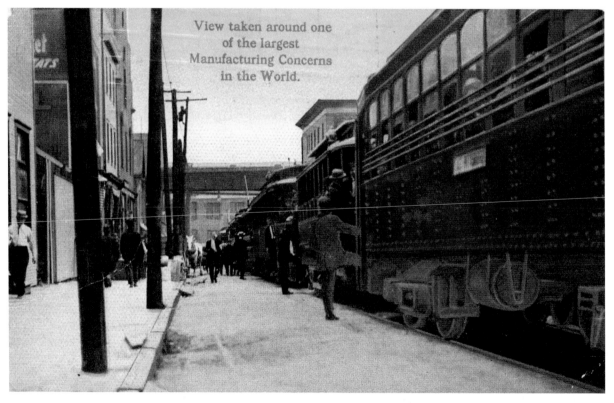

A shift change is occurring in this postcard postmarked September 29, 1916 at the Westinghouse Electric & Manufacturing Company on Electric Avenue in East Pittsburgh. Founded in 1886 by George Westinghouse Jr. (born October 6, 1846 and died March 12, 1914), the company employed more than 22,000 people by 1886. This area was served by PRC streetcar Routes 55 (Homestead–East Pittsburgh), 62 (East Pittsburgh–Trafford), 64 (Wilkinsburg–East Pittsburgh), and 87 (Ardmore).

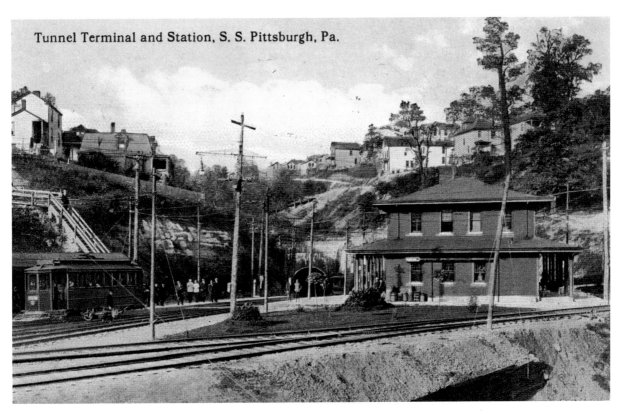

South Hills Junction, also known as Tunnel Terminal and Station, is shown in this postcard postmarked June 23, 1914. This was a PRC major junction served by trolley car Routes 35 (Library), 36 (Drake), 37 (Shannon), 38 Mt. (Lebanon), 39 (Brookline), 40 (Mt. Washington), 42 (Dormont), 43 (Neeld Avenue), 44 (Knoxville), 47 (Carrick via Tunnel), and 48 (Arlington).

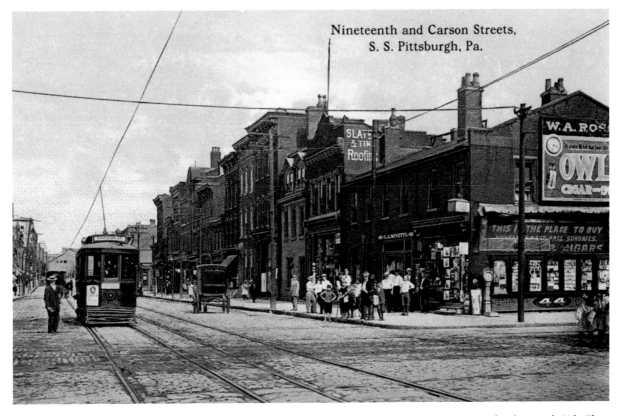

A Route 50 (Carson Street) trolley car is making a passenger stop on Carson Street at 19th Street (in the South Side Flats neighborhood of Pittsburgh) in this 1912 postcard scene.

An amazing amount of pedestrian traffic is on Liberty Avenue and 6th Avenue in downtown Pittsburgh in this postcard postmarked August 2, 1911. Before widespread use of the automobile, the vast majority of people came to downtown areas by trolley car.

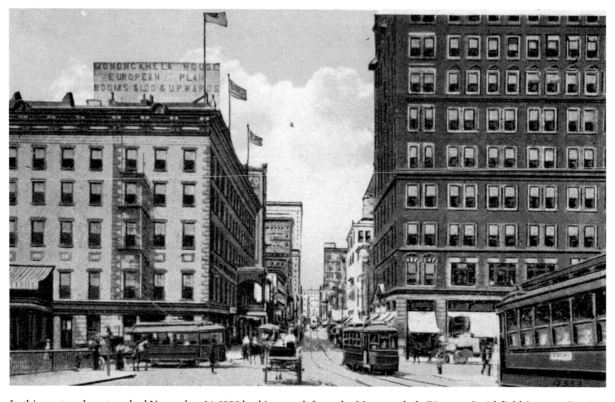

In this postcard postmarked November 14, 1928 looking north from the Monongahela River on Smithfield Street at Fort Pitt Boulevard in downtown Pittsburgh, there are trolley cars, horse drawn carriages, and pedestrians with no automobiles in sight.

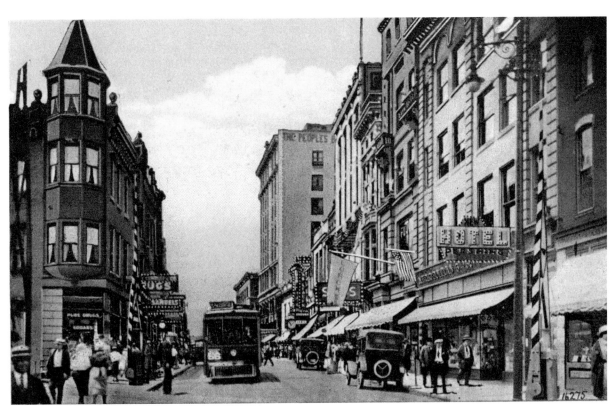

Looking west on 5th Avenue at the Baltimore & Ohio Railroad crossing in downtown McKeesport, a Pittsburgh Railways trolley car is passing through the well patronized business district around 1930. PRC trolley car Routes 56 (McKeesport), 68 (Homestead–Duquesne, McKeesport), and 98 (McKeesport-Wilmerding), later 98 (McKeesport-Glassport), and 99 (Evans Avenue-Glassport) served McKeesport. From a peak population of 55,355 in 1940, McKeesport's population declined 64.36 percent to 19,731 in 2010 with a major factor being the steelmaking industry moving elsewhere.

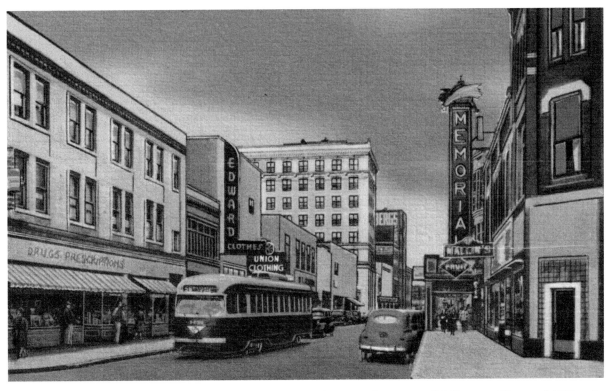

Fifth Avenue and Market Street in downtown McKeesport is the location of a Route 98 (McKeesport-Glassport) PCC car in this 1945 postcard scene.

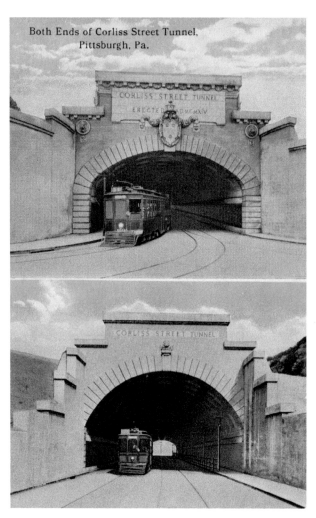

Left: The is a postcard view of both ends of the 420-foot-long concrete lined Corliss Street Tunnel with the north end facing West Carson Street and south end facing Chartiers Avenue. Completed in 1914 under the Pittsburgh, Cincinnati, Chicago & St. Louis Railroad (which today is the Norfolk Southern Railway) the tunnel was used by PRC trolley Route 31 (Sheraden–Ingram).

Below: This is a postcard postmarked February 28, 1914 of the World War I war memorial built in 1918 to honor World War I troops at the "V" intersection where on the left is a trolley car on Butler Street, and on the right is a trolley car on Penn Avenue. PRC trolley car Routes 94 (Sharpsburg–Aspinwall, 95 (Butler), and 96 (East Liberty–62nd Street) are on Butler Street while trolley car Route 88 (Frankstown) is on Penn Avenue.

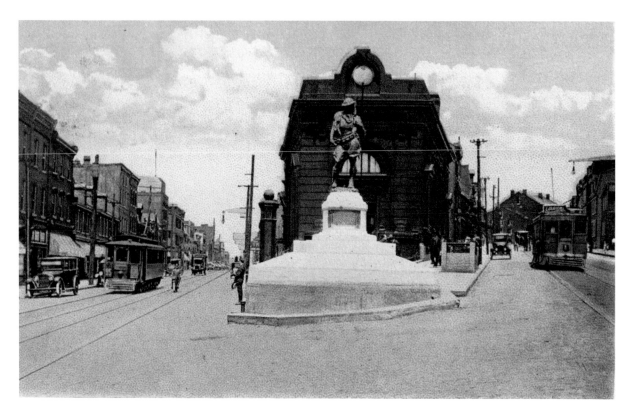

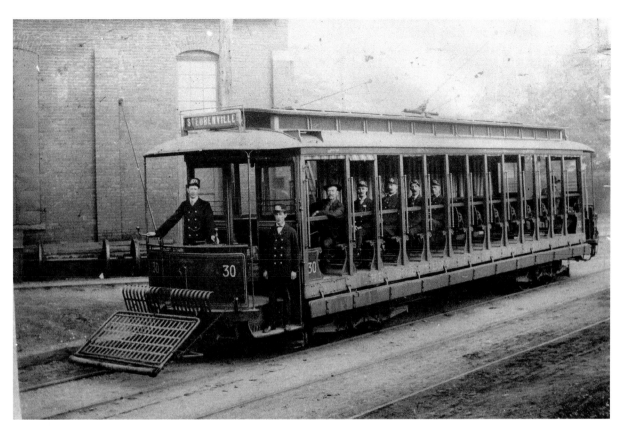

Steubenville Traction Company car No. 30, built by Jewett Car Company, is posing at the 7th and Franklin Streets Steubenville, Ohio, car barn around 1910. (*W.J.B. Gwinn photograph*)

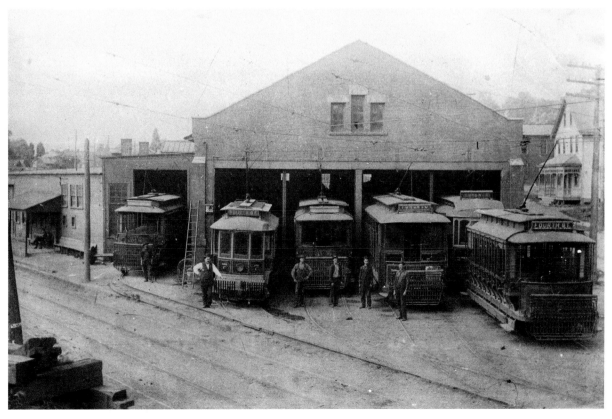

This is a neat 1910 photo of the Steubenville Traction Company Steubenville, Ohio, car barn with a line-up of their vintage single truck trolley cars used on the company's Toronto, Fourth, and Pleasant Heights trolley car lines. (*W.J.B. Gwinn photograph*)

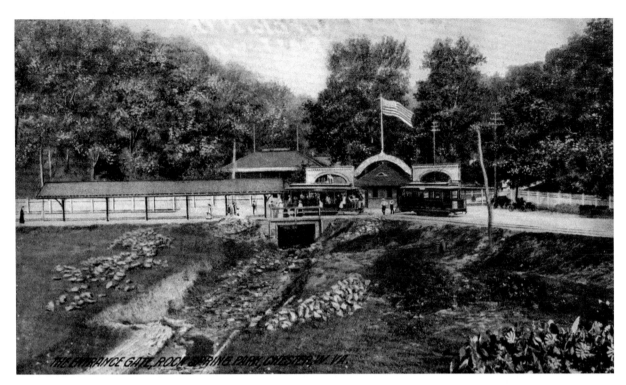

Rock Springs Park began in 1857 as Rock Springs Grove that was donated by the Marks Farm for church picnics. In 1890, East Liverpool attorney James McDonald bought 170 acres of the A. E. Marks Estate of which 11 acres were Rock Spring Grove to be made into an amusement park. Rock Springs Park officially opened on May 26, 1897 when the East Liverpool Street Railway Company opened trolley car service to the park. Two trolley cars are shown in this postcard scene at the park entranceway. The line was converted to bus operation in 1934. Following the June 26, 1974 "Last Dance at Virginia Gardens" (park's dance hall), the park was replaced by a rerouted U.S. Highway Route 30.

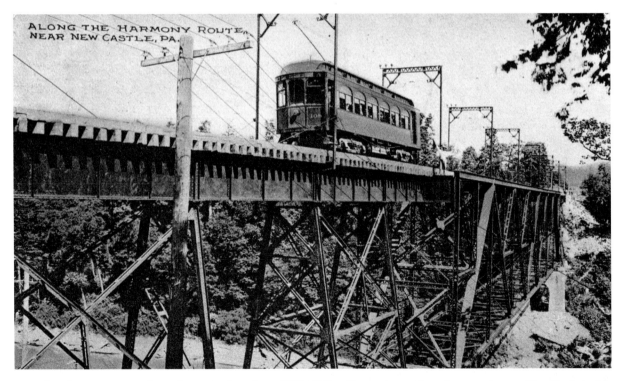

A Pittsburgh, Harmony, Butler and New Castle Railway (PHB&NC) trolley car is crossing a long trestle near New Castle in this postcard postmarked January 4, 1910. First trolley car operated to Ellwood City on July 2, 1908. The line connected Pittsburgh with Zelienople, Beaver Falls, Evans City, Harmony, Butler, Ellwood City, and New Castle. Because there were numerous possible stops over the entire system, it was advisable for passengers to flag down the trolley car operator if they wanted to ride.

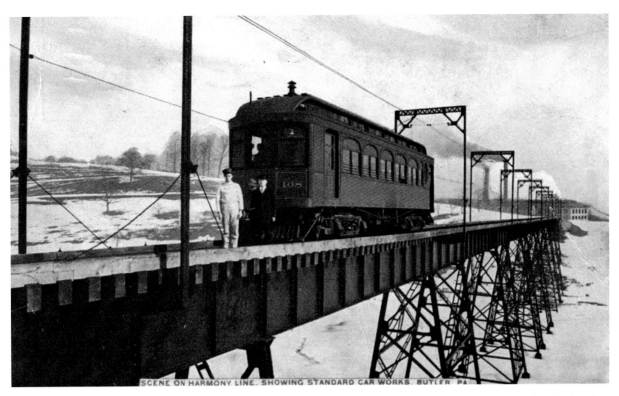

PHB&NC car No. 108 is posing in a postcard scene on a bridge with the Standard Steel Car Company (SSC) of Butler, Pennsylvania, in the distance. Established in 1902, the SSC became one of the largest builders of steel cars in the United States. It was purchased by Pullman, Inc. in 1929 and was merged in 1934 to form Pullman-Standard Car Manufacturing Company.

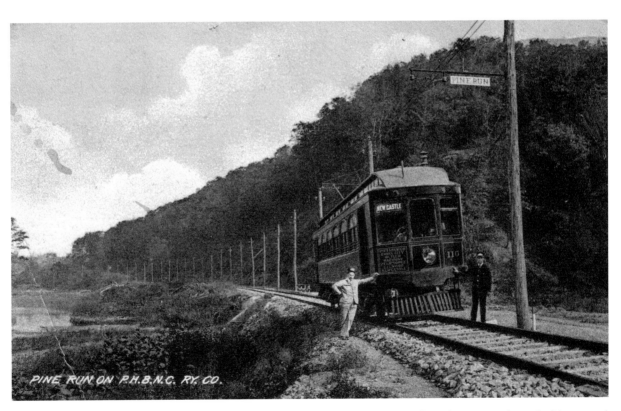

A photo stop with car No. 110 at Pine Run on the PHB&NC line between Evans City and Elwood Junction is shown in this postcard scene. The car was on the Pittsburgh via Evans City and Elwood Junction line to New Castle, Pennsylvania. New Castle had Pennsylvania Railroad connections to Pittsburgh, Sharon, Sharpsville, and Erie while Ellwood City had passenger service via the Baltimore & Ohio Railroad to Akron, Cleveland, and Chicago plus the Pittsburgh & Lake Erie Railroad to Pittsburgh and Youngstown.

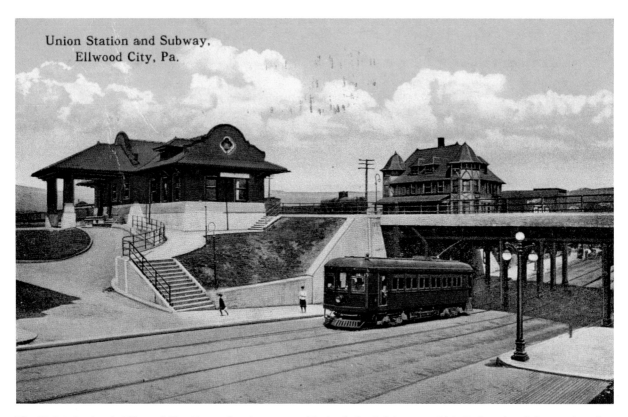

The Union Station in Ellwood City, Pennsylvania, was used by both the Baltimore & Ohio Railroad and the Pittsburgh & Lake Erie Railroad in this postcard postmarked September 11, 1917. This was a convenient transfer point for the PHB&NC interurban trolley car at the station stop. The PHB&NC interurban car shown in the postcard was one of five lower height cars purchased to handle the low bridge clearance at this station.

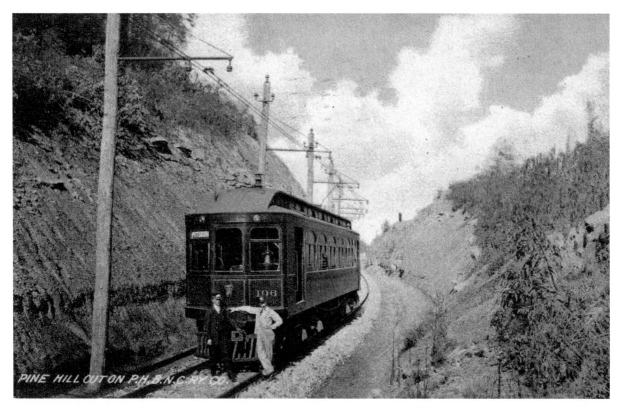

This postcard postmarked December 5, 1911 shows the PHB&NC crew posing for a picture with car No. 106 at the Pine Hill cut in this postcard postmarked December 30, 1911.

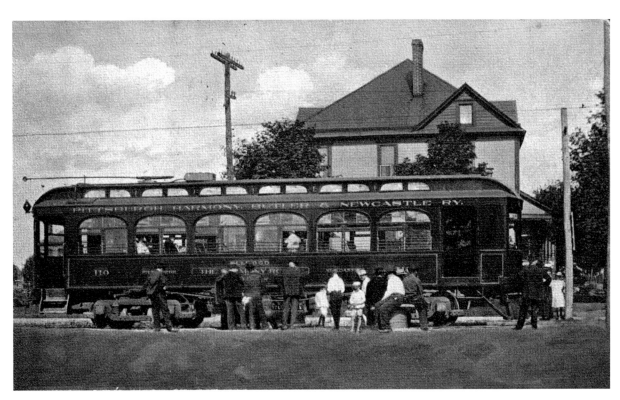

Passengers are waiting to board PHB&NC car No. 110 in this postcard postmarked February 7, 1911. The first trip over the new Ellwood City line to Beaver Falls was an inspection trip made on December 23, 1914. Leaving the station at Fifth Street and Spring Avenue the line headed in a southerly direction through Koppel and Homewood to Morado where it connected with the Beaver Valley Traction (BVT) line to Beaver Falls. BVT employees operated the cars on their portion of the line between Morado and Beaver Falls.

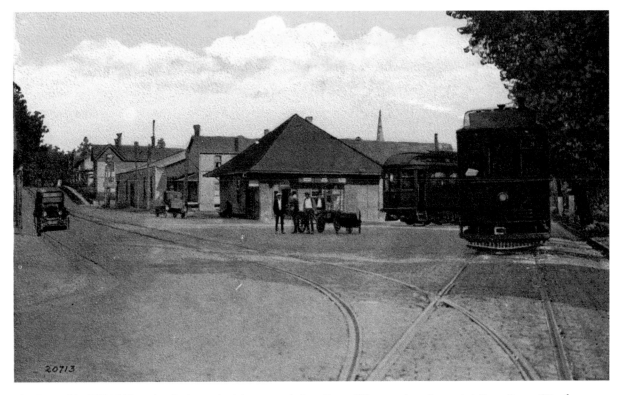

The Evans City PHB&NC station is shown in this postcard view. Evans City was a junction point. From Evans City, there was trolley service south to Pittsburgh, northwest to Elwood Junction and New Castle, and northeast to Butler. There was service from Elwood Junction south to Beaver Falls. A separate line operated from Butler south to Pittsburgh.

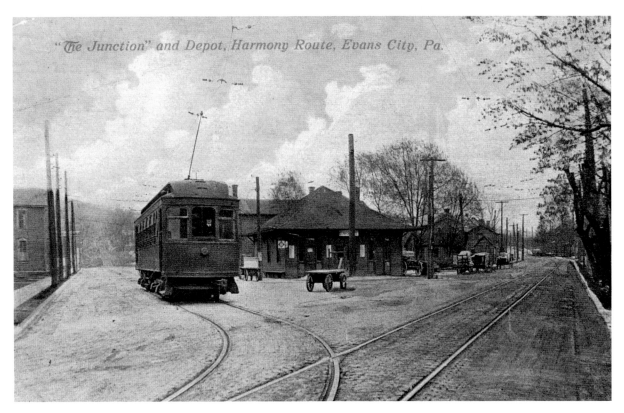

Another view of the Evans City junction and station is shown in this postcard postmarked September 3, 1920. Interurban trolleys came to this junction from three different directions.

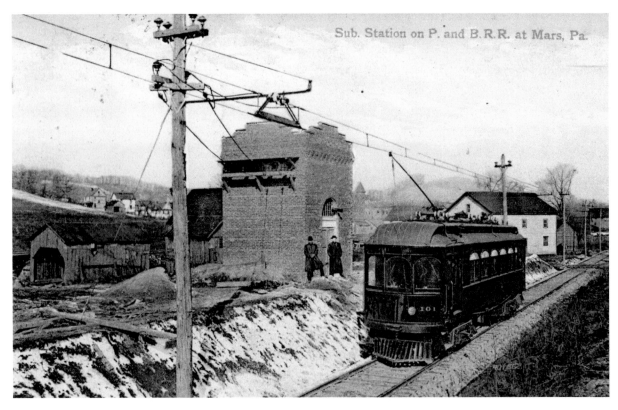

PHB&NC car No. 101 is operating on the Butler Short Line (BSL) passing the substation at Mars, Pennsylvania, in this postcard postmarked on May 11, 1920. In 1917, the PHB&NC purchased the BSL, which connected Butler with Pittsburgh roughly following today's Highway Route 8.

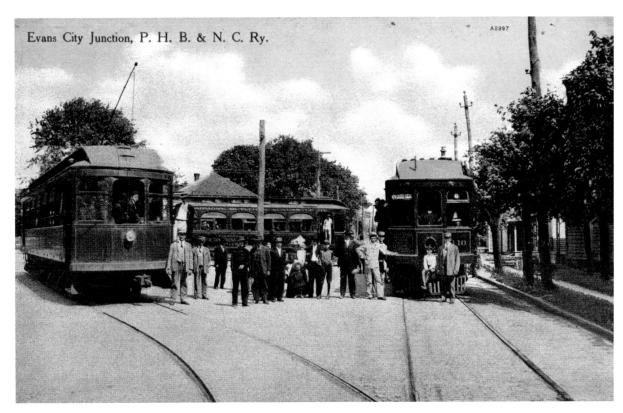

Three PHB&NC cars are at the Evans City Junction in this postcard scene. When the interurban trolley line opened in 1908, it was the beginning of suburban living. It made it possible for people to live in a rural area and promptly travel to the city.

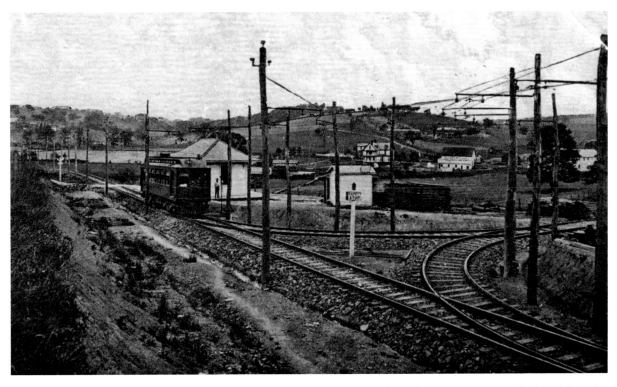

Warrendale, a northern suburb of Pittsburgh, is in the northwestern corner of Allegheny County on the Pittsburgh & Butler Street Railway as noted in this postcard scene. The interurban line opened in 1907 and in 1917 became part of the Pittsburgh, Harmony, Butler, & New Castle Railway. Known as the Butler Short Line, it closed on April 22, 1931 and was replaced by the existing bus service on Highway 8.

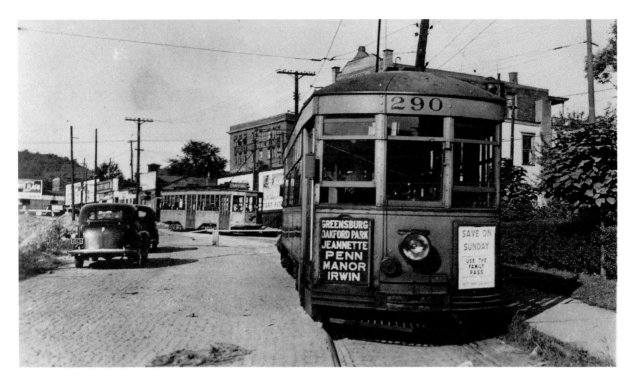

West Penn Railways (WPR) car No. 290 (one of ten cars, Nos. 288–297, seating forty-four passengers built by Cincinnati Car Company in 1921) is at Trafford, Pennsylvania, with the connecting Pittsburgh Railways Company (PRC) Route 62 (East Pittsburgh–Trafford) car in the left rear of the photo. The WPR lower front destination sign shows reading up: Irwin, Manor, Penn, Jeannette, Oakford Park, and Greensburg. The lower right-hand sign is lettered "Save on Sunday, use the family pass."

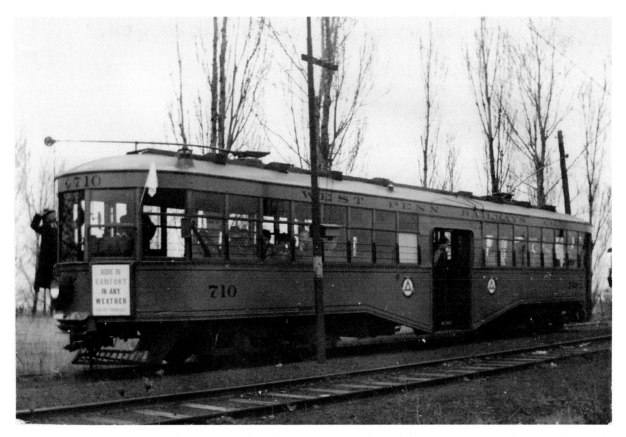

On November 10, 1946, Calumet siding on the WPR line between Latrobe and Hecla Junction is the location of WPR car No. 710 (one of six cars, Nos. 709–714, seating seventy passengers built by Cincinnati Car Company in 1916). The lower front car sign noted: "Ride in comfort in any weather, go by trolley." (*W.J.B. Gwinn photograph*)

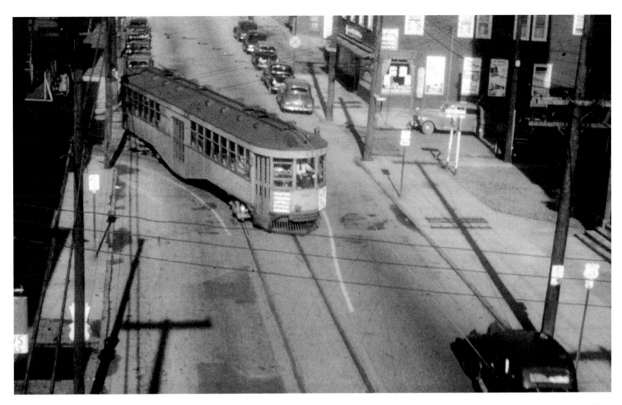

Connellsville, Pennsylvania, a city in Fayette County about 50 miles southeast of Pittsburgh on the Youghiogheny River (has seen a 43.88 percent decline in population from 13,608 in 1940 to 7,637 in 2010) is the location of WPR car No. 729 (one of six cars, Nos. 728–733, seating seventy passengers built by West Penn Railways in 1923) on June 19, 1949. (*Bob's Photograph*)

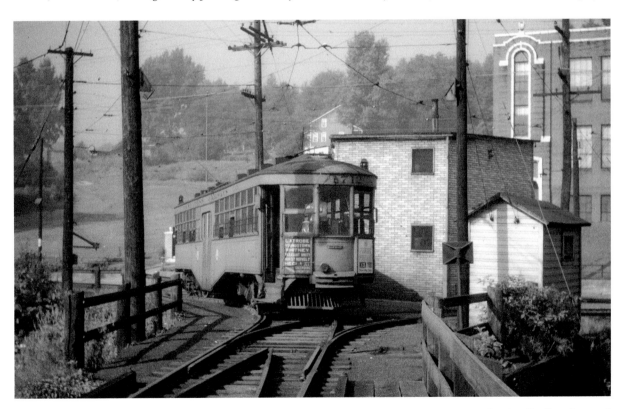

On August 23, 1950, WPR car No. 712 is at Hecla Junction. One of its early predecessor operations was a local trolley line chartered on September 27, 1889 in Greensburg. At its peak, WPR operated a 339.47-mile system with the main line of the system being the 30.6-mile segment between Greensburg and Uniontown via Hecla, Mt. Pleasant, Scottdale, and Connellsville. WPR's last day of operation was August 9, 1952 for Greensburg–Uniontown plus Connellsville–South Connellsville. (*Bob's Photograph*)

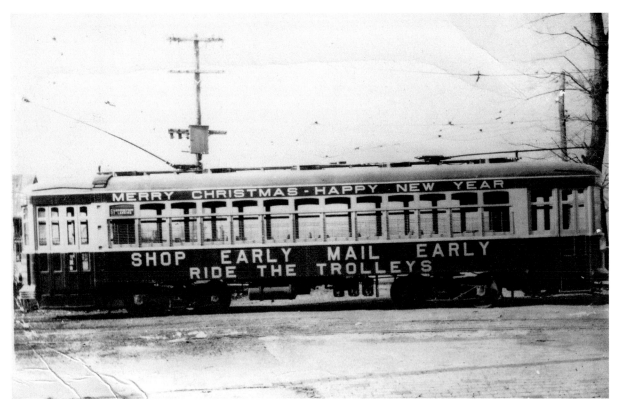

Wheeling Traction Company car No. 927 was painted for the 1928 holidays and lettered "Merry Christmas—Happy New Year" and below the windows "Shop Early Mail Early" and on the bottom "Ride the trolleys." (*W.J.B. Gwinn photograph*)

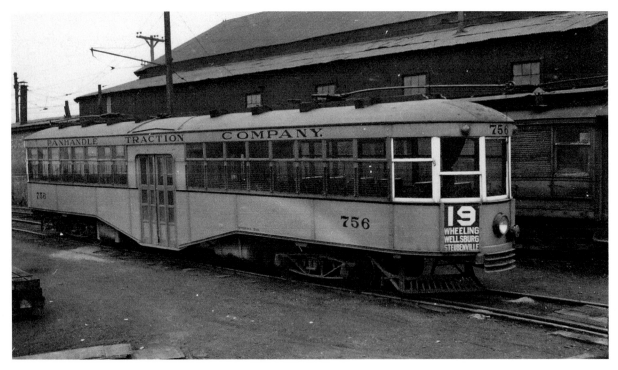

Panhandle Traction Company (PTC) car No. 756 was leased and operated by the Wheeling Traction Company and connected Wheeling with Wellsburg. According to the *McGraw Electric Railway Directory 1924*, PTC had thirteen cars and 19.51 miles of track. (*B.H. Nichols collection*)

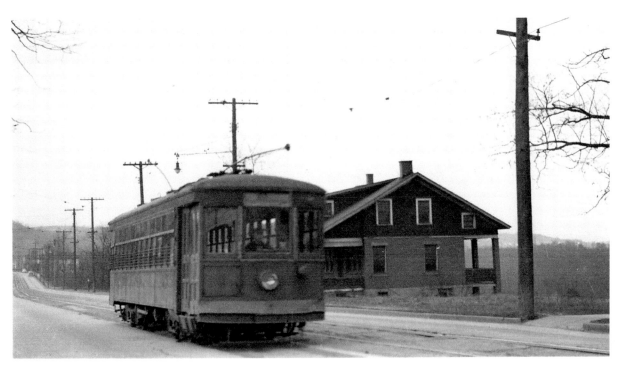

Beaver Valley Traction Company car No. 613 is passing by College Hill. North of College Hill was Morado where connection was made with the PHB&NC. The Beaver Valley Traction Company line served as a link between the PHB&NC at Morado to Beaver, Pennsylvania, to the Steubenville, East Liverpool & Beaver Valley Traction Company at Steubenville, Ohio, where connection was made to the Wheeling Traction Company from Steubenville, Ohio, to Wheeling, West Virginia, and Moundsville, West Virginia.

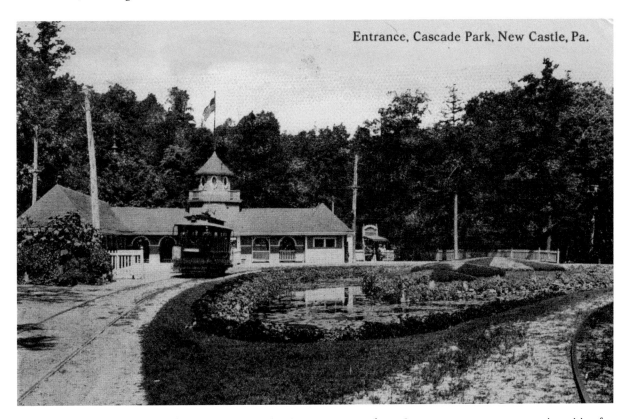

The entrance to Cascade Park (where a New Castle Electric Street Railway Company open summer car is waiting for departure time) is shown in this postcard postmarked October 12, 1911. This park was opened on May 29, 1897 by the New Castle Electric Street Company (which later became Penn Power Company) and was also accessible by the PHB&NC. In 1934, Cascade Park was donated by Penn Power Company to the city of New Castle.

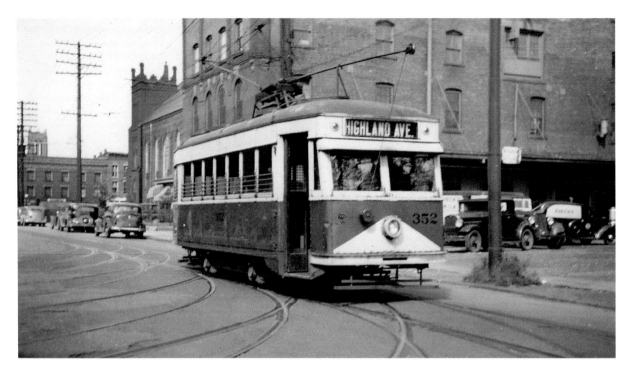

New Castle Electric Street Railway Company car No. 352 was modernized to attract ridership. This was originally a Birney car designed small and lightweight for one-man operation which saved the expense of a conductor plus for safety reasons if a passenger or object blocked the door, the car would not start. Heavy snow and rough track could derail these lightweight cars. By 1941, New Castle's trolley cars were completely replaced by buses.

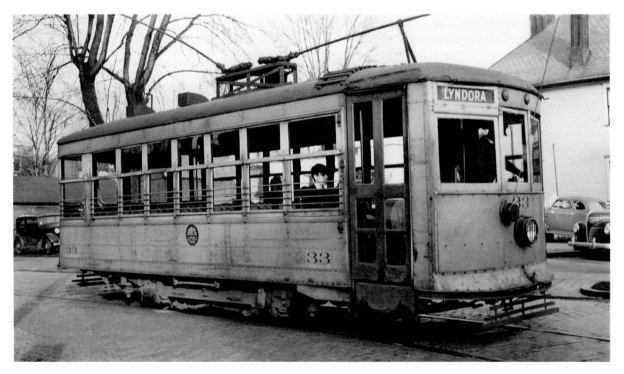

Butler Traction Company car No. 33 is on the Lyndora line around 1920. Butler, Pennsylvania's first trolley car system opened in August 1900. During July 4, 1901, over 7,000 people came to the 400-acre Alameda Park opened by the trolley company to see a parade of brass bands, comedy acts, and evening fireworks. The initial success of the park resulted in the trolley company adding a roller coaster and carousel. Butler's trolley cars were replaced by buses in 1941, and the park closed in 1944. In 1967, Butler County purchased Alameda Park, and it has reopened with playgrounds, picnic area, and a mountain bike trail.

1

Pittsburgh Trolley Car Routes

The Citizens Passenger Railway Company opened its first horsecar line on August 22, 1859 with four cars in service from downtown Pittsburgh via Penn Avenue to Lawrenceville. Each car had a capacity of thirty seated passengers, weighed about 4,200 pounds, and was unheated with straw supplied to keep passengers' feet from freezing. By September 1, 1859, there were seven cars in service. The horsecars traveled 5 mph.

On September 12, 1889, the Pittsburgh Traction Company reopened the former Pittsburgh, Oakland & East Liberty horsecar line as a cable car line. The trip to East Liberty that required one hour and forty five minutes by horsecar was thirty minutes by cable car which was more comfortable, because the larger cable cars had double trucks instead of four small wheels on the horsecar. However, the cable, with a length of life that varied depending on usage, was expensive to replace.

In the spring of 1890, the Second Avenue Traction Company opened Pittsburgh's first permanent and successful electric trolley car line from downtown Pittsburgh via 2nd Avenue to Glenwood that showed its advantages over other systems. Pittsburgh's population grew from 238,617 in 1890 to 321,616 in 1900 along with the growth of the steel, railroad, glass, and other industries resulted in the growth of electric trolley lines. The largest trolley company was Consolidated Traction Company chartered on July 24, 1895 with 187 miles of track. Second largest was United Traction Company of Pittsburgh chartered July 27, 1896 with 157 miles of track. The Monongahela Street Railway Company opened a 1.5-mile line in Monongahela on September 30, 1895. On January 1, 1902, Pittsburgh area trolley systems were consolidated into the Pittsburgh Railways Company (PRC).

The Mount Washington Tunnel Company began in March 1903 to construct a tunnel through Mount Washington to provide direct interurban trolley service from the South Hills to downtown Pittsburgh. Tunnel excavation began at both the north and south end at the same time. Working two day and two night shifts with thirty workers on each shift six days a week, the workers averaged 300 feet per month through solid rock. The Canonsburg & Washington Railway Company was chartered in March 1903 to construct a line to Canonsburg. Northside Routes 10 (Bellevue) and 15 (West View) opened in the summer of 1903. Route 10 went north on East Street, passed Westview Park, and reached its terminus. It became Route 15 and headed to downtown Pittsburgh. On the east side of Pittsburgh, trolley service was extended from Wilmerding to Trafford and from McKeesport to Glassport. During 1903, PRC added 34.3 miles of track, creating a 445.56-mile system. Four

workers lost their lives in the difficult and dangerous construction of the 3,492-foot-long Mount Washington Tunnel completed at a cost of $875,000 which opened December1, 1904. The 29-mile Pittsburgh to Washington interurban line opened on February 14, 1909 followed by completion on June 20, 1910 of the Charleroi line which left the Washington line at Washington Junction which is about 7.8 miles south of Pittsburgh. The 35-mile Pittsburgh via Black Diamond and Charleroi to Roscoe line had a branch line from Black Diamond to Donora added during 1911. In 1914, PRC operated about 600 miles of track.

PRC went into bankruptcy and receivership in 1918. Fares were increased in September 1920 and steps were taken to reduce costs. The South Side's Sarah Street horsecar line which had been in service more than fifty years made its last run on August 27, 1923. Trolley Route 24 (Schoenville) was cut from the rest of the system to avoid the cost of rebuilding a bridge. Car No. 4344 served that line until it closed on May 8, 1952. Some non-revenue trackage was abandoned reducing the system to a 592.06-mile system by the end of 1924. The Pittsburgh Motor Coach Company (PMC), organized as a separate part of PRC on July 27, 1925, operated thirty-four buses on five routes, and carried over 1.1 million riders in its first year. PRC purchased the Crafton & Chartiers Valley Traction Company which operated Route 29 (Thornburg) on September 13, 1927 followed in 1928 by the Homestead & Mifflin Street Railway which PRC used for Route 65 (Munhall Lincoln Place).

Pittsburgh's population peaked at 676,806 in 1950; however, it declined to 305,704 by 2010. During 1933, PRC ended trailer car operations, and the trolley car lines became one man operation. Trolley Route 33 (Mount Washington–West End) was abandoned on January 30, 1933. PRC ordered a Presidents' Conference Committee (PCC) car from St. Louis Car Company for $17,097.87 that was delivered on July 26, 1936. On May 24, 1936, PRC Route 98 (McKeesport–Wilmerding) made its last run due to the widening of the Lincoln Highway in East McKeesport. That route number was later used for the Glassport–McKeesport trolley line.

In January 1937, seventy-five new PCC cars, Nos. 1000–1074, ordered by PRC arrived from St. Louis Car Company followed by twenty-five more, Nos. 1075–1099, during March and April 1937. The first ten PCC cars were assigned to Route 38 (Mount Lebanon) on February 4, 1937. An additional 100 PCC cars were ordered from St. Louis Car Company, with Nos. 1100–1174 received October–December 1937 and Nos. 1175–1199 received January 1938. PRC management was pleased with their rapid acceleration, smooth operation, and comfortable seating. PRC had motors on 382 of

the older cars rewound to speed up their operation to keep pace with the PCC car fleet. In January 1938, twenty-five new PCC cars were delivered, Nos. 1175-1199.

Trolley car Route 78 (Oakmont-Verona) made its last run on March 27, 1938. During 1940, St. Louis Car Company delivered 100 more PCC cars, Nos. 1200-1299. On March 29, 1941, trolley car Route 16 (Superior-Shadeland) made its last run. After Japan attacked Pearl Harbor, the United States declared war on Japan on December 8, 1941 followed by Germany declaring war on the United States on December 11, 1941. In 1942, 50 million more riders used PRC than in 1941. The 100 PCC cars, Nos. 1400-1499, ordered in June 1941 arrived during February-May 1942. Between November 1944 and March 1945, sixty-four new PCC cars, Nos. 1500-1563, were received. On July 8, 1944 trolley car Route 65 (Homeville-Homestead-Lincoln Place) was discontinued with a portion becoming Route 59 (Homeville-Mifflin) and Route 65 (Munhall-Lincoln Place). Route 65 began operating to Munhall Loop on July 9, 1944. All-electric PCC car No. 1600 was received on September 5, 1945. Between October 1945 and January 1946, PCC cars Nos. 1601-1699 arrived and PRC had a total of 566 PCC cars. Trolley car Route 46 (Brownsville) became Route 49 (Beltzhoover) on September 29, 1946. PRC 1947 ridership reached a record 288,962,016.

On May 28, 1949, delivery was completed on the 1700 series PCC cars resulting in a total of 666 PCC cars. The peak trolley car mileage of 606 miles in 1918 had declined to 532.9 miles in 1951. As ridership declined, trolley car Route 51 (Bon Air Shuttle) made its last run on February 7, 1950 followed by trolley car Route 52 (36th Street Shuttle) on August 2, 1950.

Under a 1950 reorganization, Charles D. Palmer became president, and the motor coach division was merged into Pittsburgh Railways. As ridership declined with more people driving automobiles, operational costs needed to be reduced. Trolley Route 9 (Charles Street Transfer) was permanently discontinued on September 14, 1951. Mount Oliver Incline was abandoned on July 6, 1951. Trolley Route 81 (Atwood Shuttle) last day of operation was September 8, 1951. On October 13, 1951, trolley Routes 17 (Reedsdale) and 20 (Rebecca) were abandoned. Over the next two years, the following trolley routes were abandoned: 24 (Schoenville) on May 8, 1952; 78 (Laketon Road Shuttle) on July 30, 1952; Route 2 (Etna on September 1, 1952; Route 3 (Millvale) on September 1, 1952; and 29 (Thornburg Shuttle on November 15, 1952). Route 23 (Sewickley-Coraopolis-McKees Rocks) was cut back to Neville Island on June 21, 1952. Route 99 (Evans Avenue-Glassport) was replaced by trolley car Route 98 (McKeesport-Glassport) on November 9, 1952.

On January 2, 1953, Route 38A (Mt Lebanon-Castle Shannon) became a rush-hour extension of Route 38. Trolley car service ended on 59 (Homeville-Homestead-18th Street Munhall) on March 7, 1953, 56B/99 (Evans Avenue-10th Ward) on May 27, 1953, 23 (Neville Island) on May 29, 1953, and 32 (P&LE Transfer) on June 6, 1953. Route 34 (Elliott) was combined with Route 31 (Sheraden-Ingram) on April 18, 1953 to become Route 34/31(Elliott-Sheraden-Ingram).

By June 20, 1953, all of the local Washington, Pennsylvania, trolley lines had been abandoned. The Washington and Charleroi interurban lines used PCC cars Nos. 1613-1619 and 1645-1647 that were slightly modified from the 1600 series PCC cars while cars Nos. 1700-1725 were delivered with special trucks, high-intensity overhead lights, horns, cowcatchers, and operable rear windows. PCC car No. 1723 made the last interurban trip leaving Charleroi at 2 a.m. on June 28, 1953, and the cutback line became Route 35 (Library). The last Washington interurban trip was made by PCC car No. 1711 which left Pittsburgh at 12:20 a.m. on August 29, 1953, and the cutback line became Route 36 (Drake) which temporarily used Walther Wye until the new Drake Loop was completed on September 25, 1953 in Upper St. Clair Township at McLaughlin Run and Drake Road. Route 63 (Corey Avenue) shuttle trolley service ended on August 29, 1953. On November 28, 1953, the Penn Incline made its last ride. Double-ended car No. 4393, the last double-ended car to operate in regular service made the final trip on Route 53 (Evergreen) on December 5, 1953. Track mileage had declined to 430.76 miles by the end of 1953.

A thirty-five-day transit strike that ended June 13, 1954 plus a department store strike resulted in a 45 million decline in ridership in 1954. A City of Duquesne renewal project resulted in the end of trolley service for Route 60 (East Liberty-Homestead) on September 20, 1958 and also for the 16-mile-long Route 68 (Homestead-Duquesne-McKeesport) which was Pittsburgh's longest trolley line plus served Kennywood Park. Last day for Route 69 (Squirrel Hill) trolley service was September 20, 1958. Allegheny County permitted PRC to abandon the trackage without responsibility for rail removal which meant the end of trolley routes 94 (Sharpsburg-Aspinwall), 95 (Butler Street), and 96 (East Liberty-62nd Street) on November 12, 1960.

A fifty-six-day strike, Pittsburgh's longest transit strike, ended on December 8, 1957 after agreement was reached on a 26 cent per hour wage increase over a two-year period. Street resurfacing projects resulted in three trolley route conversions to bus operation. Last day for Route 4 (Troy Hill) was July 6, 1957. Last day for Route 1 (Spring Garden), and Route 5 (Spring Hill) was October 5, 1957. The June 19, 1959 opening of the new Fort Pitt Bridge resulted in West End trolley routes 25 (Island Avenue), 26 (West Park-McKees Rocks), 27 (Carnegie), 28 (Heidelberg), 30 (Craft-Ingram), and 31/34 (Elliott-Sheraden-Ingram) making their last runs in the early morning hours of June 21, 1959. PCC car No. 1784, the last car on Routes 28 and 30 arrived at Ingram car barn around 3 a.m. followed by PCC car No. 1493 the last car on Routes 26 and 31/34 arriving at Ingram car barn about 3:20 a.m. The Pittsburgh (Knoxville) Incline made its last run on December 3, 1960. Sewer work resulted in Trolley Route 7 (Charles Street) converted to bus operation on September 1, 1961. A North Side redevelopment project resulted in end of trolley routes 18 (Woods Run) and 19 (Western Avenue) on November 12, 1961. With the abandonment of Route 62 (Trafford) on May 2, 1962; thirty-six full-time trolley routes remained as follows: 6, 8, 10, 13, 15, 21, 22, 35, 36,

38, 39, 40, 42, 44, 48, 49, 50, 53, 55, 56, 58, 64, 65, 66, 67, 68, 71, 73, 75, 76, 77/54, 82, 85, 87, 88, and 98. As riding declined, service was cut; only about 300 PCC cars were needed for rush hour in 1962.

On May 26, 1963, Route 42 (Dormont) was combined with Route 38 (Mount Lebanon) to create Route 42/38 (Mount Lebanon via Dormont). This eliminated the need to replace trackage on West Liberty Avenue. A weight restriction on the South 22nd Street Bridge resulted in Route 77/54 being cut back to avoid that bridge on July 7, 1963. High winds hit Glassport, Pennsylvania, on August 3, 1963 knocking down Route 98 trolley poles and wires requiring six hours to drag stranded Route 98 PCC car No. 1412 to McKeesport where live powered lines were available. On August 5, 1963, PRC operated buses on Route 98. Effective August 6, 1963, Noble J. Dick Bus Lines served Route 98. PCC trolley No. 1655 made the last regular service run on Route 56 (McKeesport via Second Avenue) on August 31, 1963 with buses taking over that line on September 1, 1963. This was the last trolley car abandonment under PRC management.

Port Authority of Allegheny County (PAAC) offered PRC $18.5 million for its transit assets. When PRC did not accept that offer, PAAC had the property condemned, and a value of $5 million was set for PRC property. PAAC on February 28, 1964 filed a Petition In Condemnation against significant parts but not all of PRC's transit assets and deposited with the court $3.75 million of the $5 million it felt the property was worth. PRC objected, however, the Court of Common Pleas on February 29, 1964 overruled PRC's objections and permitted the takeover to proceed which occurred that day at midnight. PAAC took over 287 of the 388 active PCC cars, 219 active buses, and the street railway trackage still in service. PAAC left out a significant amount of property including a number of PCC cars and the Mount Washington Tunnel. PRC fought back and was able to prove the Mount Washington Tunnel had significant value for the system. On June 26, 1967, a final settlement was reached that with interest gave PRC $16,558,000.

Port Authority Transit (PAT) began their changeover to bus operation with trolley car Route 55 (Homestead–East Pittsburgh) converted to bus operation on July 5, 1964, and base service on Route 56B was cut back to Munhall Loop with the Route 65 (Munhall–Lincoln Place) trolley extended over Route 55 trackage to East Pittsburgh from 5 a.m. to 8 p.m. Monday through Friday plus trolley car routes: 58 (Greenfield), 57 (Glenwood), and 22 (Crosstown) became bus routes.

On September 5, 1965, PAT converted the following three Northside trolley car routes to bus operation: 8 (Perrysville), 10 (Westview), and 15 (Bellevue). Trolley car Route 13 (Emsworth) was combined at all times with Route 6 (Brighton Road) becoming Route 6/13 (Brighton/Emsworth). Routes 10 and 15 both served Westview Park and were the last trolley car lines in the United States serving an amusement park.

Two East End trolley car routes were also converted to bus operation on September 5, 1965: 65 (Munhall–Lincoln Place) and 77/54 (North Side–Carrick via Bloomfield). Last scheduled PCC cars were as follows: Route 8 No. 1683 arrived back at Keating Car House at 5:28 a.m. and was the last trolley car to use Keating Car House; Route 10 No. 1790 arrived at West View at 1:24 a.m.; Route 15 No. 1777 arrived at West View at 12:40 a.m.; Route 65 No. 1673 arrived at Craft Avenue Car House at 1:26 a.m.; and Route 77/54 No. 1438 arrived at Craft Avenue Car House at 2:31 a.m. With the above conversions to bus operation, PAT operated 283 PCC cars on its twenty-three remaining trolley car lines.

On December 31, 1965, PAT discontinued trolley car service between Avalon Loop and Emsworth on Route 6/13 (Brighton–Emsworth) due to deterioration of bridge timbers on the Ben Avon and Avalon trolley car bridges. PCC car No. 1795 was the last car to Emsworth crossing the Avalon bridge at 1:12 a.m. on December 31, 1965 after which the line became Route 6/14 (Brighton–Avalon) terminating at the Avalon Loop. Route 85 (Bedford) was converted to bus operation on June 26, 1966. On September 4, 1966, PAT converted South Hills trolley car Routes 39 (Brookline) and 40 (Mount Washington) to bus operation; cut back East End Route 87 (Ardmore) from Wilmerding to Wilkinsburg; plus there was Monday through Friday trolley car operation and Saturday/Sunday bus operation for East End routes 64 (Wilkinsburg–East Pittsburgh), 66 (Wilkinsburg via Forbes), 67 (Swissvale–Rankin–Braddock), 71 (Negley–Highland Park), 73 (Highland Park), 75 (East Liberty–Wilkinsburg), 76 (Hamilton), 82 (Lincoln), 87 (Ardmore), and 88 (Frankstown); and Craft Avenue Car House was now closed on Saturdays and Sundays. On January 29, 1967, ten East End routes 64, 66, 67, 71, 73, 75, 76, 82, 87, and 88 were converted to bus operation every day of the week.

April 31, 1966 was the last day of trolley car operation on Route 6/14 (Brighton–Avalon) and Route 21 (Fineview) which eliminated all trolley car service on Pittsburgh's North Side (north of the Allegheny River). Turning at Federal Street to Henderson Street, Route 21 climbed to its Charles Street terminus and returned via Perrysville Avenue to downtown Pittsburgh. PCC Car No. 1678 (with a standing load of passengers) made the last Route 21 regular service run leaving downtown at 11:26 p.m. and returned to 6th and Penn Avenue (downtown) forty minutes later.

On March 31, 1968, peak period Route 47 (Carrick via Tunnel) was eliminated and replaced by rerouted Route 53 (Carrick) which no longer operated on South 18th Street but operated beginning at Brentwood Loop as former trolley car Route 47 (Carrick via Tunnel). On March 31, 1968, Route 48 (Arlington) was replaced by an extension of bus Route 54A (Arlington Heights). Trolley car Routes 44 (Knoxville), 49 (Beltzhoover), and 53 (Carrick) made their final runs Saturday evening November 13, 1971 and early Sunday morning November 14, 1971.

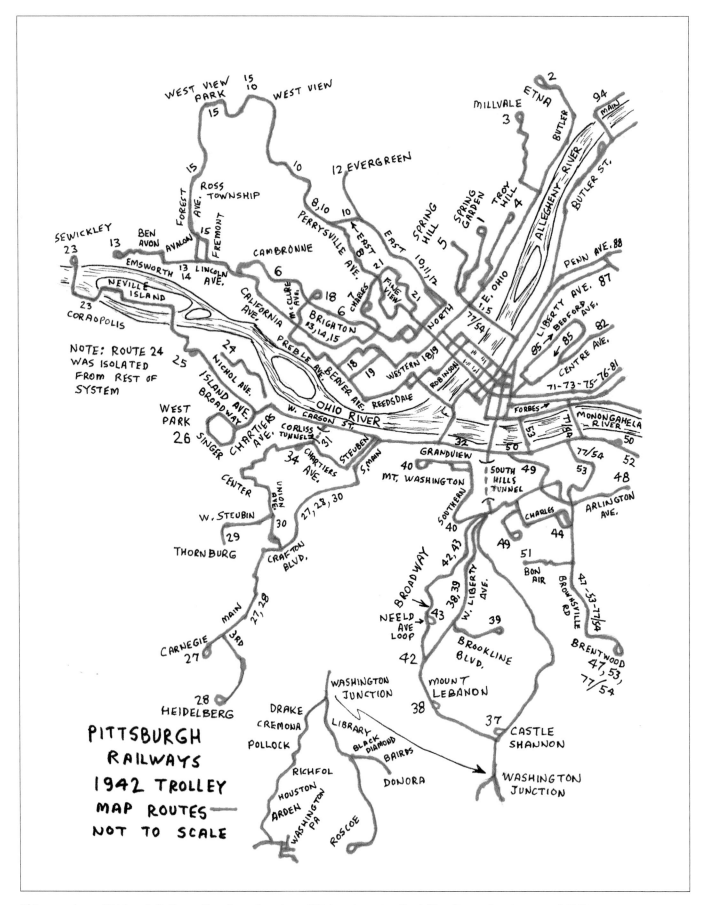

This map shows Pittsburgh Railways lines from downtown Pittsburgh west to Sewickley, Pennsylvania, around 1942.

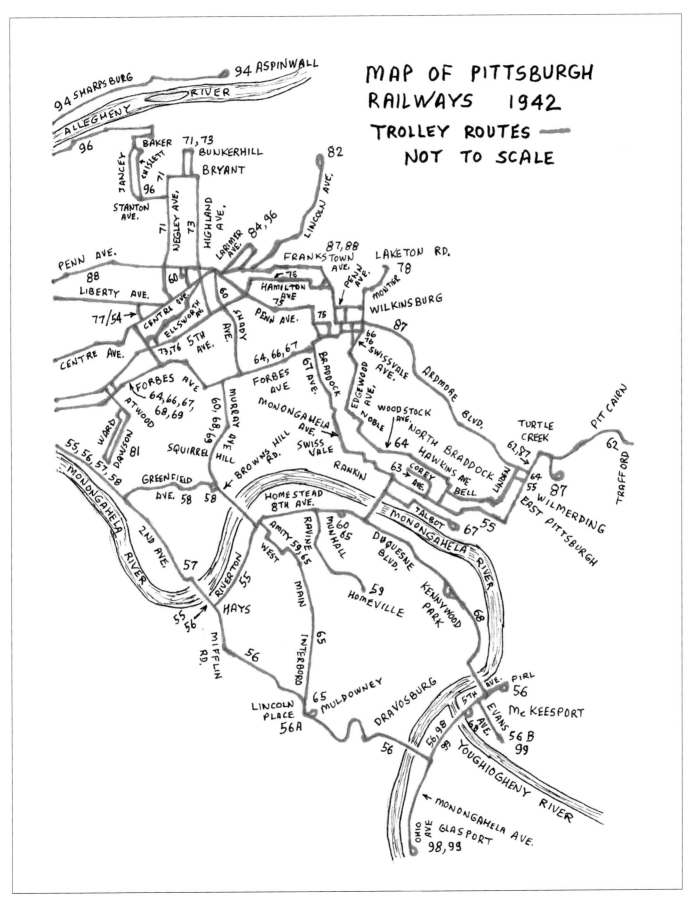

The above map covers Pittsburgh Railways east of downtown Pittsburgh to Trafford, Pennsylvania, around 1942.

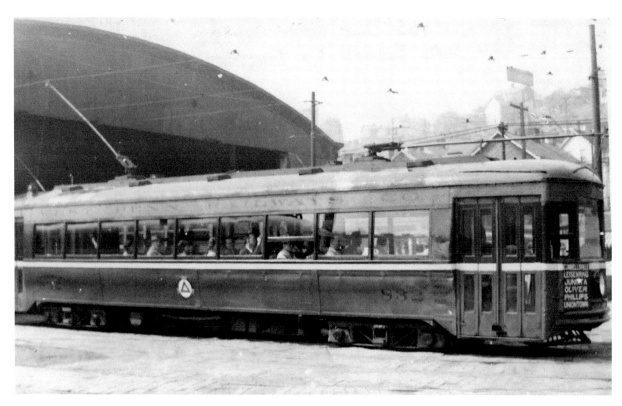

Former West Penn Railways car No. 832 is at the Pittsburgh Railways Company (PRC) Charleroi Car Barn for its next run to the PRC Ingram Car Barn. Weighing 32,000 pounds and seating forty-eight passengers, this double-end curved-side interurban car was built in 1930 by Cincinnati Car Company for the West Penn Railways. (*W.J.B. Gwinn photograph*)

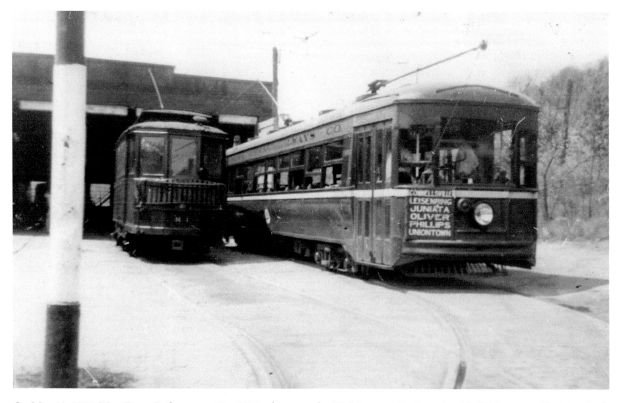

On May 10, 1953, West Penn Railways car No. 832 is shown at the PRC Ingram Car Barn beside PRC pay car No. M-1. Both of these cars plus a third car, No. 3756, were moved on February 7, 1954 to the County Home Siding in Washington County, Pennsylvania, which became the Arden Trolley Museum. In 1990, the museum became known as the Pennsylvania Trolley Museum. (*W.J.B. Gwinn photograph*)

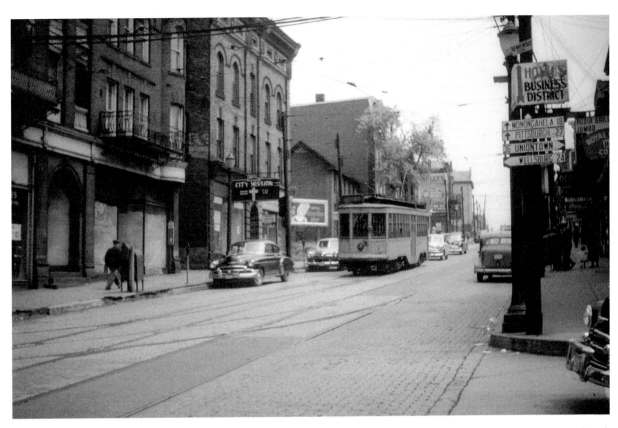

A 4300 series double-truck, double-end, deck-roof, low-speed, and one-man-operated Pittsburgh Railways Company (PRC) car is operating on one of the three city lines in Washington Pennsylvania in May 1951. (*Bob's Photos*)

PRC double-truck, single-end, low-floor car No. 4826 signed for East Pittsburgh is waiting for the next assignment on October 16, 1953. This was one of forty cars, Nos. 4825–4864, built in 1922 by Pressed Steel Car Company. (*Bob's Photos*)

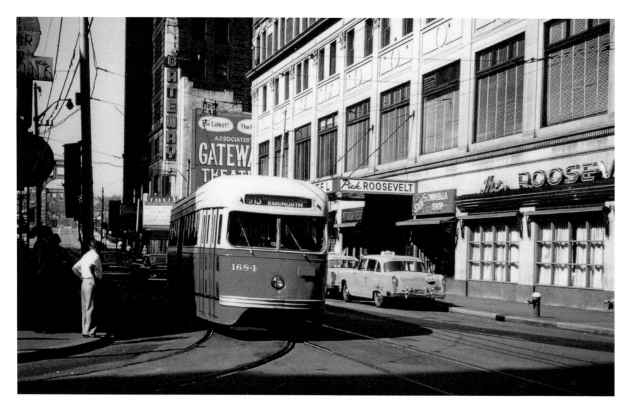

On September 10, 1961, a Route 6/13 PRC car No. 1684 is in downtown Pittsburgh on Penn Avenue ready to turn onto 6th Street. This St. Louis Car Company 1945 built car weighed 36,265 pounds and seated fifty-four passengers. On the right is the Pick Roosevelt Hotel that opened in 1927 and was reportedly originally named for President Theodore Roosevelt. The hotel was purchased by the Albert Pick Hotel Chain in 1947. It closed in 1972 and was converted into apartments. (*Kenneth C. Springirth photograph*)

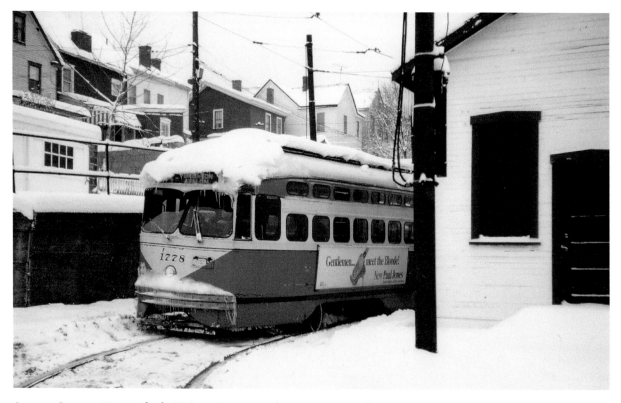

A snowy January 23, 1966 finds PRC car No. 1778 at the Route 6/14 Avalon Loop. This was one of twenty-five PCC cars, Nos. 1775–1799, built by St. Louis Car Company and delivered during June–July 1948. Weighing 37,765 pounds, each car was powered by four GE type 1220 motors and seated fifty passengers. (*Kenneth C. Springirth photograph*)

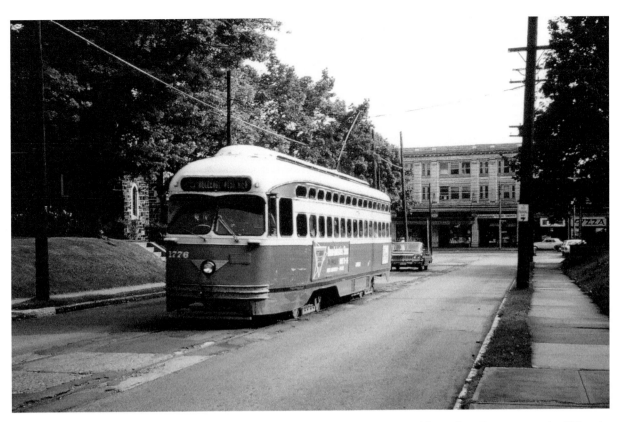

On May 23, 1965, Port Authority Transit (PAT) Route 15 PCC car No. 1776 is northbound on Fremont north of Lincoln Avenue in the borough of Bellevue which means "beautiful view" and was chosen by J. J. East an early resident. (*Kenneth C. Springirth photograph*)

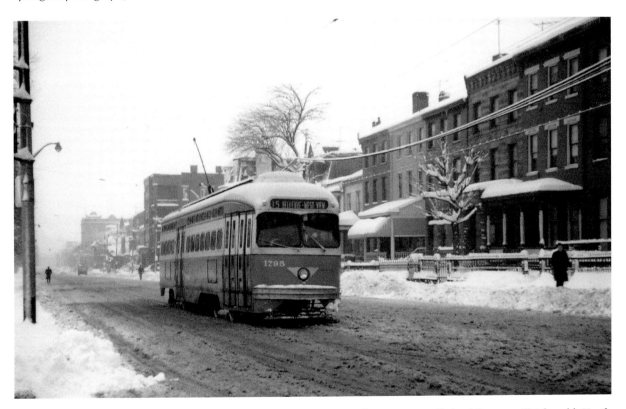

On a snowy January 23, 1966, PAT Route 15 PCC car No. 1795 is on North Avenue near Federal Street on Pittsburgh's North Side. This line connected downtown Pittsburgh with West View Park. (*Kenneth C. Springirth photograph*)

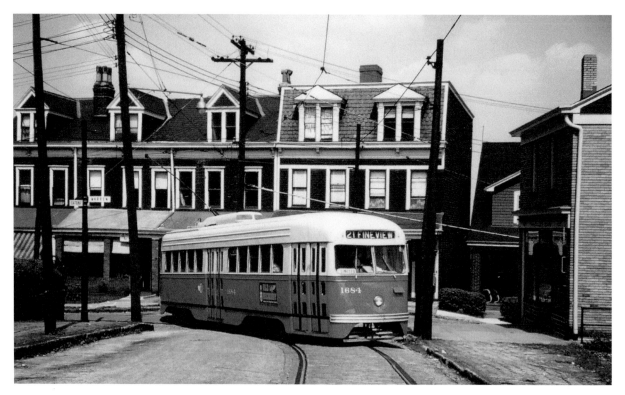

On a June 11, 1961 special trolley car charter, Pittsburgh Railways Company (PRC) Route 21 PCC car No. 1684, has paused for a photo stop on Warren Street at Catoma Street in the Fineview neighborhood north of downtown Pittsburgh. As noted in this scene, residents had access to this trolley line from their front porches, driveways, and private entranceways. With its over 12 percent grades, this was a unique trolley car line in North America. (*Kenneth C. Springirth photograph*)

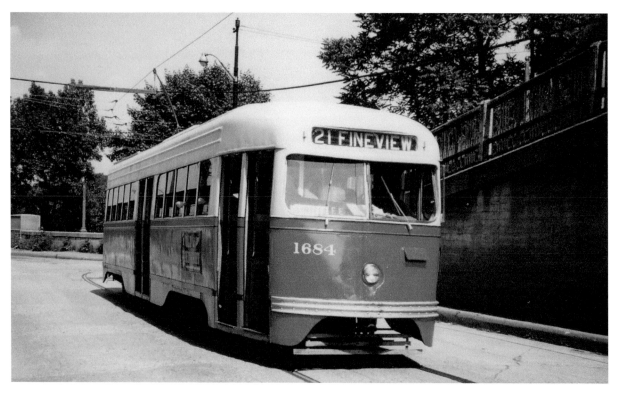

The Route 21 (Fineview) northern terminus on Charles Street at Perrysville Avenue is the location of PRC PCC car No. 1684 on a June 11, 1961 rail excursion. In 1951, PCC cars used on this line had special springs installed in their brake valves to increase air pressure on the drum brakes to provide fast action on the line's heavy grades. (*Kenneth C. Springirth photograph*)

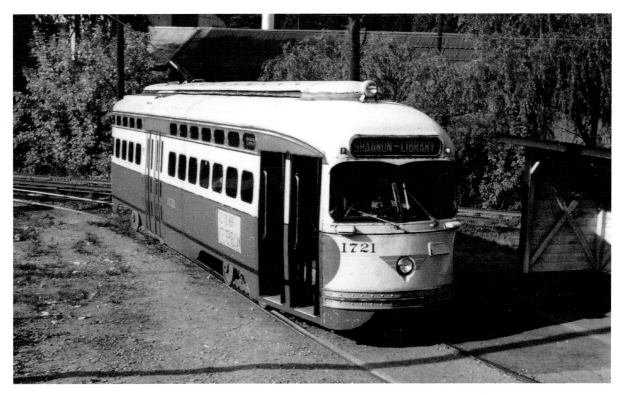

PCC car No. 1721 is at the PRC Library loop in the Library neighborhood of South Park Township, Allegheny County on October 26, 1959. The new light rail vehicles later placed in service on the new light rail system could not handle the loop so the loop was removed in 2004. (*Kenneth C. Springirth photograph*)

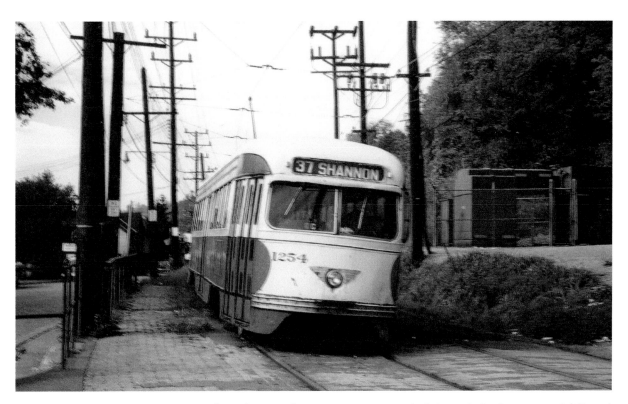

On September 15, 1962, PCC car No. 1254 (one of seventy-five cars, Nos. 1200–1274, built St. Louis Car Company and delivered during March–May 1940 powered by four Westinghouse type 1432 motors) is at the PRC Frederick Stop in the Overbrook neighborhood on a Route 37 trip to Castle Shannon, which was a cutback point used for certain scheduled rush hour and Saturday afternoon trips for both Routes 35 (Library) and Route 36 (Drake). (*Kenneth C. Springirth photograph*)

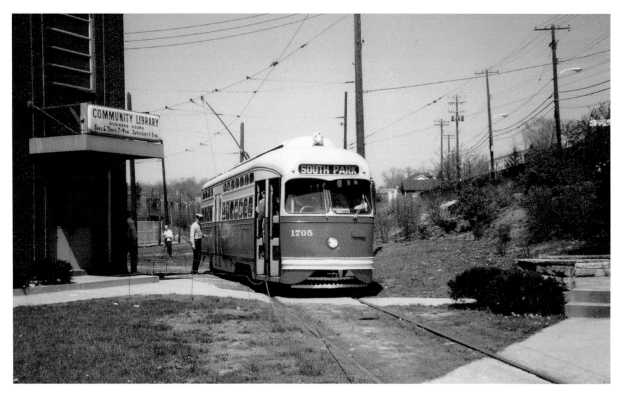

Nicely repainted PRC PCC car No. 1705 is at the Castle Shannon loop on a special rail excursion on April 21, 1963. South Park, shown on the front destination sign, is a location south of Castle Shannon. The Borough of Castle Shannon located in Allegheny County south of Pittsburgh, from a peak population of 12,036 in 1970, has declined 30.9 percent to 8,316 by 2010 as a result of a decline in the region's steel industry. (*Kenneth C. Springirth photograph*)

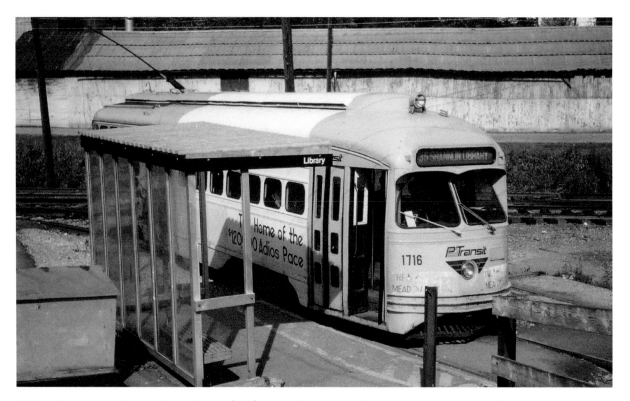

PCC car No. 1716 in a Port Authority Transit (PAT) mod colored paint scheme is at Library, the southern terminus of Route 35 (Shannon–Library) on October 11, 1980 waiting for departure time. (*Kenneth C. Springirth photograph*)

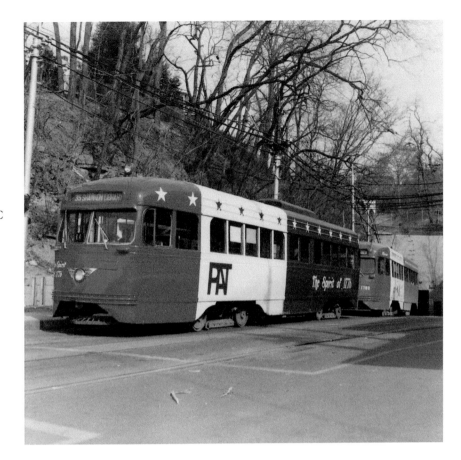

Route 35 Shannon–Library PCC car No. 1776 is at South Hills Junction on February 28, 1976. This originally was PCC car No. 1616 (one of seventy-four PCC cars, Nos. 1601–1674, delivered by St. Louis Car Company during August–October 1945) that had been rebuilt into car No. 1776 and repainted to honor the United States Bicentennial. Behind it was PCC car No. 1788 that was rebuilt from car No. 1639. (*Kenneth C. Springirth photograph*)

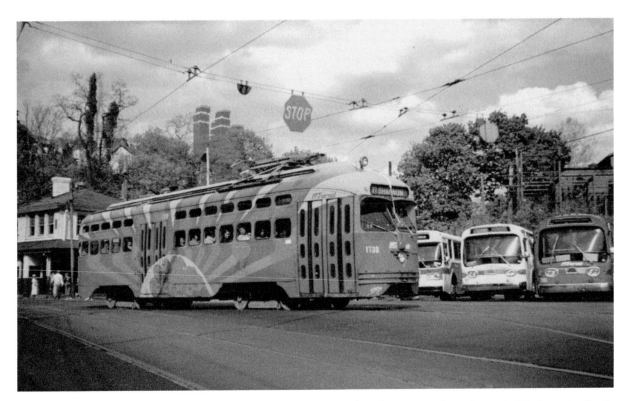

Around 1976, PCC car No. 1730 in a unique psychedelic paint scheme (that first appeared on July 26, 1972) is departing South Hills Junction for its southbound Route 37 (Shannon) trip to Castle Shannon, Pennsylvania. PAT refurbished a number of trolleys in colorful paint schemes, which presented a positive image that increased ridership. (*Photographer Carl H. Sturner Used with permission from Audio-Visual Designs [www.audiovisualdesigns.com]*)

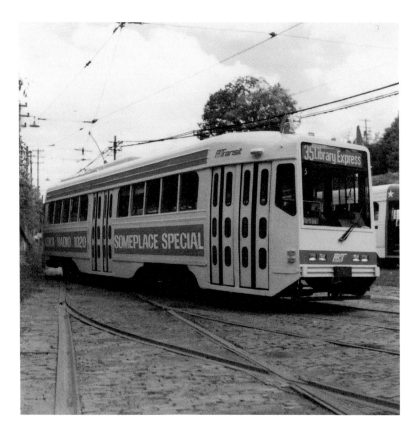

PCC car No. 1779 is at the South Hills Junction on September 21, 1975. This was originally car No. 1647 (built by St. Louis Car Company in 1945) that was rebuilt with a distinctive flat front designed by PAT engineer Philip C. Castellana. The car featured an enlarged electric illuminated front destination sign and route number, one piece front windshield, and a new polyurethane vehicle finish. (*Kenneth C. Springirth photograph*)

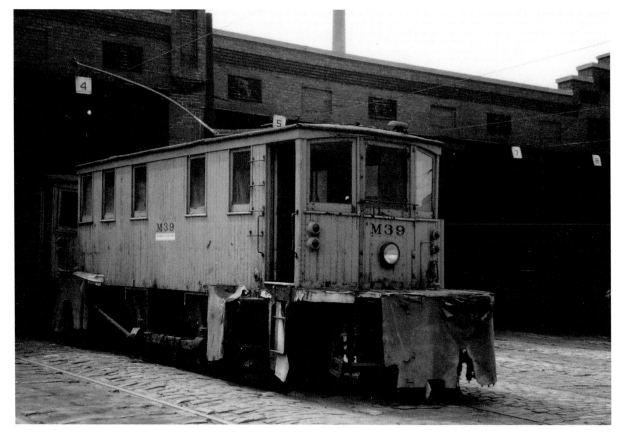

On June 25, 1966, PAT Craft Avenue Car Barn is the location of snow sweeper No. M39 that was originally built by McGuire Manufacturing Company in 1898. This company was noted for their snow sweepers and became the McGuire-Cummings Manufacturing Company in 1904. (*Kenneth C. Springirth photograph*)

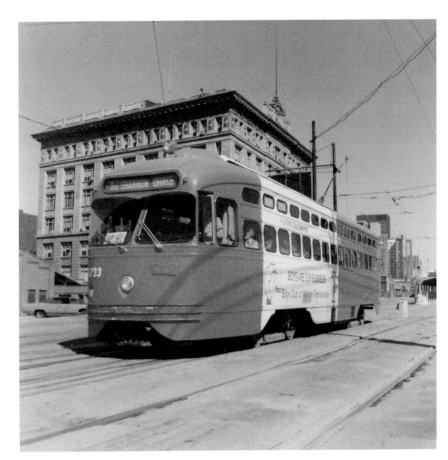

PAT Route 36 (Shannon–Drake) PCC car No. 1723 is on Smithfield Street near Carson with the Pittsburgh & Lake Erie Railroad (P&LE) Station in the background on October 4, 1975. The last train to use that station was the P&LE commuter train, which operated between College Hill and Pittsburgh which made its last run on July 12, 1985. (*Kenneth C. Springirth photograph*)

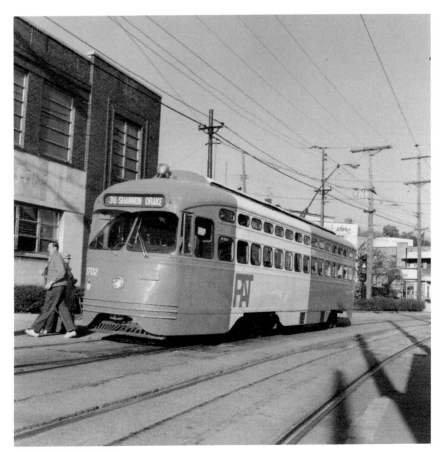

On October 21, 1973, PAT Route 36 (Shannon–Drake) PCC car No. 1702 is at the borough of Castle Shannon in Allegheny County in front of the Castle Shannon Municipal Building. Castle Shannon prominent farmer David Strawbridge named the area Castle Shanahan, which over time evolved into Castle Shannon and was incorporated as a borough in 1919. (*Kenneth C. Springirth photograph*)

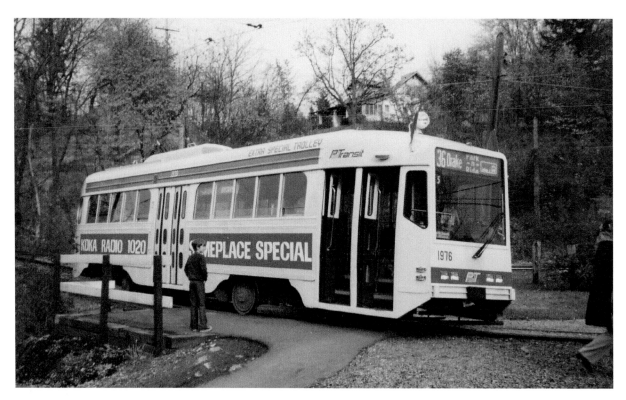

Drake Loop is the location of PAT Route 36 (Drake) car No. 1976 in October 1975. This car was originally No. 1603 that was rebuilt and became No. 1784 in 1972. It was stored after a collision with car No. 1744 on December 1, 1974. During 1975, it was rebuilt with a flat front to resemble a new light rail vehicle, renumbered 1976, and operated until it was retired in January 1982. (*Harold Geissenheimer [former director of PAT Transit Operations] photograph*)

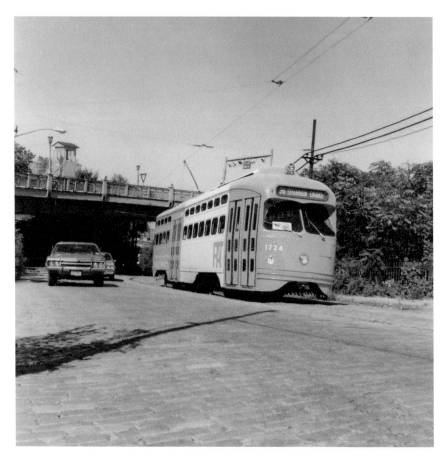

On October 4, 1975, Arlington Avenue at McArdle Roadway is the location of PAT Route 36 (Shannon Drake) PCC car No. 1724 in a yellow and white paint scheme. (*Kenneth C. Springirth photograph*)

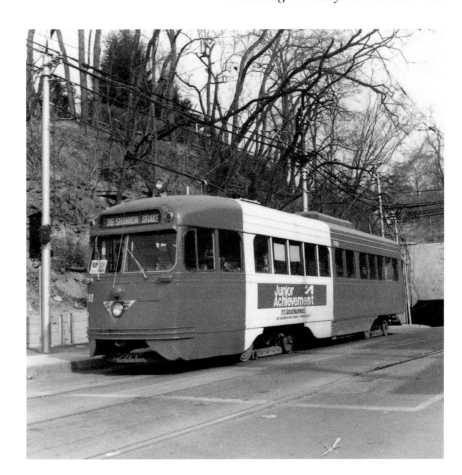

South Hills Junction is the location on February 28, 1976 of PAT Route 36 (Shannon–Drake) PCC car No. 1780 (rebuilt from PCC car No. 1619 and advertising Junior Achievement). (*Kenneth C. Springirth photograph*)

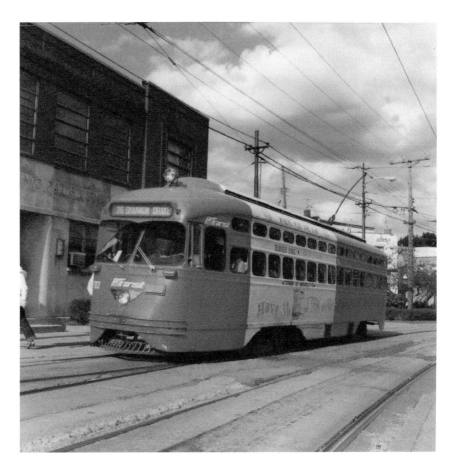

The advertisement on PAT Route 36 (Shannon–Drake) PCC car No. 1703 at the Castle Shannon Municipal building on September 15, 1979 is a neat way to help pay for the repainting of the car. (*Kenneth C. Springirth photograph*)

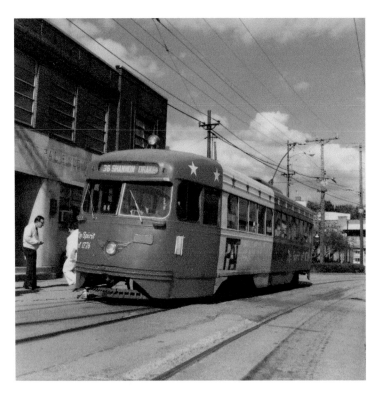

On September 15, 1979, specially painted "Spirit of 1776" rebuilt PAT PCC car No. 1776 (originally car No. 1616) is at the Castle Shannon Municipal Building on Route 36 (Shannon–Drake). Special painted transit vehicles are a way to increase ridership as reported by the October 10, 1975 page 6 *Passenger Transport* that noted that PAT ridership for the first seven days of September 1975 was 383,604 or 23 percent higher than the 312,726 for the same seven days of September 1971. Average Saturday ridership increased 40 percent from 157,145 to 219,214. Average Sunday ridership almost doubled from 56,195 to 102,249. (*Kenneth C. Springirth photograph*)

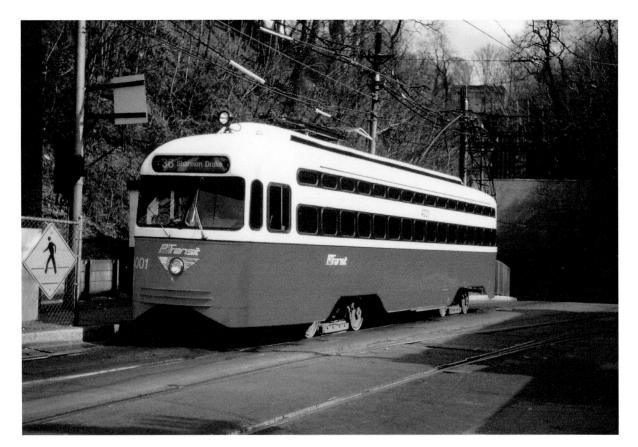

Smart looking PCC car No. 4001 (rebuilt from car No. 1720) on Route 36 (Shannon–Drake) is at South Hills Junction on April 16, 1983. This was one of twelve 1700 series PCC cars that were rebuilt to be used on the Overbrook–Library and Drake lines that could not accommodate the new Siemens Duewag model SD-400 light rail cars. The original plan was to reconstruct forty-five of the 1700 series PCC cars; however, budget constraints and technical difficulties resulted in twelve cars receiving the complete overhaul and renumbered 4001–4012 and four partially rebuilt and retaining their original number. (*Kenneth C. Springirth photograph*)

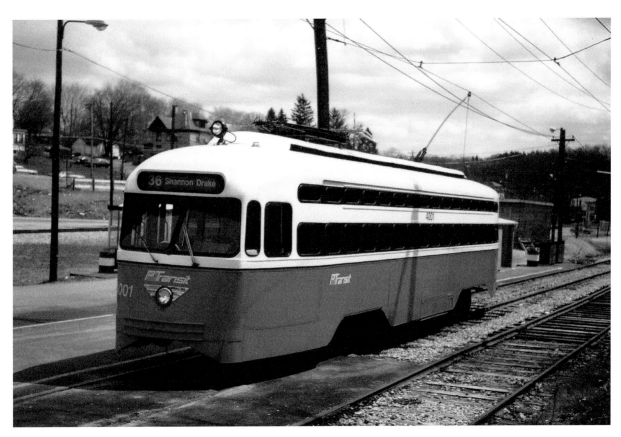

PAT PCC car No. 4001 (rebuilt from car No. 1720) is passing through Castle Shannon on April 16, 1983. The rebuilt 4000 series PCC cars were assigned to the unrebuilt lines: 47D (Drake via Overbrook), 47L (Library via Overbrook), 47S (South Hills Village via Overbrook), and 47 (Shannon) that could not accommodate the new heavier light rail vehicles. (*Kenneth C. Springirth photograph*)

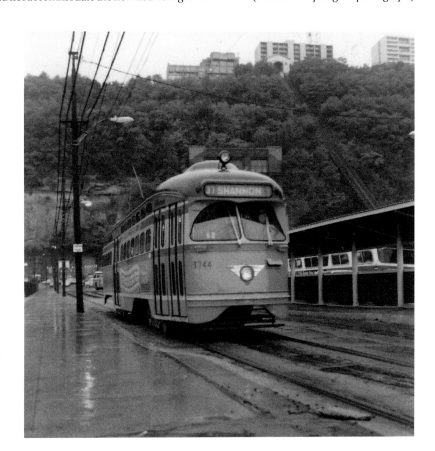

On a rainy July 21, 1980, PAT Route 37 (Shannon) car No. 1744 (advertising Freight House Shops) is on the Smithfield Street Bridge northbound to downtown Pittsburgh. (*Kenneth C. Springirth photograph*)

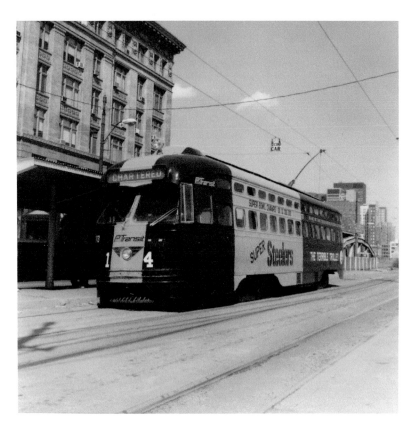

Painted up for the Pittsburgh Steelers, PAT PCC trolley car No. 1713 is at the Pittsburgh & Lake Erie Railroad station on Smithfield Street just north of Carson Street in downtown Pittsburgh on October 11, 1980. The wide variety of paint schemes has made this Pittsburgh trolley system very unique. (*Kenneth C. Springirth photograph*)

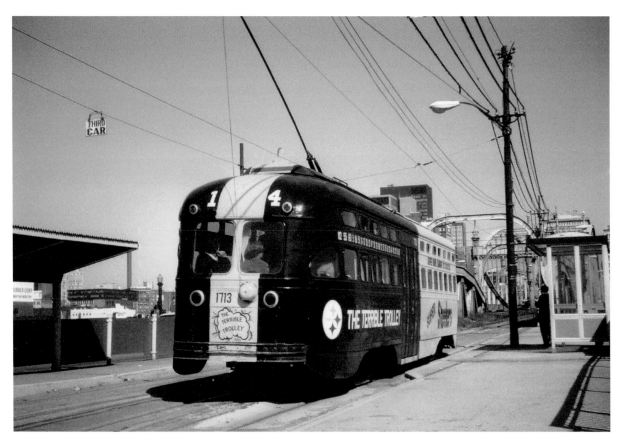

This is a view of the rear of the above Pittsburgh Steelers trolley car No.1713 showing the unique designation "The Terrible Trolley" northbound from Station Square ready to cross the Smithfield Street Bridge over the Monongahela River to downtown Pittsburgh on October 11, 1980. (*Kenneth C. Springirth photograph*)

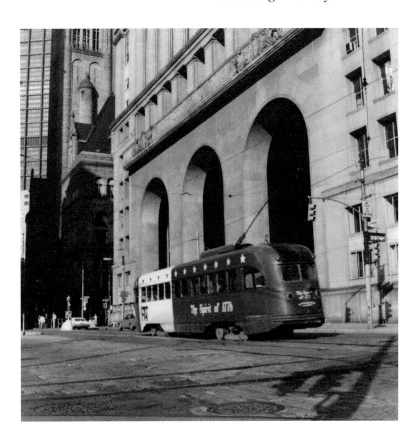

On September 15, 1979, PAT PCC car No. 1776 (rebuilt from car No. 1616) is at 4th Avenue and Grant Street in downtown Pittsburgh. (*Kenneth C. Springirth photograph*)

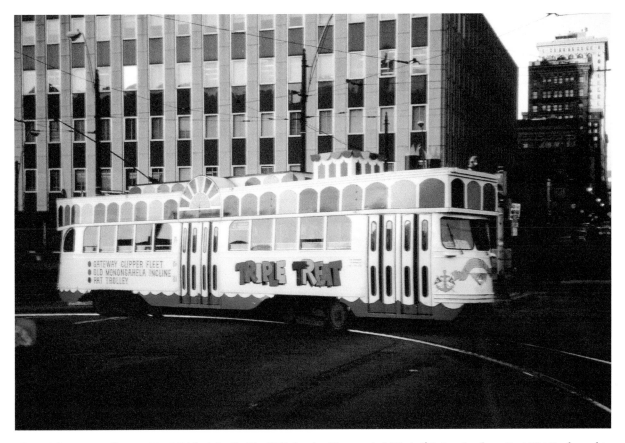

The Triple Treat trolley car No. 1794 (originally No. 1669 that had been rehabilitated) is turning from Fort Pitt Boulevard to Smithfield Street in downtown Pittsburgh on an October 21, 1978 Route 49 Tunnel bypass trip. The smokestack on the roof was too high to clear the South Hills Tunnel. (*Kenneth C. Springirth photograph*)

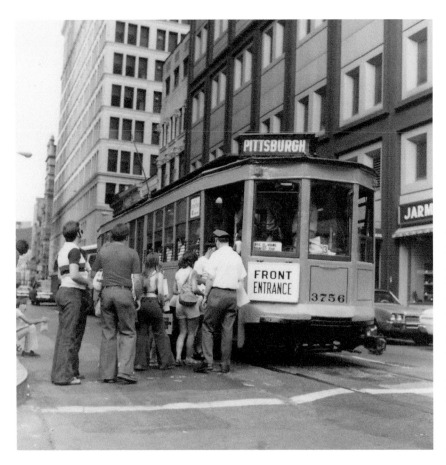

Wood Street at 5th Avenue in downtown Pittsburgh on July 4, 1976 is the location of former Pittsburgh Railways car No. 3756 (one of twenty cars, Nos. 3750–3769, purchased from Osgood Bradley Car Company in 1925) on loan from the Arden Trolley Museum (now known as the Pennsylvania Trolley Museum) on a special PAT downtown trolley car routing to commemorate the bicentennial of the United States. (*Kenneth C. Springirth photograph*)

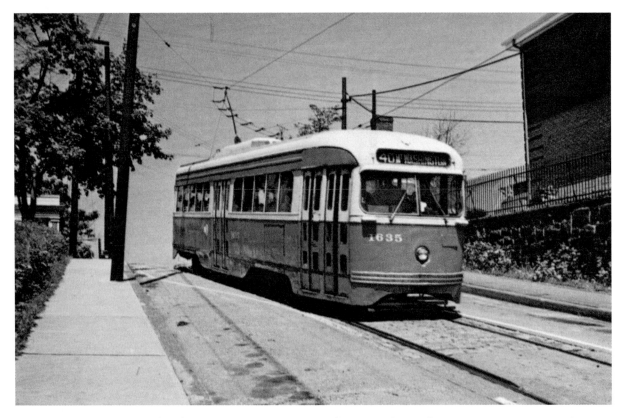

Pittsburgh Railways Company (PRC) PCC car No. 1635 is on Route 40 (Mount Washington) on Sycamore Street near Bertha Street on July 5, 1963. (*Photographer Carl H. Sturner Used with permission from Audio-Visual Designs [www.audiovisualdesigns.com]*)

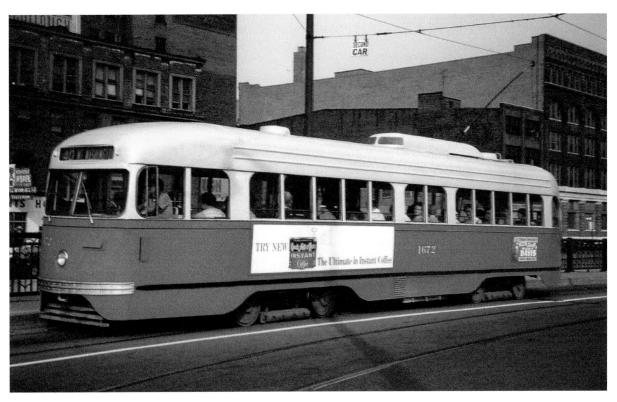

On September 11, 1961, PRC Route 40 PCC car No. 1672 is on Fort Pitt Boulevard near Smithfield Street in downtown Pittsburgh. Note the difference between this 1600 series PCC car compared to the 1700 series PCC car in the below picture which has standee windows (small windows above the regular passenger windows) and a different body style. (*Kenneth C. Springirth photograph*)

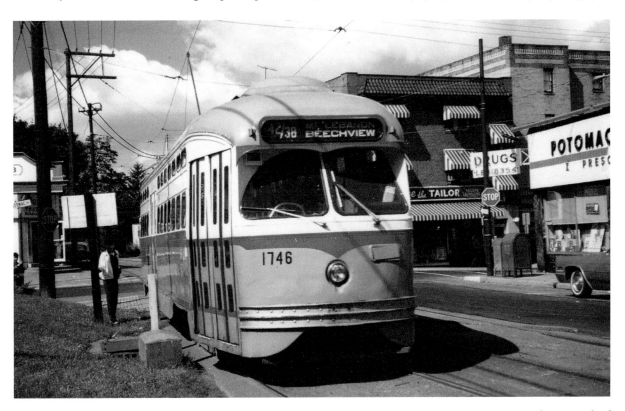

Port Authority Transit (PAT) Route 42/38 PCC car No. 1746 is on Broadway Avenue at Potomac Avenue in the Borough of Dormont on August 10, 1968. Even though Dormont has close proximity to jobs in Pittsburgh and is on the PAT trolley car system, its population has declined 35.9 percent from its peak of 13,405 in 1950 to 8,593 in 2010 largely caused by the loss of jobs in the steel industry. (*Kenneth C. Springirth photograph*)

PCC car No. 1777, with its nice looking radio advertisement, is at Clearview Loop in Mount Lebanon, a township in Allegheny County on September 22, 1974. This car was rebuilt from car No. 1615. Mount Lebanon became a trolley car suburb in 1901 strongly shaped by trolley car service which became a primary means of transportation until the arrival of the automobile. (*Kenneth C. Springirth photograph*)

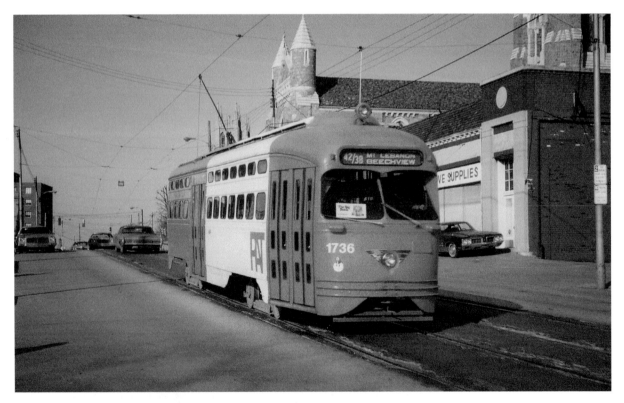

Washington Road at Oak Way in Mount Lebanon is the location of PAT Route 42/38 PCC car No. 1736 on February 28, 1976. Mount Lebanon's population of 39,157 in 1970 declined 15.37 percent to 33,137 in 2010. Even though this is a walkable town with a short public transit ride to major league sporting events, the loss of industry has contributed to the population loss. (*Kenneth C. Springirth photograph*)

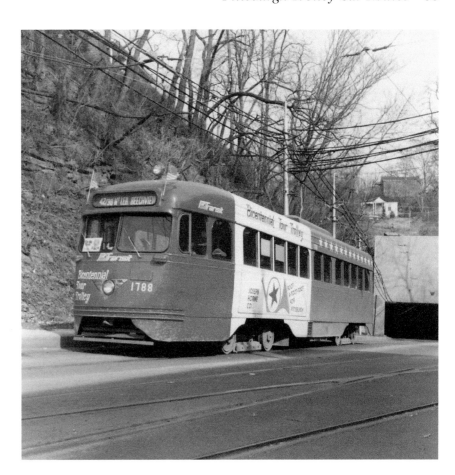

Route 42/38 (Mount Lebanon-Beechview) PCC car No. 1788 "Bicentennial Tour Trolley" is at South Hill Junction on February 28, 1976. This car was rebuilt from No. 1639. (*Kenneth C. Springirth photograph*)

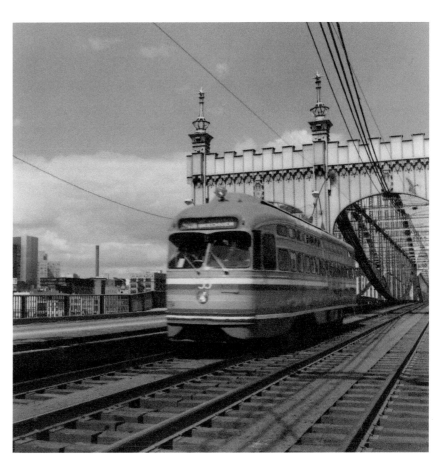

Southbound PAT PCC car No. 1754 blends in nicely with the Smithfield Street Bridge on September 15, 1979. Designed by Gustav Lindenthal, the Smithfield Street Bridge opened for traffic on March 19, 1883 and was the first to use a lenticular or lens shaped design plus was one of the first major bridges in the United States built primarily with steel. (*Kenneth C. Springirth photograph*)

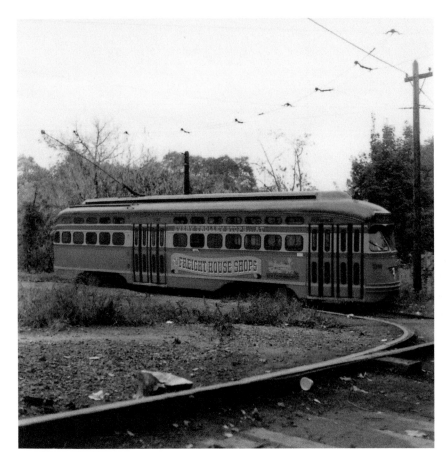

PAT Route 42/38 (Mount Lebanon-Beechview) PCC car No. 1744, advertising "Freight House Shops" is at Clearview Loop in Mount Lebanon waiting for departure time on October 11, 1980. (*Kenneth C. Springirth photograph*)

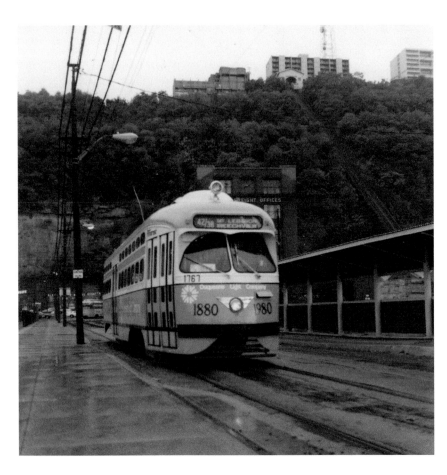

On July 21, 1980, PAT Route 42/38 PCC car No. 1767, specially painted for the local electric utility is northbound on the Smithfield Street Bridge. (*Kenneth C. Springirth photograph*)

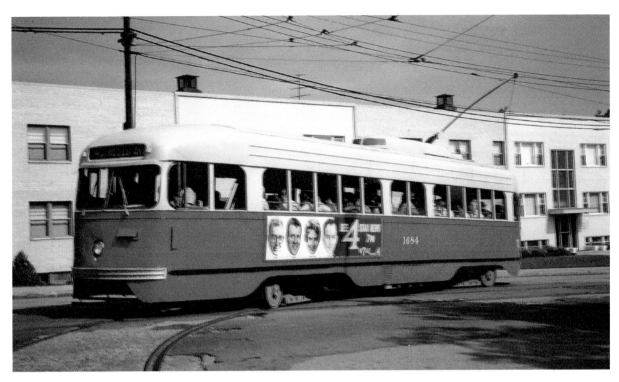

Pittsburgh Railways Company (PRC) PCC car No. 1684 is at the Neeld Avenue Loop for a picture stop on a June 11, 1961 rail excursion. This was a rush hour cutback loop for Route 42 (Dormont). (*Kenneth C. Springirth photograph*)

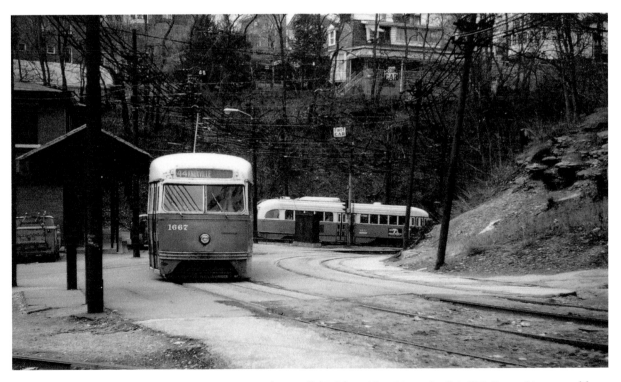

South Hills Junction is the location of PRC Route 44 (Knoxville) PCC car No. 1667 on April 4, 1970. Route 44 operated from downtown Pittsburgh via Smithfield Street Bridge, Smithfield Street, Liberty Avenue, 12th Street, Penn Avenue, 11th Street, Liberty Avenue, Wood Avenue, Fort Pitt Boulevard, Smithfield Street Bridge, through Mount Washington Tunnel, private right of way to Warrington Avenue, Beltzhoover Avenue, Charles Street, Knox Avenue, Bausman Street, Amanda Street, and Charles Street. It served the downtown Pennsylvania Railroad station, and its roll sign read 44 (Knoxville and PA Station). However, the downtown loop was shortened for its final years, and the line no longer used 12th Street near the Pennsylvania Station when the line was converted to bus operation on November 13, 1971. This is why the above roll sign simply reads 44 (Knoxville). (*Kenneth C. Springirth photograph*)

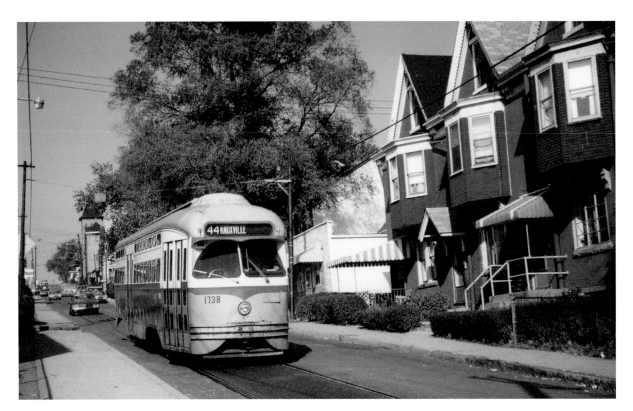

Port Authority Transit (PAT) Route 44 PCC car No. 1738 is on Knox Avenue in the Knoxville neighborhood in the southern part of Pittsburgh on October 30, 1971. Knoxville was a borough that was incorporated on September 7, 1877 and was annexed by the City of Pittsburgh in 1927. (*Kenneth C. Springirth photograph*)

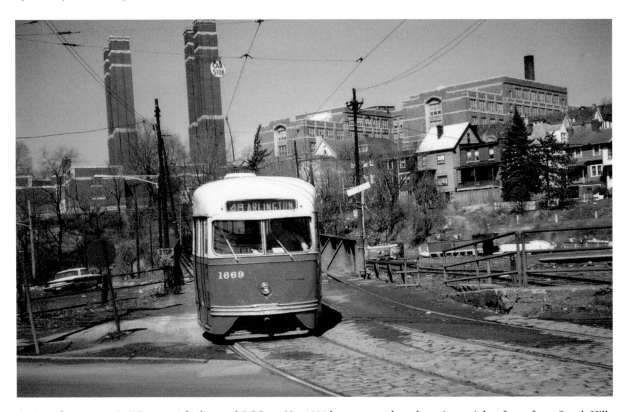

On March 30, 1968, PAT Route 48 (Arlington) PCC car No. 1669 has emerged on the private right of way from South Hills Junction and is about to turn onto East Warrington Avenue at Haberman Avenue for its eastbound trip via Warrington Avenue and Arlington Avenue to Arlington Avenue at Eleanor Street. (*Kenneth C. Springirth photograph*)

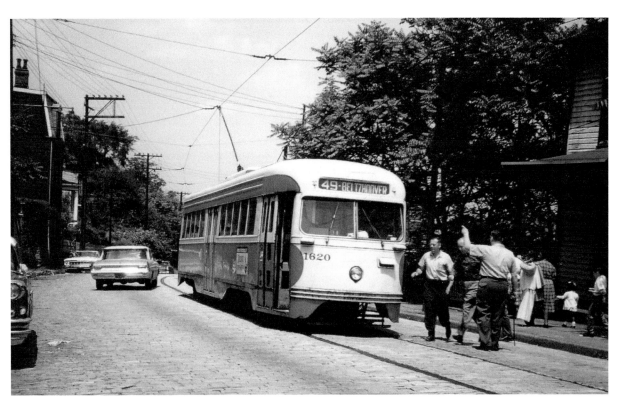

Pittsburgh Railways Company (PRC) PCC car No. 1620 on a trolley excursion is making a photo stop on a single track section of Arlington Avenue used by Route 49 (Beltzhoover) on June 11, 1961. (*Kenneth C. Springirth photograph*)

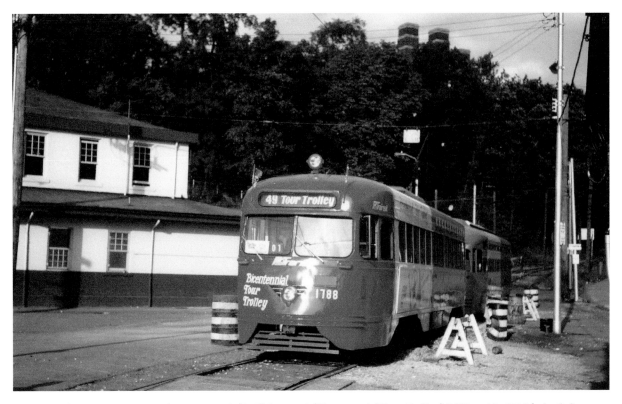

On September 21, 1975, Port Authority Transit (PAT) Route 49 (Bicentennial Tour Trolley) PCC car No. 1788 (rebuilt from car No. 1639) is at South Hills Junction waiting for departure time. After Routes 44 (Knoxville), 49 (Beltzhoover), and 53 (Carrick) made their final trolley car runs in the early morning of November 14, 1971, their trackage was retained as a tunnel bypass and used by Route 49 (Arlington–Warrington). (*Kenneth C. Springirth photograph*)

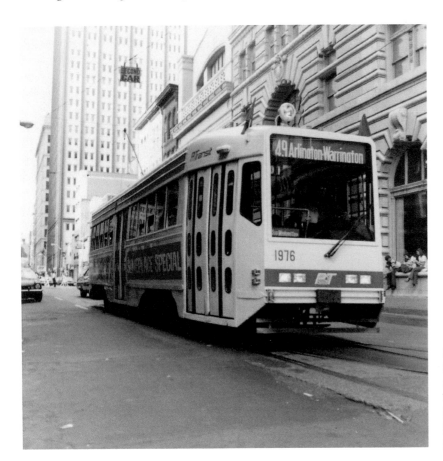

Downtown Pittsburgh on Wood Street at 4th Avenue is the location of PAT Route 49 (Arlington–Warrington) PCC car No. 1976 (rebuilt from car No. 1603) on July 4, 1976. (*Kenneth C. Springirth photograph*)

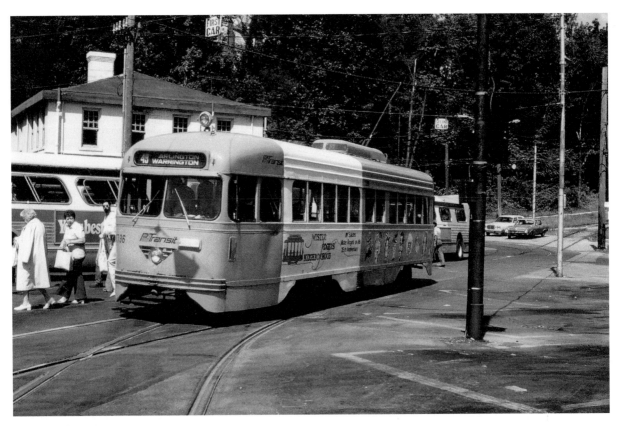

PAT Route 49 (Arlington–Warrington) PCC car No. 1796 (rebuilt from PCC car No. 1638) is at South Hills Junction on July 30, 1091. (*Kenneth C. Springirth photograph*)

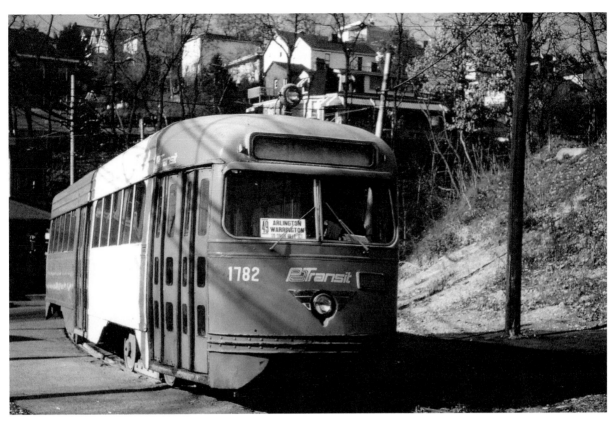

On November 14, 1981, PAT Route 49 (Arlington–Warrington to South Hills Junction) PCC car No. 1782 (rebuilt from car No. 1623) is at South Hills Junction waiting for departure time. (*Kenneth C. Springirth photograph*)

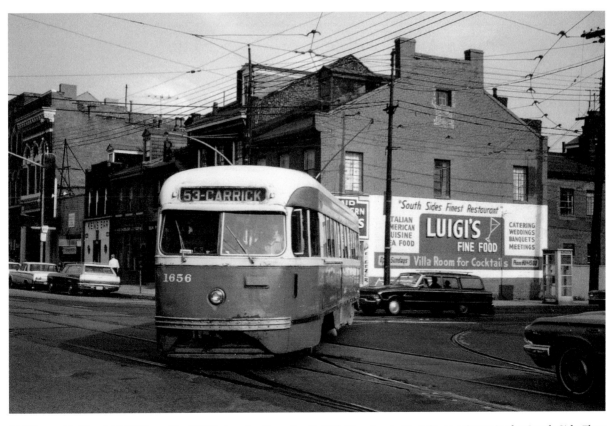

PAT Route 53 (Carrick) PCC car No. 1656 is turning from South 18th Street onto East Carson Street in the South Side Flats neighborhood of Pittsburgh for its trip to downtown Pittsburgh on July 16, 1967. (*Kenneth C. Springirth photograph*)

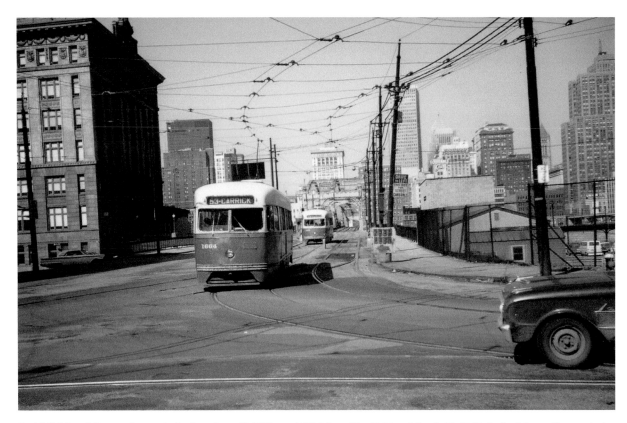

Smithfield and Carson Streets is the location of PAT Route 53 PCC car No. 1664 on March 30, 1968. Left of the trolley car is the Pittsburgh & Lake Erie Railroad (P&LE) passenger station and behind the second PCC car in the distance is the Smithfield Street Bridge. (*Kenneth C. Springirth photograph*)

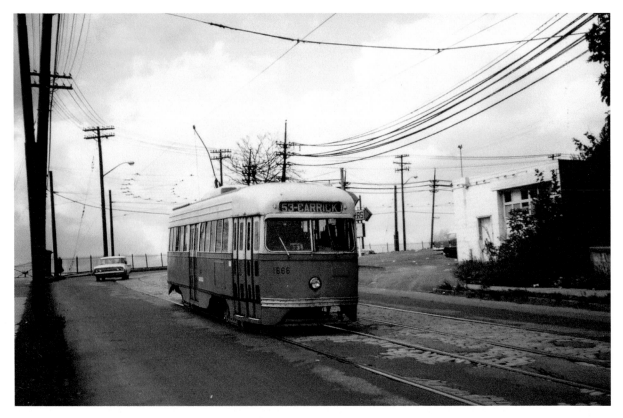

On October 26, 1968, PAT Route 53 PCC car No. 1666 is on Brownsville Road north of Wynoka Street and north of the South Side Cemetery. (*Kenneth C. Springirth photograph*)

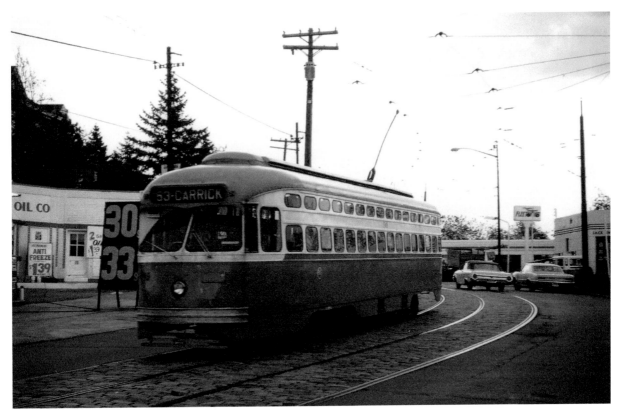

Route 53 (Carrick) PCC car No. 1749 is on Brownsville Road at Carrick Avenue in the Carrick neighborhood of Pittsburgh on October 26, 1968. Dr. H. O'Brien received permission to establish a post office in the south part of Pittsburgh plus name it and he chose Carrick, after the name of his hometown in Ireland, Carrie-on-Suir. (*Kenneth C. Springirth photograph*)

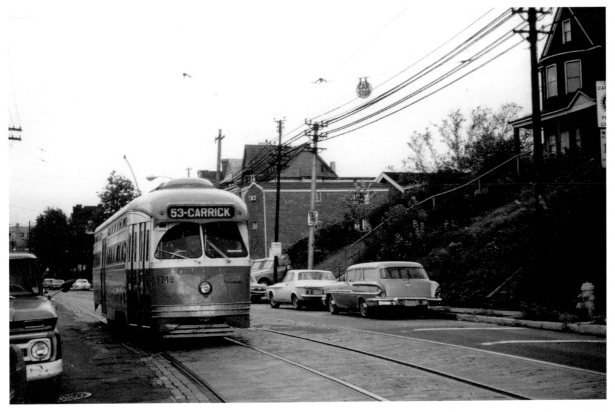

Brownsville Road at Quincy Avenue is the location of PAT Route 53 PCC car No. 1749 on October 26, 1968. (*Kenneth C. Springirth photograph*)

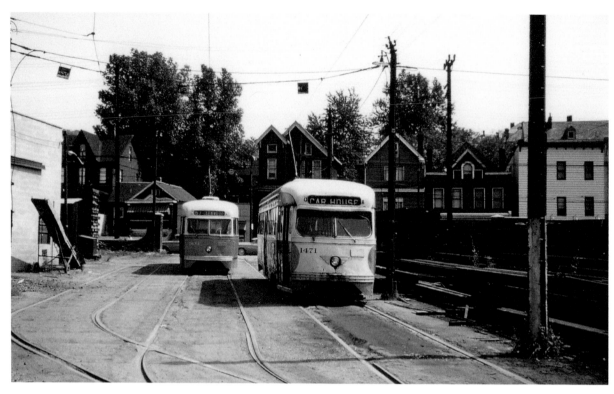

From left to right: Pittsburgh Railways Company (PRC) PCC cars built by St. Louis Car Company No. 1633 (one of seventy-four cars, Nos. 1601–1674, built by St. Louis Car Company and delivered during August–October 1945) and No. 1471 (one of seventy-five cars, Nos. 1400–1474, built by St. Louis Car Company and delivered during February–March 1942) are at Glenwood Loop on August 25, 1962. (*Kenneth C. Springirth photograph*)

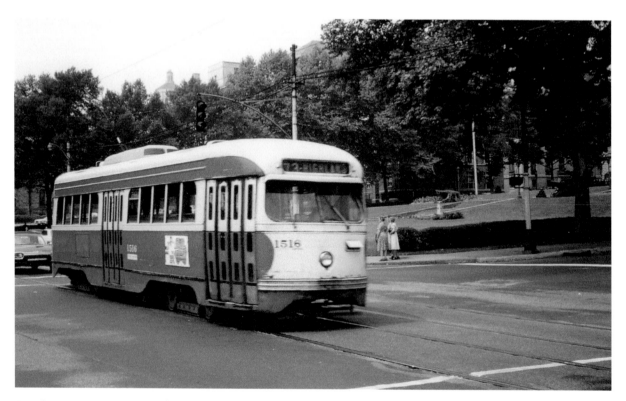

On July 24, 1964, PRC Route 73 (Highland) PCC car No. 1516 (one of fifty cars, Nos. 1500–1549, built by St. Louis Car Company and delivered in November–December 1944) is on Fifth Avenue at Bigelow Boulevard in the Oakland neighborhood, which is the academic and healthcare center of Pittsburgh. (*Kenneth C. Springirth photograph*)

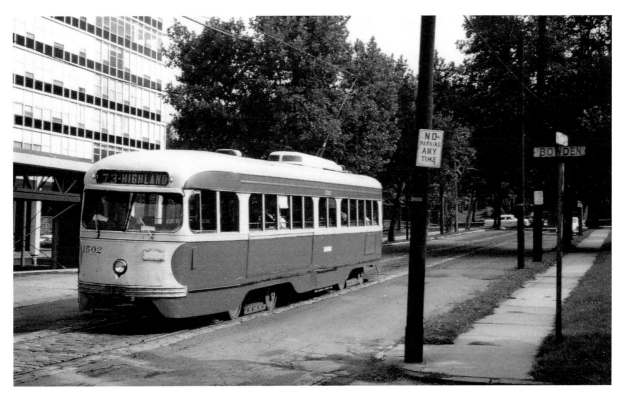

North St. Clair Street at Bowden Street in the Highland Park neighborhood of Pittsburgh is the location of PRC Route 73 PCC car No. 1502 on August 23, 1964. This was near the site of the former Highland Avenue Car House. (*Kenneth C. Springirth photograph*)

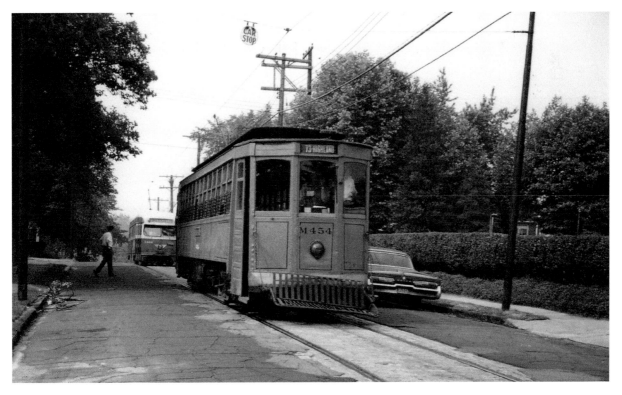

On June 25, 1966, Port Authority Transit (PAT) Route 73 car No. M454 (originally car No. 4115 one of fifty double-truck, single-end cars, Nos. 4100–4149, built in 1911 by Pressed Steel Car Company for Pittsburgh Railways Company that later became a snow scrapper) is on North Euclid Avenue at Bowden Street in the Highland Park neighborhood of Pittsburgh on a rail excursion with a 1400 series PCC car behind it. (*Kenneth C. Springirth photograph*)

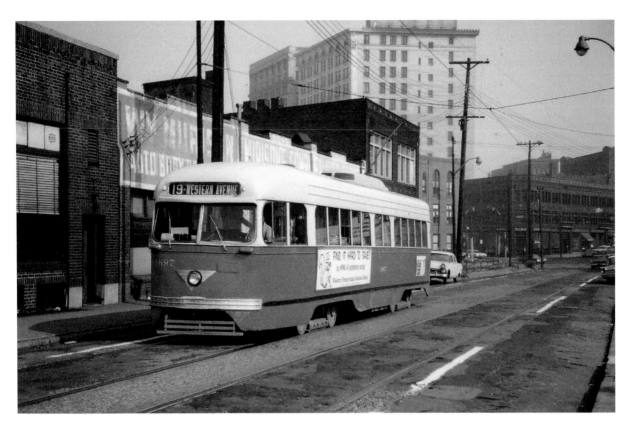

Ellsworth Avenue near Highland Avenue in the East Liberty neighborhood of Pittsburgh is the location of Pittsburgh Railways Company (PRC) PCC car No. 1697 on an October 20, 1963 rail excursion with that destination sign reading 19 (Western Avenue); however, this street trackage was actually used by Route 75 (Highland). (*Kenneth C. Springirth photograph*)

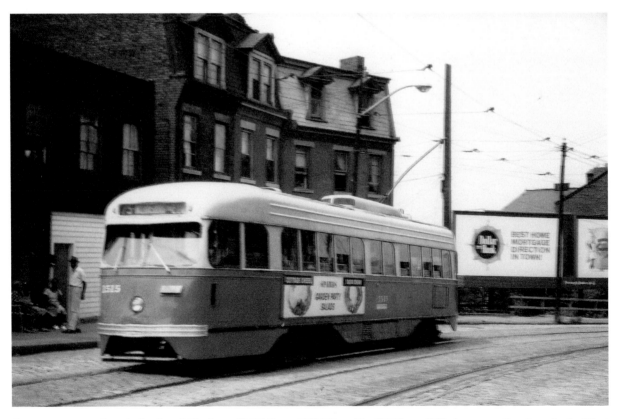

On June 25, 1966, Port Authority of Allegheny (PAT) Route 75 PCC car No. 1515 is on Fifth Avenue at Brenham in the West Oakland neighborhood of Pittsburgh. (*Kenneth C. Springirth photograph*)

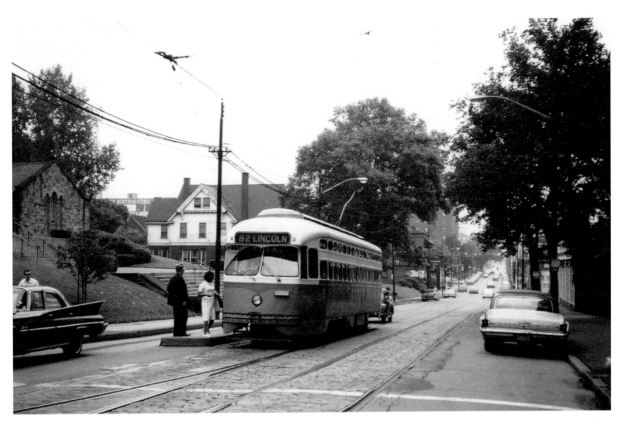

Route 82 PAT PCC car No. 1767 is making a passenger stop on Centre Avenue at Liberty Avenue on August 14, 1966 in the Shadyside neighborhood of Pittsburgh. (*Kenneth C. Springirth photograph*)

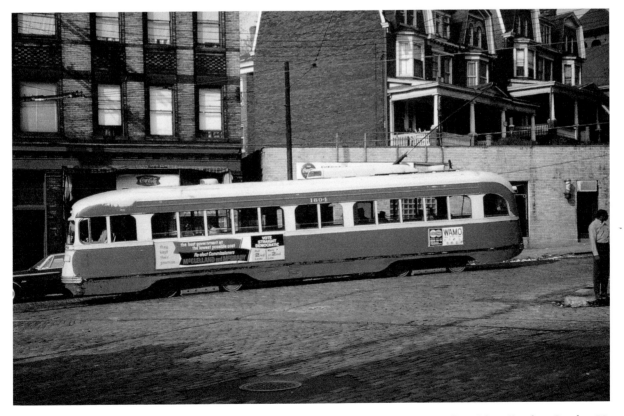

Pittsburgh Railways Company (PRC) Route 85 PCC car No. 1604 is on Herron Avenue at Bryn Mawr Road on October 29, 1963. (*Kenneth C. Springirth photograph*)

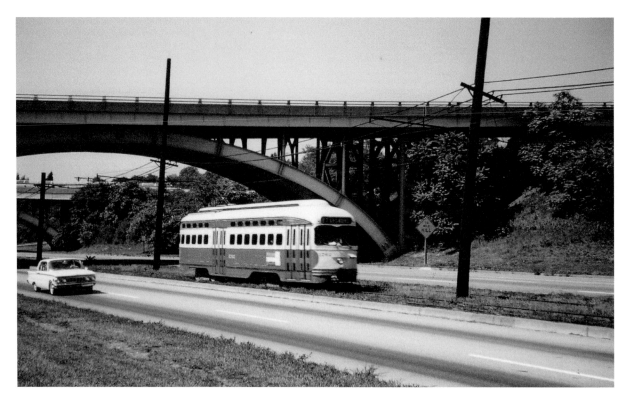

On October 25, 1962, PRC Route 87 PCC car No. 1762 is on the center of the road private right of way of Ardmore Boulevard. After the 1958 abandonment of Route 68 (Homestead–Duquesne–McKeesport), the 13.7-mile Route 87 was Pittsburgh's longest trolley car line. (*Kenneth C. Springirth photograph*)

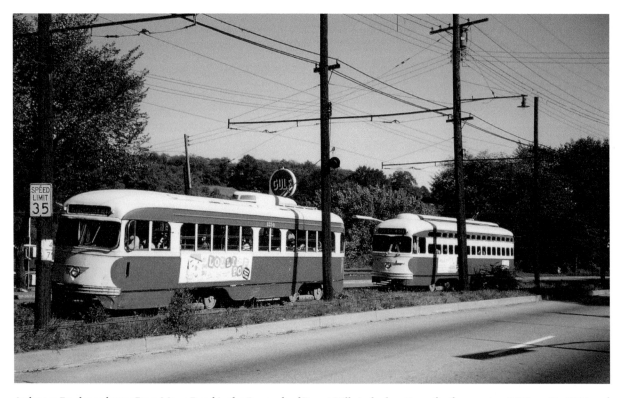

Ardmore Boulevard near Bryn Mawr Road in the Borough of Forest Hills is the location of rail excursion PCC car No. 1254 and Route 87 regular service PCC car No. 1747 on September 15, 1962. From a peak population of 9,561 in 1970, the population of Forest Hills declined 31.8 percent to 6,518 by 2010. Population of Allegheny County declined 24.88 percent from 1,628,587 in 1960 to 1,223,348 in 2010. With the decline of the steel industry, many people moved from Allegheny County, because jobs were not available. (*Kenneth C. Springirth photograph*)

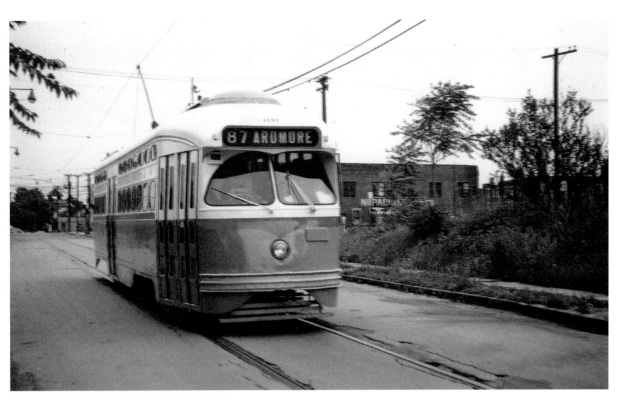

PCC car No. 1797 is showing the new Port Authority Transit color scheme on a June 7, 1964 rail excursion at a photo stop on Euclid Avenue and Baum Boulevard. (*Kenneth C. Springirth photograph*)

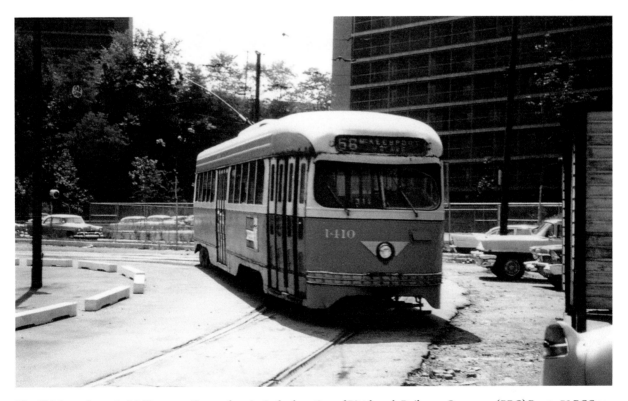

The Pirl Street Loop in McKeesport, Pennsylvania, is the location of Pittsburgh Railways Company (PRC) Route 56 PCC car No. 1410 on August 25, 1962. (*Kenneth C. Springirth photograph*)

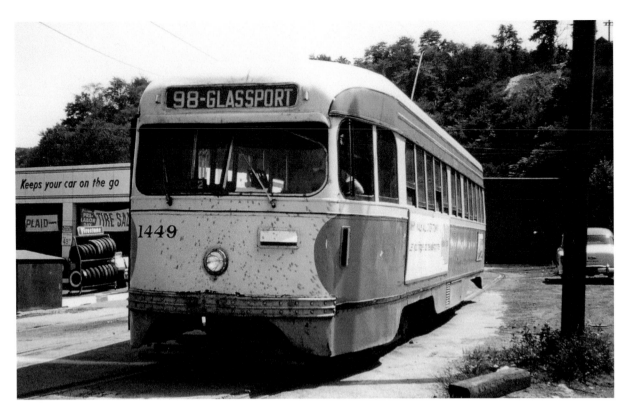

PRC Route 98 PCC car No. 1449 is waiting for departure time at the Pirl Street Loop in McKeesport on August 25, 1962. (*Kenneth C. Springirth photograph*)

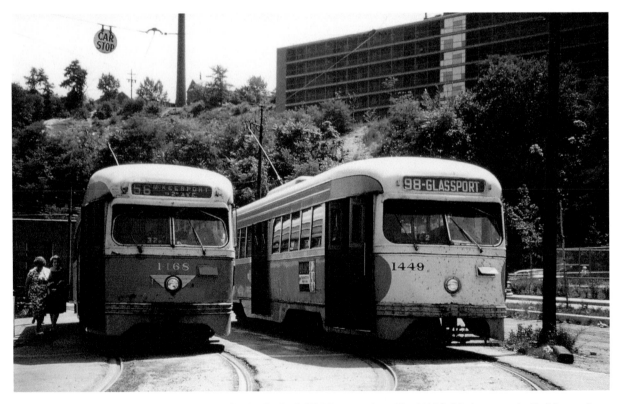

Pirl Street Loop in McKeesport was a terminal point for both PRC Routes 56 car No. 1468 (with the upper half of the car front painted cream, lower half painted red, and silver headlight wings) and Route 98 car No. 1449 (with the front predominately in cream) on August 25, 1962. (*Kenneth C. Springirth photograph*)

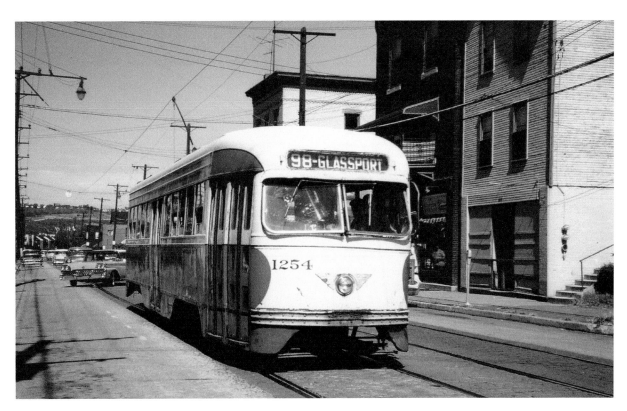

On a September 15, 1962 rail excursion, PRC PCC car No. 1254 is on Monongahela Avenue at 5th Street in the borough of Glassport. This community has faced a severe economic decline with a major loss of the steel making industry in the Greater Pittsburgh area as evidenced by a 48.75 percent decline in population from 8,748 in 1940 to 4,483 in 2010. (*Kenneth C. Springirth photograph*)

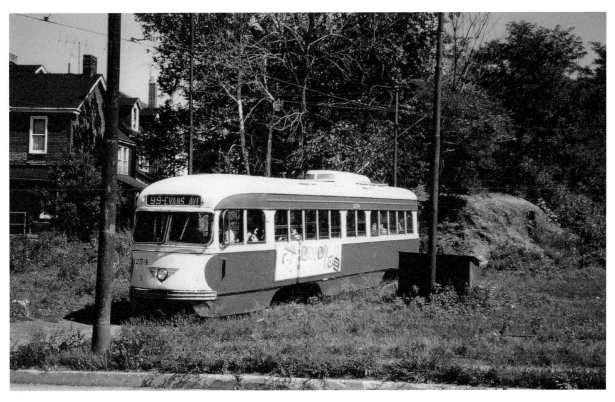

The Route 98 (Glassport) terminus is the location of PRC PCC car No. 1254 on September 15, 1962. This line linked the borough of Glassport with the city of McKeesport where connections were made with train, trolley car, and bus routes to Pittsburgh and points beyond. (*Kenneth C. Springirth photograph*)

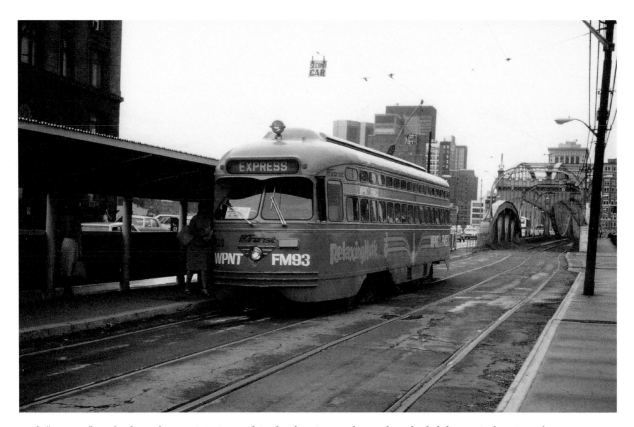

With "Express" on the front destination sign and Drake showing on the card on the left front window, on July 21, 1980, Port Authority Transit (PAT) PCC car No. 1739 is loading passengers at the Pittsburgh & Lake Erie Train Station stop on Smithfield Street for a trip that skips certain stops to provide faster rush-hour service for commuters heading south to Drake. (*Kenneth C. Springirth photograph*)

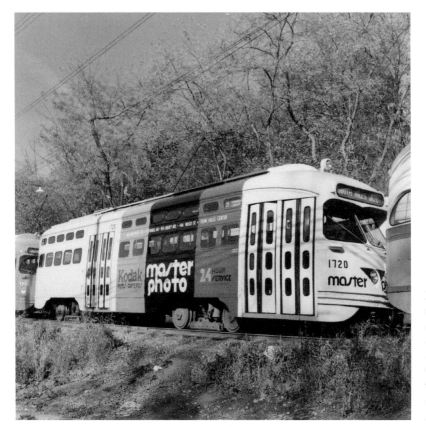

PAT PCC car No. 1720 with its special paint scheme (providing advertisement revenue to PAT plus an attractive-looking car making for an improved ride impression) is at the South Hills (Tunnel Carhouse) waiting for its next assignment on October 27, 1974. (*Kenneth C. Springirth photograph*)

2
Changeover to Light Rail

The Mount Washington Trolley Tunnel was reconstructed with the rails in pavement to accommodate buses. Trackage on Warrington and Arlington Avenues formerly used by Routes 44, 49, and 53 was retained for use as a tunnel bypass and was served by a new temporary route 49 (Arlington–Warrington). During the reconstruction of the Mount Washington Tunnel (which occurred from 1973 to September 1975 when it reopened for joint rail and bus operation), from 6 a.m. to 2 p.m. all trolleys were inbound via the Mount Washington Tunnel and outbound via the bypass. From 2 p.m. to 9:30 p.m., trolleys were outbound via the tunnel and inbound by the bypass. From 9:30 p.m. to 6 a.m., all service in both directions used the bypass. On October 26, 1975, full trolley car service in both directions was restored in the Mount Washington Transit Tunnel. Surviving trolley routes were 35 (Library), 36 (Drake), 37 (Shannon), and 42/38 (Mt. Lebanon–Beechview).

In 1975, the South Hills Light Rapid Transit System developed out of the stalemate surrounding the proposed Skybus system. The March 5, 1976 *Pittsburgh Post Gazette* front page headline "Light Rail Trolleys Proposed" noted, "A new trolley system featuring the latest in light-rail technology was recommended yesterday for Pittsburgh's South Hills corridor." The consulting firm DeLeuw, Cather & Co. recommended the new trolley system:

> It would be the most effective in terms of cost per passenger. It would require the lowest annual operating and maintenance subsidies. It would necessitate the lowest commitment of state and county funds. It would offer much higher accessibility to transit riders because of less need for an elaborate feeder system in the suburbs and neighborhoods, offsetting slightly longer travel times. It would provide compatibility with future transit plans in other corridors. It would best meet environmental standards of air quality control, noise abatement, energy conservation, and visual and esthetic impact.

The Urban Mass Transportation Administration agreed on October 29, 1976 to reprogram Early Action funds to upgrade the existing South Hills trolley system.

In 1979, UMTA announced a $265 million grant to PAT for the initial reconstruction and upgrading of the South Hills light rail system. Stage I of the of the light rail transit (LRT) plan involved rebuilding the 10.5-mile main line from downtown Pittsburgh via Beechview and Mount Lebanon to Bethel Park and Upper St. Clair. On December 10, 1980, under Federal funding, construction began on the downtown subway and the new line from South Hills Village Station and Light Rail Maintenance Center to Castle Shannon.

A fleet of fifty-five new Model SD400 light rail vehicles built by Siemens Duewag began operating from South Hills Village via new trackage to Dorchester and rebuilt trackage from Dorchester to Castle Shannon reopened on April 15, 1984. PCC car No. 1769 made the first trip greeted by 100 people at Dorchester Station who welcomed the opening of the line serving the nearby Dorchester Apartments. April 15, 1984 marked the opening of 2.8 miles of new track and the beginning of light rail transit for Pittsburgh. The new 1.1-mile downtown subway went into service on July 7, 1985. The "Beechview" line from Castle Shannon to South Hills Junction was approved for $20 million funding on May 8, 1985. While the Beechview Line was being rebuilt, the Overbrook Line was served by PCC cars. The reconstructed double-tracked Route 42S "Beechview" line with continuous welded rail and modern overhead catenary opened on May 22, 1987 routed from South Hills Junction through the Mount Washington Transit Tunnel. It served the new Station Square Station after which it crossed the Monongahela River on the Panhandle Bridge (a former Pennsylvania Railroad bridge) and entered the new subway serving the Steel Plaza Station and Wood Street Station to reach Gateway Center Station. There was also a branch line from Steel Plaza Station to Penn Station.

Stage II was the rebuilding of the Overbrook Line from South Hills Junction via Overbrook to Castle Shannon. Because of deterioration of the track and infrastructure, Overbrook Line Route 47 (Shannon) was taken out of service on June 3, 1993 while 47D (the only remaining PCC car line) operated between Drake and Washington Junction with PCC car service ending on September 4, 1999. Reconstruction of the Overbrook Line began in 1999. The rebuilt line, completely double tracked with upgraded catenary and had eight high level platform ADA accessible stations, reopened on June 2, 2004. To service this line and increase overall system capacity, twenty-eight additional light rail vehicles were purchased from Construcciones Y Auxiliar de Ferrocarriles S.A. which in English is "Construction & Other Railway Services" (CAF). These were compatible with the 55 light rail vehicles built by Siemens Duewag.

On February 6, 2004, Federal funding was approved to extend the line from downtown Pittsburgh's Gateway Station under the Allegheny River to the North Shore near Heinz Field. The completed line opened on March 25, 2012 and serves North Side Station (just west of PNC Park) and terminates at Allegheny Station (just north of Heinz Field).

In 2021, the following three lines operate: the Red Line (formerly 42S) operates from South Hills Village via Beechview to Allegheny Station in downtown Pittsburgh. The Blue Line (formerly 47S)

operates from South Hills Village via South Bank Station (Overbrook) to Allegheny Station in downtown Pittsburgh. The Silver Line renamed March 15, 2020 (to distinguish it from the Blue line to South Hills Village was called Blue Line and earlier 47L) operates from Library via South Bank Station (Overbrook) to Allegheny Station in downtown Pittsburgh.

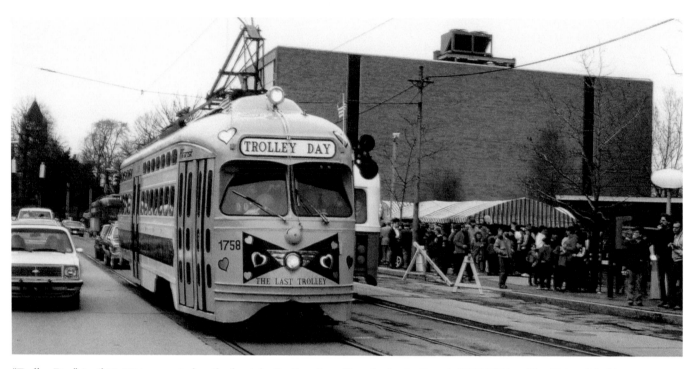

"Trolley Day" April 14, 1984 was noted on the front destination sign of Port Authority Transit (PAT) PCC car No. 1758 on Washington Road in Mount Lebanon. This was the last day of street running operation on Washington Road between Dormont and Mount Lebanon. Under Stage I conversion to Light Rail Transit, a 5.8-mile section of Route 38/42 was totally rebuilt with a downtown Pittsburgh subway plus a 3,000-foot-long subway under Washington Road from Shady Drive to McFarland Road. The second construction area extended 4.7 miles southward from Mount Lebanon to South Hills Village. Bus Routes 38 (Mt. Lebanon via West Liberty Avenue) and 42 (Potomac Avenue only via Beechview) replaced Route 42/38 Mt. Lebanon via Beechview) trolleys until the entire line was completed. (*Kenneth C. Springirth photograph*)

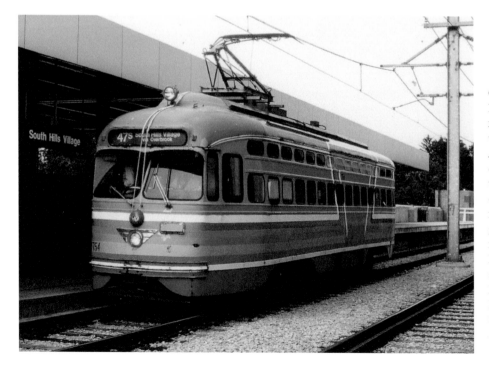

On July 5, 1985, Route 47S (South Hills Village via Overbrook) repainted PCC car No. 1754 is at the South Hills Village Station. April 15, 1984 marked the opening of the rebuilt double track (powered by an overhead catenary system supported from brackets mounted on galvanized steel poles anchored in reinforced concrete) modern light rail transit system from just south of the Castle Shannon Municipal Building to the South Hills Village Station and the new South Hills Village Car Storage and Maintenance Area. (*Kenneth C. Springirth photograph*)

On July 5, 1985, PAT PCC car No. 1742 is crossing the Smithfield Street Bridge over the Monongahela River. The new 1.1-mile downtown Pittsburgh subway went into service on July 7, 1985 with PCC cars and light rail vehicles crossing the Monongahela River east of this location via the former Pennsylvania Railroad Pan Handle Bridge to access the new subway. Note the familiar trolley pole was replaced by a pantograph. (*Kenneth C. Springirth photograph*)

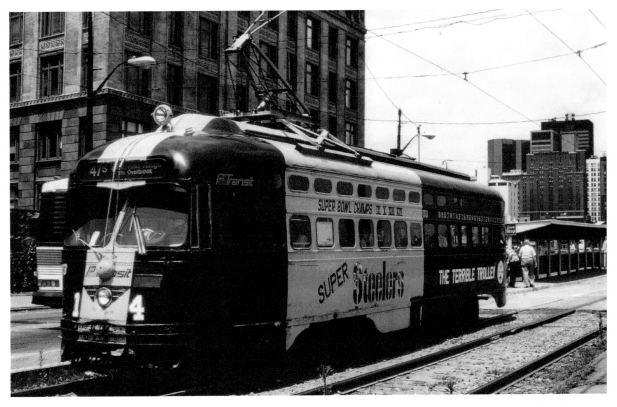

Pantograph equipped PAT Route 47S (South Hills Village via Overbrook) PCC car No. 1713 has just left the P&LE Station in downtown Pittsburgh on a July 5, 1986 southbound trip via Overbrook to South Hills Village. (*Kenneth C. Springirth photograph*)

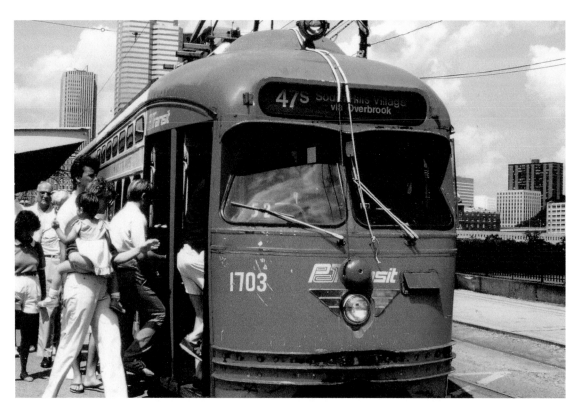

At the P&LE Station stop just south of the Smithfield Street Bridge on July 5 1985, passengers are boarding PAT Route 47S PCC car No. 1703 southbound for South Hill Village. Beginning July 7, 1985, passengers departed and boarded cars from nearby Station Square Station. (*Kenneth C. Springirth photograph*)

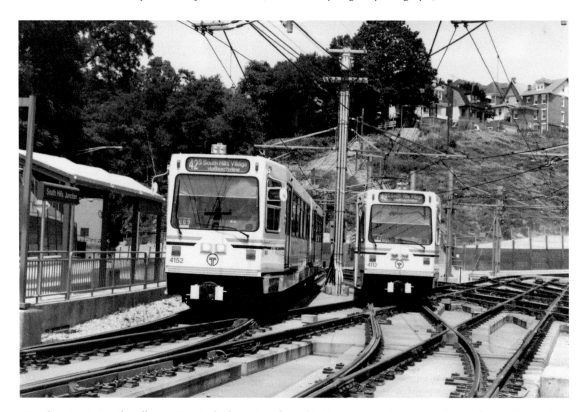

On July 2, 1988, South Hills Junction is the location of two passing PAT Route 42S cars from left to right No. 4152 southbound to South Hill Village and No. 4112 northbound to Gateway Station in downtown Pittsburgh. There were fifty-five of these model SD-400 six-axle, single-articulated, double-ended light rail vehicles, Nos. 4101–4155, built by Siemens Duewag during 1985–1987. (*Kenneth C. Springirth photograph*)

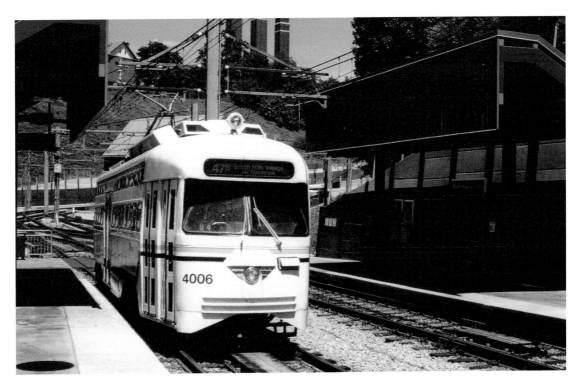

South Hills Junction on July 2, 1988 is the location of southbound PAT Route 47S rebuilt PCC car No. 4006 (originally car No. 1767). This was one of twelve rebuilt cars, Nos. 4001–4012, that had been rebuilt (essentially new cars with new propulsion, new braking systems, and a new interior with improved lighting) from 1700–1799 series PCC cars originally built by St. Louis Car Company during 1947–1948. However, car No. 4006 was the only car to receive an air conditioning system because of budget constraints. (*Kenneth C. Springirth photograph*)

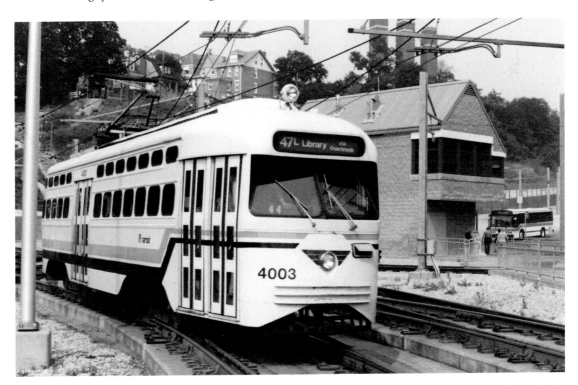

Southbound PAT Route 47L (Library via Overbrook) rebuilt PCC car No. 4003 (originally car No. 1731) is at South Hills Junction on August 3, 1988. Later that year, on October 30, 1988, Route 47L was temporarily replaced during construction on the Library Line south of Washington Junction by bus Route 49L (Library Shuttle) that connected at Washington Junction with trolley car Route 42S. On the top right of the picture, the three towers are venting towers to continuously provide fresh air for the Liberty Tunnel while simultaneously pumping out motor vehicle exhaust fumes. (*Kenneth C. Springirth photograph*)

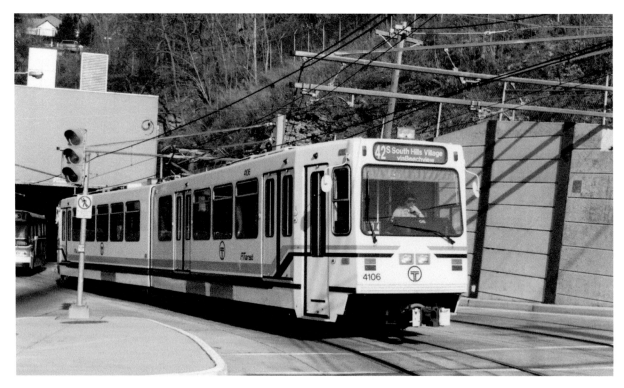

On November 25, 1988, PAT light rail vehicle No. 4106, built by Siemens Duewag, has emerged from the Mount Washington Transit Tunnel for a southbound Route 42S trip via Beechview to South Hill Village. These cars are 84.67 feet long, 8.75 feet wide, 12.42 feet high, weigh 42.9 tons, seat sixty-two passengers, and can handle a maximum of 263 passengers. With a maximum speed of 50 miles per hour, each vehicle has three high-level doors per side and one low-level door per side. (*Kenneth C. Springirth photograph*)

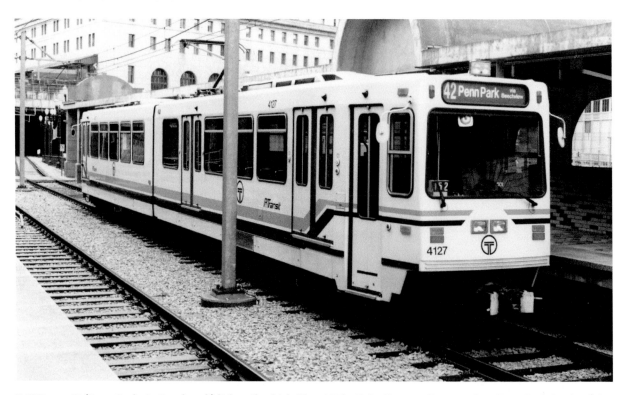

PAT Route 42 (Penn Park via Overbrook) light rail vehicle No. 4127, built by Siemens Duewag, is at Penn Park Station (also known as Penn Station) waiting for departure time on March 24, 1981. As late as 2001, there were only two afternoon rush-hour trains. While the Penn Park Station is not in regular use, it was used following Super Bowl XLV on February 6, 2011 and for "Railvolution Transit Convention" in October 2018. (*Kenneth C. Springirth photograph*)

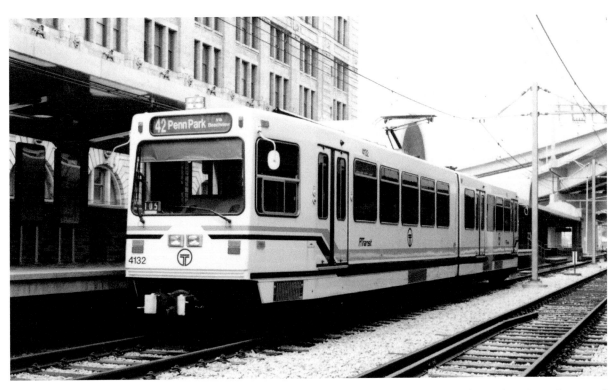

On July 3, 1989, PAT light rail vehicle No. 4132, built by Siemens Duewag, is at Penn Station located on Grant Street and Liberty Avenue in downtown Pittsburgh. When service began between Steel Plaza Station and Penn Station on June 5, 1988, it was every 10 minutes on Monday-Friday 6:30 am to 7 pm, Saturday 9 am to 6 pm, and Sunday 10 am to 6 pm. The station building was designed by architect Daniel Burnham and built during 1898–1904. (*Kenneth C. Springirth photograph*)

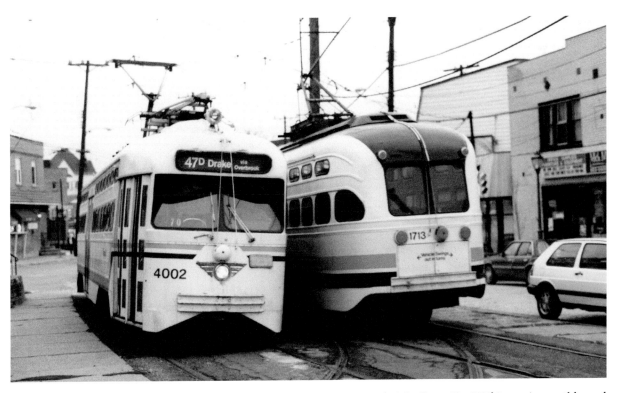

Southbound PAT Route 47D (Drake via Overbrook) rebuilt PCC car No. 4002 (originally car No. 1740) is passing northbound car No. 1713 in Castle Shannon on November 25, 1989. Car No. 1713 along with cars Nos. 1737, 1745, and 1765 received extensive body and systems rehabilitation work; however, these cars retained their original external configuration and original number. (*Kenneth C. Springirth photograph*)

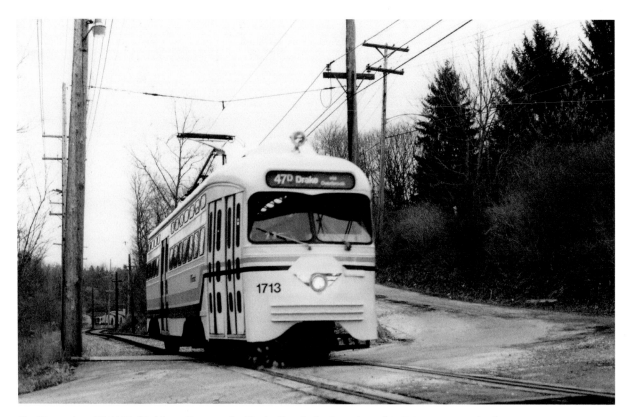

On November 25, 1989, Walthers Stop on the Drake line is the location of PAT Route 47D rebuilt PCC car No. 1713. PAT removed thirty-six PCC cars out of service on August 1, 1988 after inspections revealed deteriorated insulation on electrical wires, and twenty-seven of those were retired and used to supply parts for those remaining in operation. (*Kenneth C. Springirth photograph*)

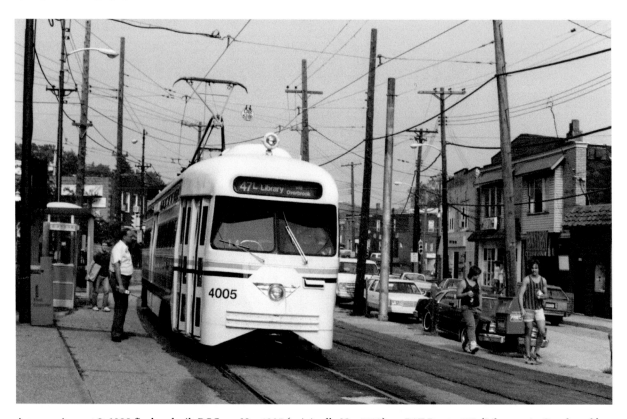

A sunny August 8, 1988 finds rebuilt PCC car No. 4005 (originally No. 1719) on PAT Route 47L (Library via Overbrook) at Castle Shannon. (*Kenneth C. Springirth photograph*)

Simmons Loop (southern terminus of the Library Line) is the location of PAT line car No. M210 on December 23, 1988. This car was built in 1940 at the Homewood Shops of the Pittsburgh Railways Company with trucks and control equipment from car No. 4306 and tower equipment from line construction car No. M211. (*Kenneth C. Springirth photograph*)

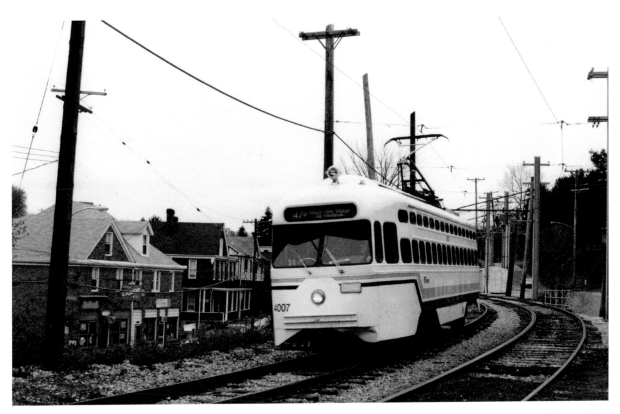

On March 24, 1989, PAT Route 47S car rebuilt PCC car No. 4007 (originally car No. 1729) is at Castle Shannon. (*Kenneth C. Springirth photograph*)

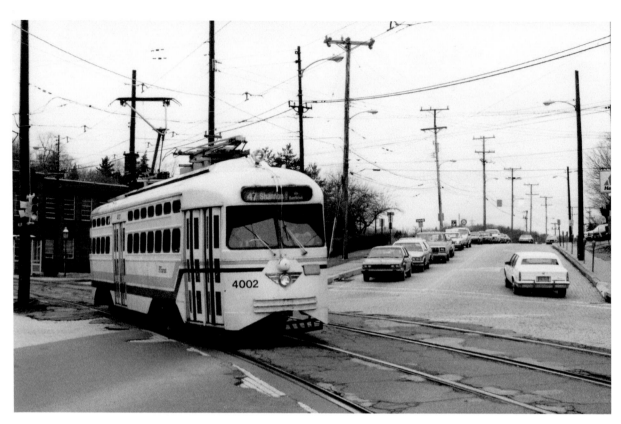

Northbound PAT Route 47 (Shannon via Overbrook) rebuilt PCC car No. 4002 (originally car No. 1740) is crossing Castle Shannon Boulevard in the borough of Castle Shannon on March 24, 1989. (*Kenneth C. Springirth photograph*)

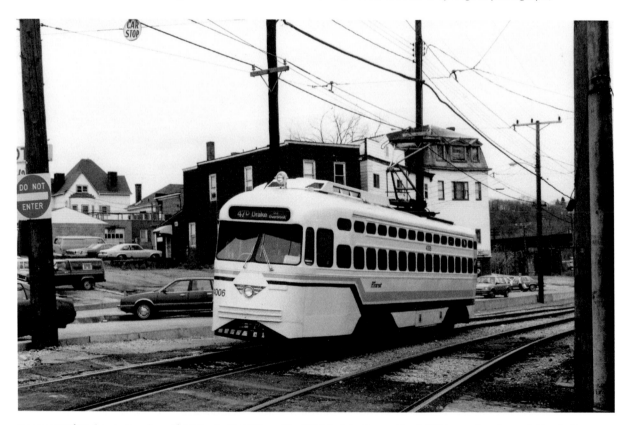

Route 47D (Drake via Overbrook) PAT rebuilt PCC car No. 4006 (originally car No. 1767) is passing through Castle Shannon on March 24, 1989. (*Kenneth C. Springirth photograph*)

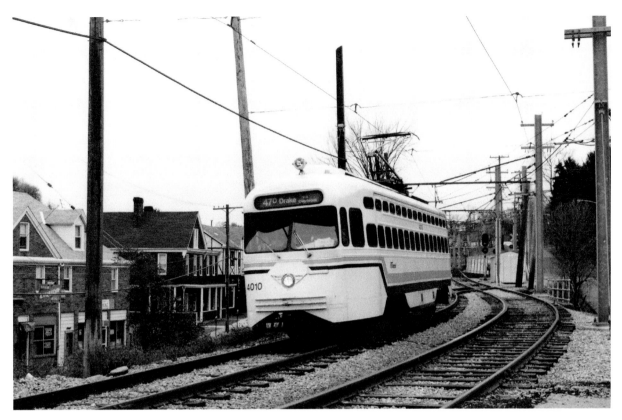

Rebuilt PCC car No. 4010 (originally car No. 1757) is on the curve at Castle Shannon handling a PAT Route 47D (Drake via Overbrook) trip on March 24, 1989. (*Kenneth C. Springirth photograph*)

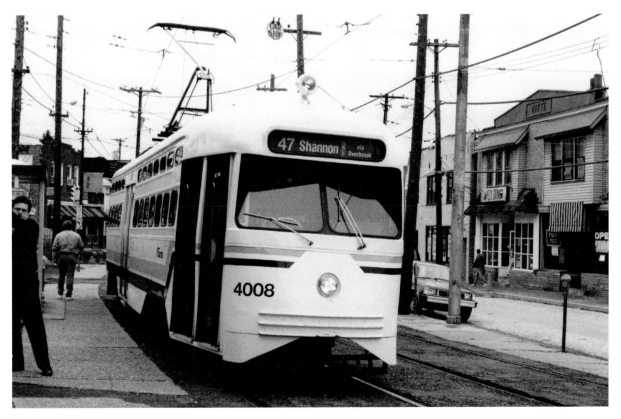

Route 47 (Shannon via Overbrook) PAT rebuilt PCC car No. 4008 (originally car No. 1709) is operating a scheduled trip to Castle Shannon on March 24, 1989. This line operated along with Route 47D (Drake via Overbrook), and Route 47S (South Hills Village via Overbrook) during the construction of the southern part of the Library line. (*Kenneth C. Springirth photograph*)

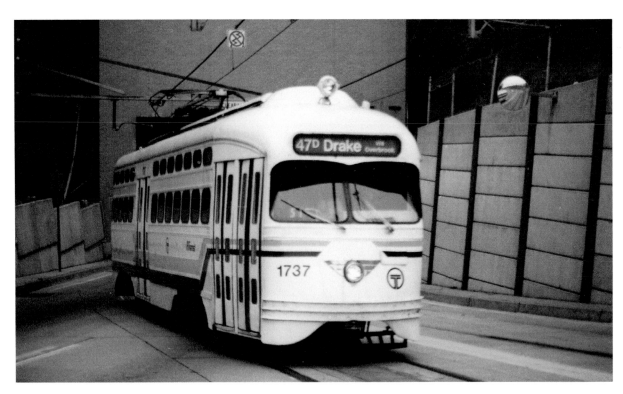

PAT Route 47D rebuilt PCC car No. 1737 has come into view from the Mount Washington Transit Tunnel on February 9, 1991. Since October 26, 1975, the tunnel has been used for joint trolley and bus operation in both directions. (*Kenneth C. Springirth photograph*)

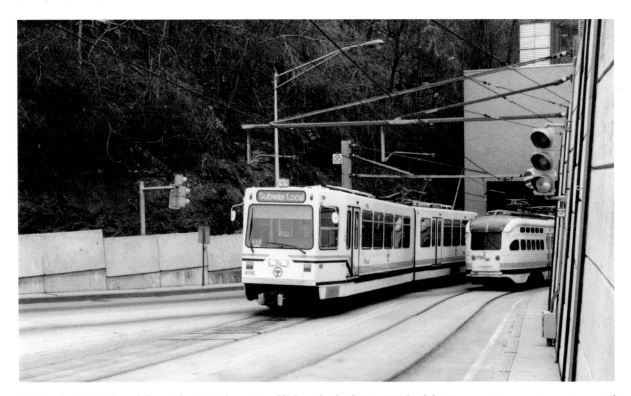

On March 17, 1990, from left to right PAT Subway Local light rail vehicle No. 4116, built by Siemens Duewag, is coming out of the Mount Washington Transit Tunnel while rebuilt PCC car No. 1765 is entering the tunnel on March 17, 1990. The Subway Local provided service between Station Square Station, Steel Plaza, Wood Street, and Gateway subway stations. (*Kenneth C. Springirth photograph*)

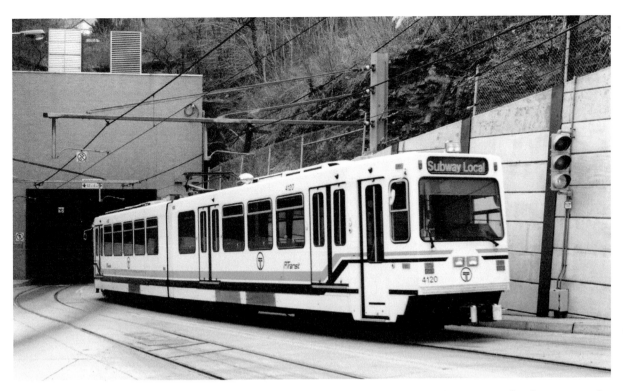

PAT Subway Local light rail vehicle No. 4120, built by Siemens Duewag, is leaving South Hills Junction and is about to enter the Mount Washington Transit Tunnel for a return trip to downtown Pittsburgh on March 17, 1990. (*Kenneth C. Springirth photograph*)

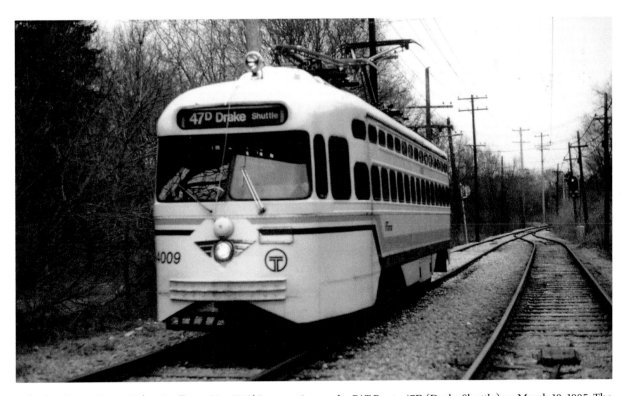

Rebuilt PCC car No. 4009 (originally car No. 1700) is operating on the PAT Route 47D (Drake Shuttle) on March 19, 1995. The full Drake line operated from downtown Pittsburgh subway using the Overbrook line) until June 6, 1993 when it was cut back from downtown Pittsburgh to Castle Shannon because of deteriorating track and began operating as a shuttle between Castle Shannon and Drake. Riders had to transfer between the Route 47D (Drake Shuttle) and either the 42L (Library via Beechview) or the 42S (South Hills Village via Beechview) at Castle Shannon or Washington Junction to travel to or from downtown Pittsburgh. (*Kenneth C. Springirth photograph*)

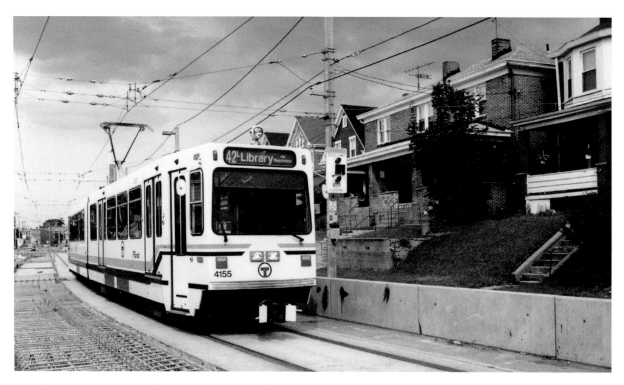

On July 25, 1998, Route 42L (Library via Beechview) light rail vehicle No. 4155, built by Siemens Duewag, is on Broadway Avenue during its reconstruction in the Beechview neighborhood of Pittsburgh. The Library line was rerouted via the Beechview line, because the Overbrook line was out of service. (*Kenneth C. Springirth photograph*)

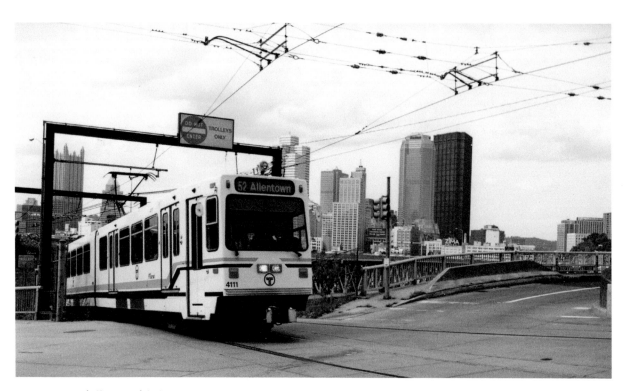

PAT Route 52 (Allentown) light rail vehicle No. 4111, built by Siemens Duewag, is on Arlington Avenue at the PJ McArdle Roadway on July 25, 1998. This historic line began as a horsecar line in 1886, by 1897 electric trolley cars operated from the South Side to downtown Pittsburgh, and in 1901 new trackage on Warrington Avenue made it possible to ride trolleys from Mt. Lebanon to downtown Pittsburgh. This was operated as Route 49 (Warrington–Arlington) during the 1976 United States Bicentennial. While budget restraints resulted in this line being taken out of service on March 27, 2011, trackage on Warrington–Arlington remains in place as a tunnel bypass route. (*Kenneth C. Springirth photograph*)

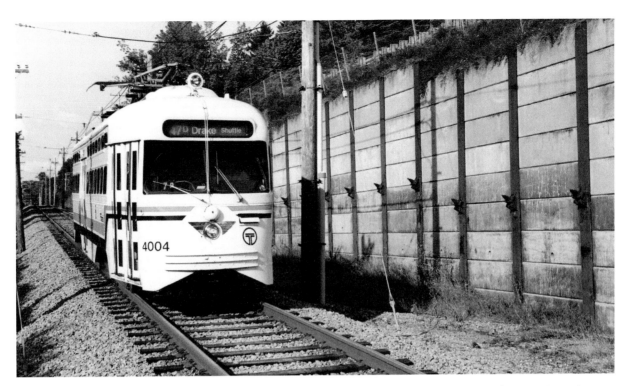

On September 4, 1999, Route 47D (Drake Shuttle) rebuilt PCC car No. 4004 (originally car No. 1739) is southbound at Fort Couch Road. This was the last day of regular PCC car service in Pittsburgh. On September 5, 1999, there was a special excursion closing out Pittsburgh's sixty-three years of PCC car service. Pittsburgh's first PCC car No. 100 was delivered in July 1936 and went into service providing the public free rides during September and October 1936. (*Kenneth C. Springirth photograph*)

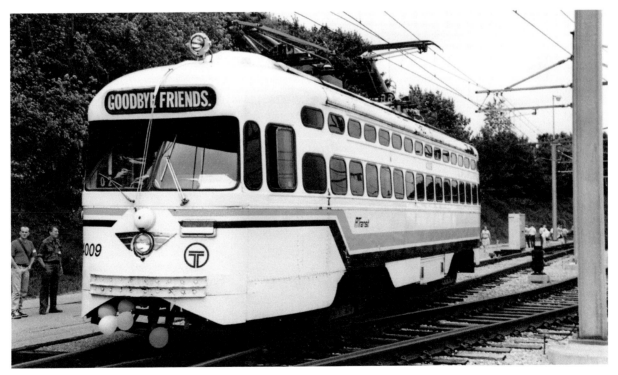

Rebuilt PCC car No. 4009 (originally car No. 1700) with "Goodby Friends" on the front destination sign at the South Hills Village PAT Maintenance Yard is on the final PCC car September 5, 1999 excursion marking the end of the PCC car era in Pittsburgh. (*Kenneth C. Springirth photograph*)

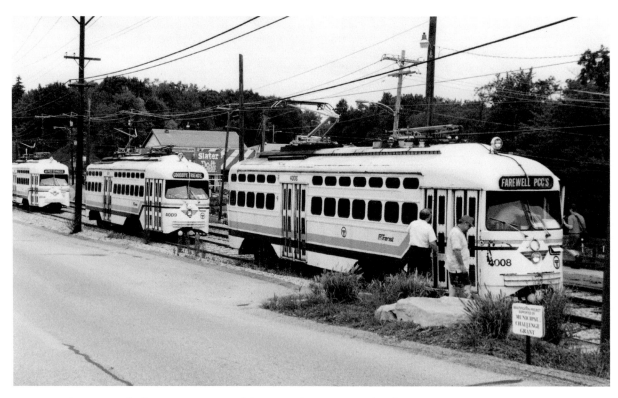

On September 5, 1999, the last remaining operable Port Authority Transit (PAT) PCC cars from right to left Nos. 4008, 4009, and 4004 are at a rail excursion photo stop on the Library Line south of Washington Junction. This was the final day of PCC car service in Pittsburgh. (*Kenneth C. Springirth photograph*)

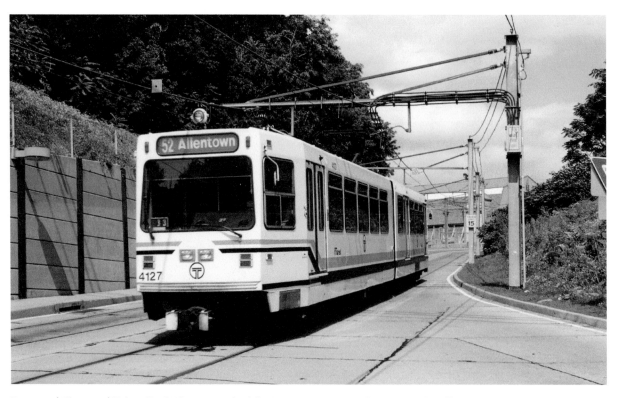

Route 52 (Allentown) light rail vehicle No. 4127, built by Siemens Duewag, is leaving South Hills Junction on a trip to downtown Pittsburgh via the Warrington–Arlington tunnel bypass route on July 7, 2003. Even though this route was taken out of service on March 27, 2011 during a challenging budget time, it has been maintained for use when the Mount Washington Transit Tunnel is closed. (*Kenneth C. Springirth photograph*)

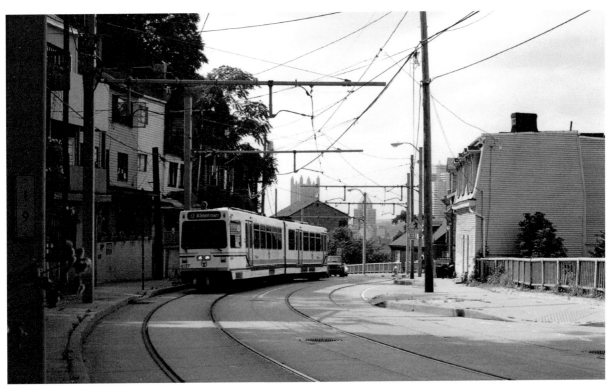

Route 52 (Allentown) light rail vehicle No. 4127, built by Siemens Duewag, is climbing up Arlington Avenue on its trip via Warrington Avenue to South Hills Junction on July 7, 2003. (*Kenneth C. Springirth photograph*)

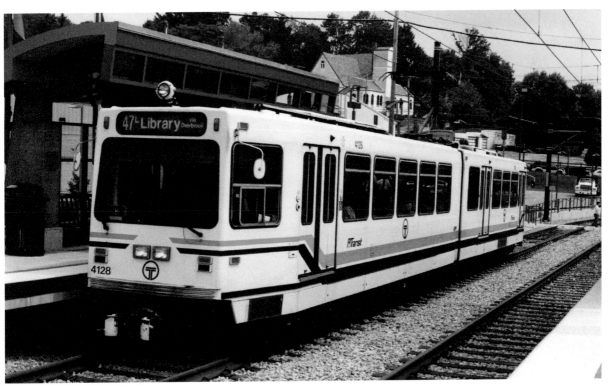

On June 6, 2004, Route 47L (Library via Overbrook) PAT light rail vehicle No. 4128, built by Siemens Duewag, is at Willow Station (serving nearby apartments and serves as a passenger transfer point between the Red Line, Blue Line, and Silver Line) located on Willow Avenue and James Street in Castle Shannon on the rebuilt Overbrook Line which had reopened on June 2, 2004. This line was completely double tracked with upgraded catenary, and this was one of the eight new high-level platform ADA accessible stations, which had replaced many former trolley car like stops. (*Kenneth C. Springirth photograph*)

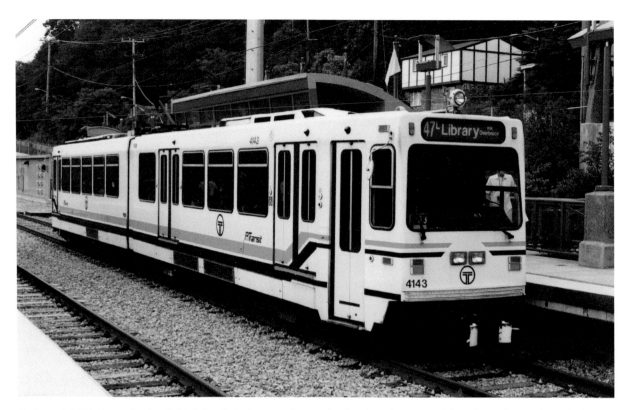

On June 6, 2004, Boggs Station (a high-level platform station on the Overbrook section of the Library line in the Beltzhoover neighborhood of Pittsburgh) is the location of PAT Route 47L light rail vehicle No. 4143, built by Siemens Duewag. (*Kenneth C. Springirth photograph*)

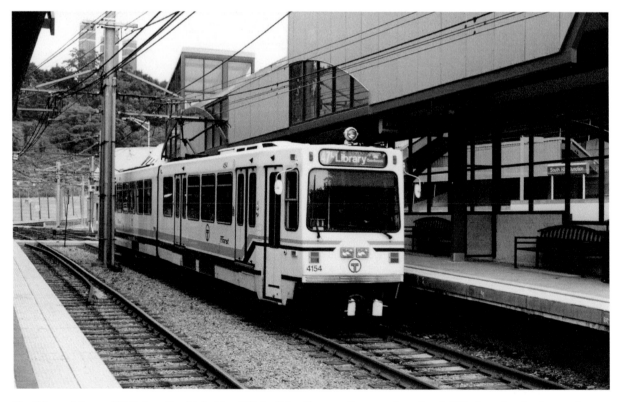

Northbound Route 47L light rail vehicle, No. 4154, built by Siemens Duewag, is at South Hills Junction Station on June 6, 2004. Northbound cars of the Beechview and Overbrook lines merge together at this station before going through the Mount Washington Transit Tunnel to downtown Pittsburgh. This station serves as a transfer point for the light rail transit routes and numerous bus routes that serve this station. (*Kenneth C. Springirth photograph*)

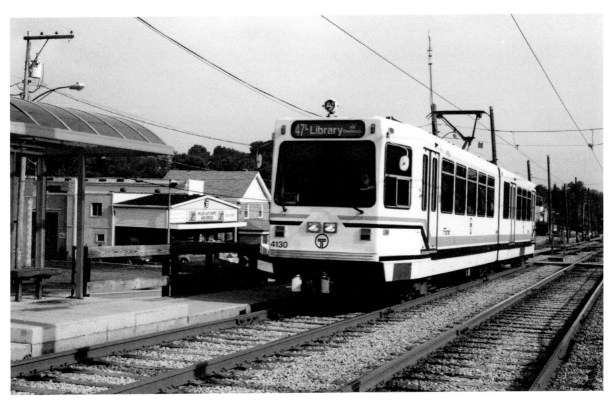

Route 47L light rail vehicle No. 4130, built by Siemens Duewag, is at the Mesta Station, a street-level station, on Brightwood Road at Mesta Street in Bethel Park on June 6, 2004. This stop was established when the Pittsburgh Railways interurban line from Charleroi to Pittsburgh was opened through Bethel Park on September 12, 1903. (*Kenneth C. Springirth photograph*)

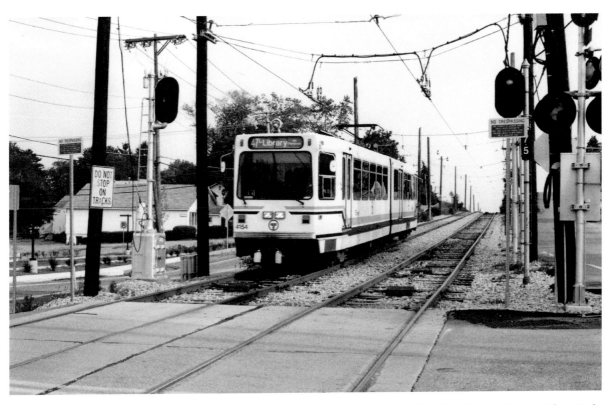

On June 6, 2004, Route 47L light rail vehicle No. 4154, built by Siemens Duewag, is at Lytle Road across the street from Lytle Station in the Municipality of Bethel Park. Lytle station originally was a street level station that later became a high platform station. (*Kenneth C. Springirth photograph*)

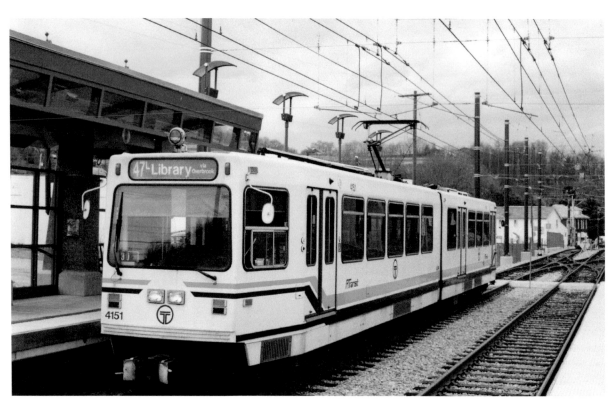

On November 2, 2004, light rail vehicle No. 4151, built by Siemens Duewag, is at the Library Station. With the introduction of the modern larger articulated double-ended cars (beginning with the Siemens Duewag type SD-400 Nos. 4101–4155 that were built during 1985–1987 and the twenty-eight additional light rail vehicles, Nos. 4301–4328, were purchased from CAF), the original loop was removed, and in 2004 a new larger station was built. (*Kenneth C. Springirth photograph*)

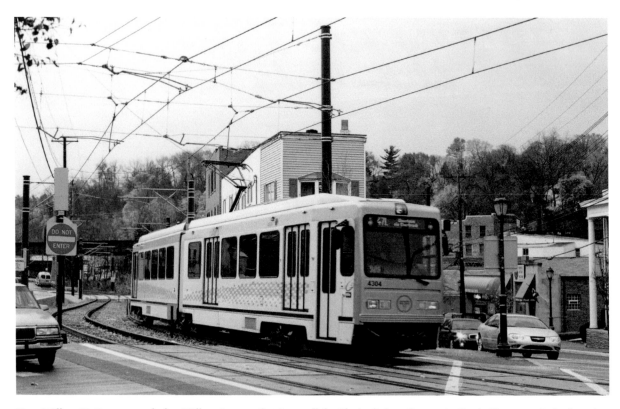

Near Willow Station, named after Willow Avenue that is parallel with the light rail route in Castle Shannon, is the location on November 2, 2004 of Route 47L light rail vehicle No. 4304, built by CAF. Castle Shannon is a suburban community that is served by an excellent light rail system that enhances its livability. (*Kenneth C. Springirth photograph*)

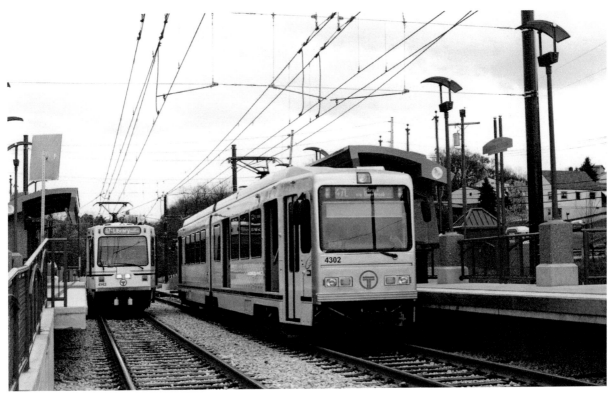

From left to right: PAT Route 47L light rail vehicle No. 4142, built by Siemens Duewag, and Route 47L light rail vehicle No. 4302, built by CAF, are at the Library terminus, southernmost point by rail on the PAT light rail system, on November 2, 2004. This originally was the Pittsburgh Railways interurban line from Pittsburgh to Charleroi, Pennsylvania, that was cut back to Library on June 28, 1953. (*Kenneth C. Springirth photograph*)

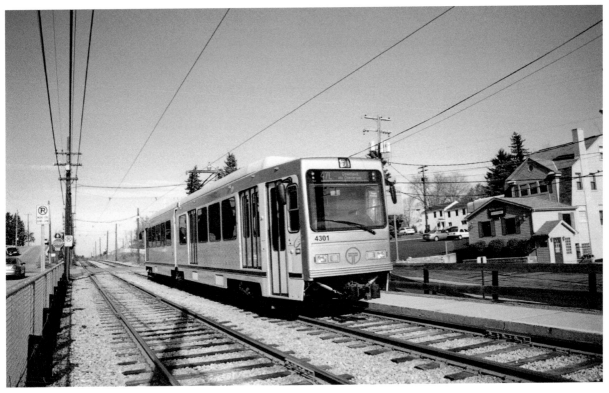

Northbound Route 47L light rail vehicle No. 4301, built by CAF, is at the street-level Mesta stop in Bethel Park on November 11, 2004. (*Kenneth C. Springirth photograph*)

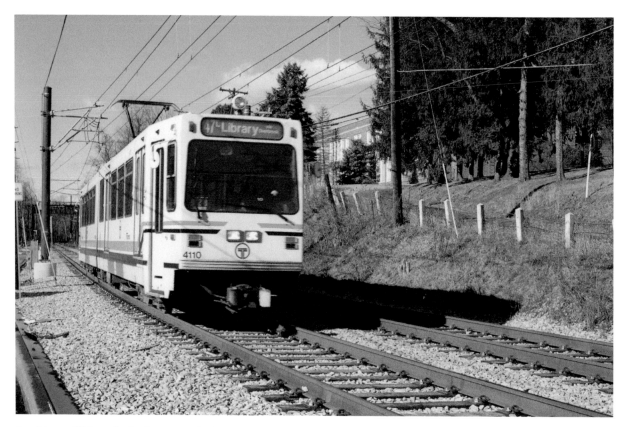

Southbound light rail vehicle No. 4110, built by Siemens Duewag, is approaching the Route 47L Library terminus on December 27, 2004. (*Kenneth C. Springirth photograph*)

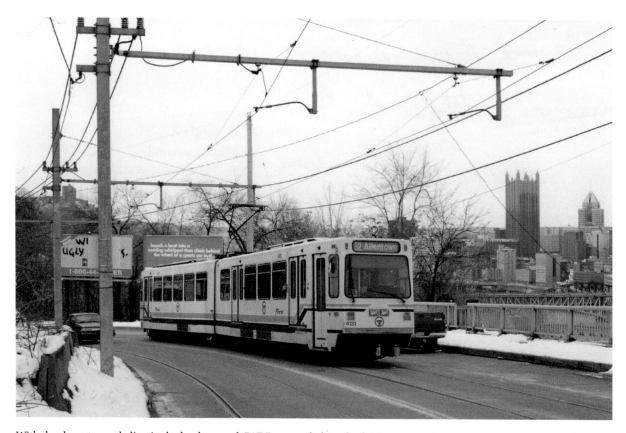

With the downtown skyline in the background, PAT Route 52 light rail vehicle No. 4131, built by Siemens Duewag, is heading on the downward trip via Arlington Avenue to downtown Pittsburgh on March 4, 2005. (*Kenneth C. Springirth photograph*)

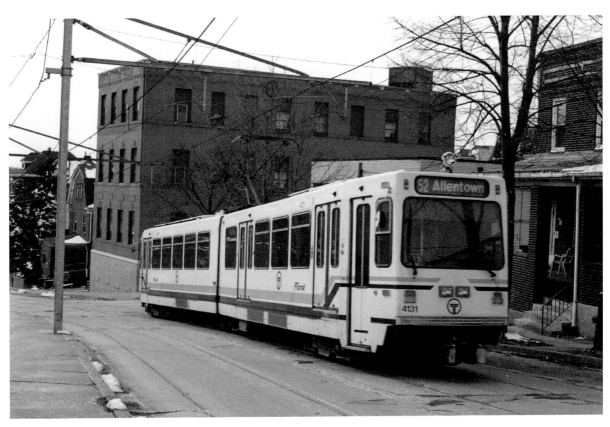

March 4, 2005, East Warrington Avenue at Beltzhoover Avenue is the location of PAT light rail vehicle No. 4131, built by Siemens Duewag, on the Route 52 (Allentown) line. (*Kenneth C. Springirth photograph*)

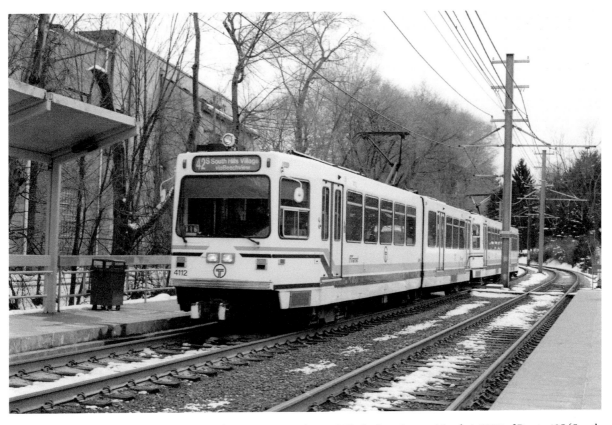

The street-level St. Anne's station in Castle Shannon on March 4, 2005 is the location on March 4, 2005 of Route 42S (South Hills Village via Beechview) light rail vehicle No. 4112, built by Siemens Duewag. (*Kenneth C. Springirth photograph*)

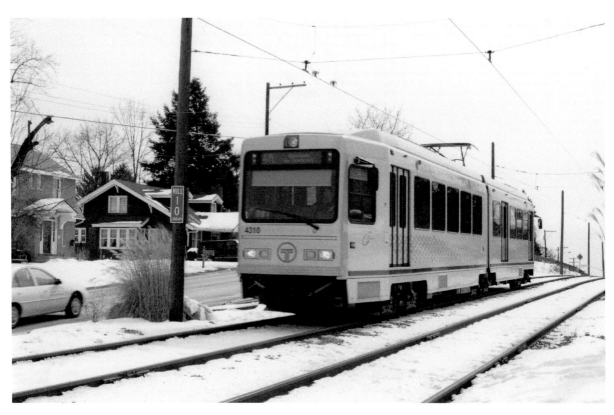

On a snowy March 4, 2005, Route 47L PAT light rail vehicle No. 4310, built by CAF, is south of the Lytle Station. (*Kenneth C. Springirth photograph*)

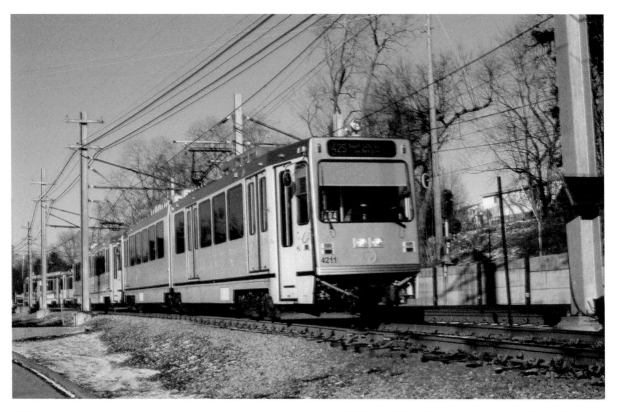

With the ground showing a trace of snow on January 26, 2006, Route 42S (South Hills Village via Beechview) light rail vehicle No. 4211 (originally No. 4111 built by Siemens Duewag, overhauled by CAF, and renumbered 4211) is near Dorchester station which was built to serve the Dorchester Apartments to make public transportation convenient for the apartment residents. (*Kenneth C. Springirth photograph*)

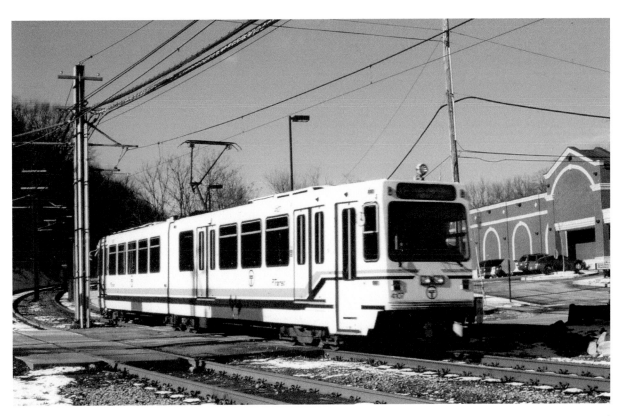

Northbound to Pittsburgh, Route 42S light rail vehicle No. 4107, built by Siemens Duewag, is crossing Mount Lebanon Road near Castle Shannon Boulevard in Mount Lebanon Township on January 26, 2006. (*Kenneth C. Springirth photograph*)

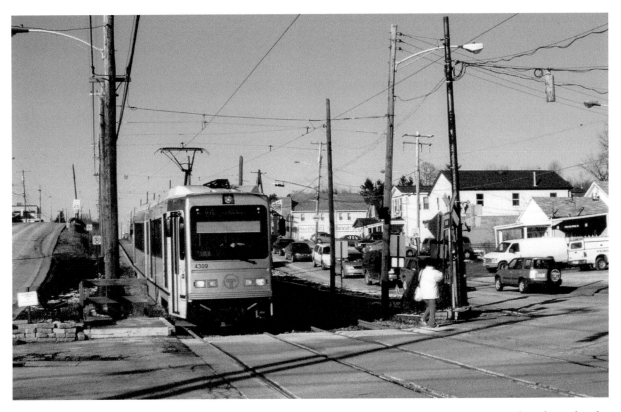

Southbound for Library on January 26, 2006, Route 47L car No. 4309, built by CAF, is ready to cross South Park Road in the Municipality of Bethel Park. One block east of this location at 2600 South Park Road, former Port Authority Transit PCC car No. 4007 that was rebuilt from former Pittsburgh Railways PCC car No. 1729 is on static display outside at the Bethel Park Historical Society Schoolhouse Arts Center that was originally the Bethel Park High School. (*Kenneth C. Springirth photograph*)

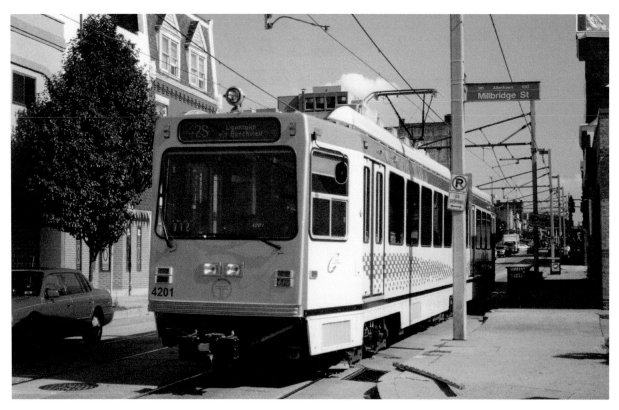

PAT Route 42S car No. 4201 (originally No. 4101 built by Siemens Duewag and rebuilt plus renumbered 4201 by CAF) is on East Warrington Avenue at Millbridge Street in the Allentown neighborhood of Pittsburgh on June 30, 2006. (*Kenneth C. Springirth photograph*)

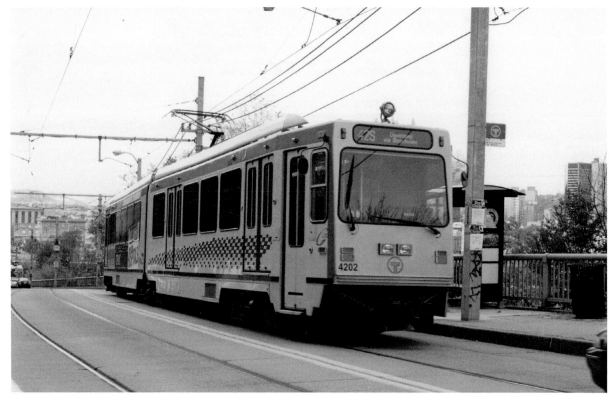

On November 2, 2006, PAT Route 42S light rail vehicle No. 4202 (originally No. 4102 built by Siemens Duewag, rebuilt by Construcciones Y Auxiliar de Ferrocarriles S.A. which in English is "Construction & Other Railway Services" (CAF), and renumbered 4202 is on the tunnel bypass route to Pittsburgh via Arlington Avenue. (*Kenneth C. Springirth photograph*)

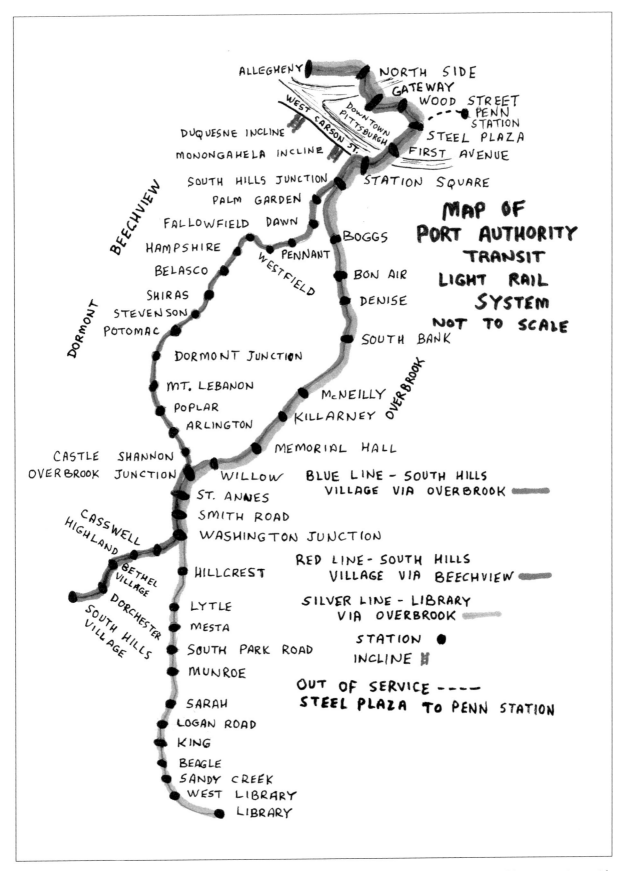

In April 2021, the Pittsburgh Port Authority Transit operates a 26.2-mile light rail system that serves fifty-two stations with three lines as follows: Blue Line–South Hills Village via Overbrook, Red Line–South Hills Village via Beechview, and Silver Line–Library via Overbrook. The section between Steel Plaza Station and Penn Station is currently out of service.

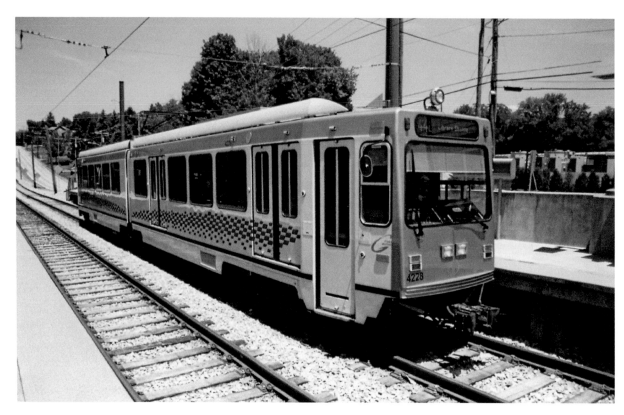

Lytle Station in the municipality of Bethel Park is the location of PAT light rail vehicle No. 4228 (originally car No. 4128 built by Siemens Duewag, rebuilt by CAF, and renumbered 4228) on a northbound trip to Pittsburgh on July 3, 2007. (*Kenneth C. Springirth photograph*)

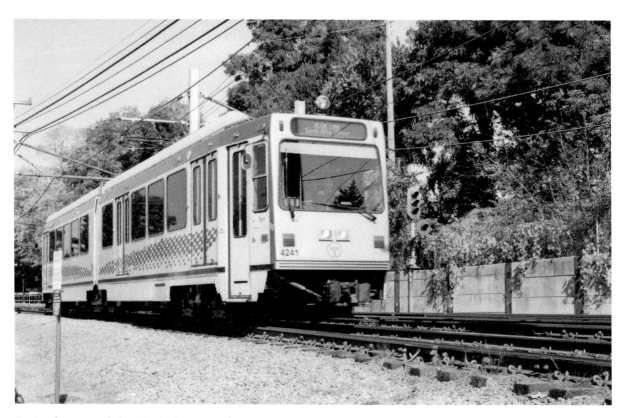

On October 2, 2014, light rail vehicle No. 4241 (originally car No. 4141 built by Siemens Duewag, rebuilt by CAF, and renumbered 4241) has just left Dorchester station heading for South Hills Village. (*Kenneth C. Springirth photograph*)

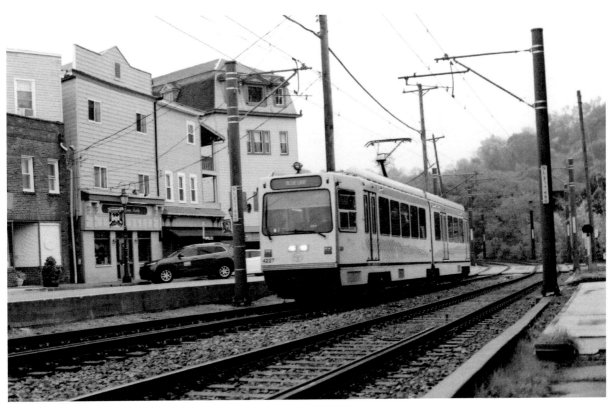

On October 29, 2017, light rail vehicle No. 4227 (originally car No. 4127 built by Siemens Duewag, rebuilt by CAF, and renumbered 4227) is near Willow Station handling a Blue Line trip (formerly Route 47S South Hills Village via Overbrook). (*Kenneth C. Springirth photograph*)

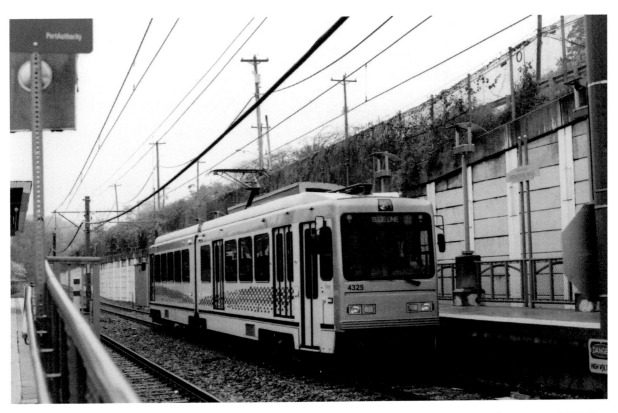

Memorial Hall Station (name comes from a nearby Veterans of Foreign War post) is the location on October 29, 2017 of PAT Blue Line light rail vehicle No. 4325, built by CAF. This station is located in Castle Shannon on the Overbrook branch. PAT leases this station's parking lot from the nearby Castle Shannon Volunteer Fire Department. (*Kenneth C. Springirth photograph*)

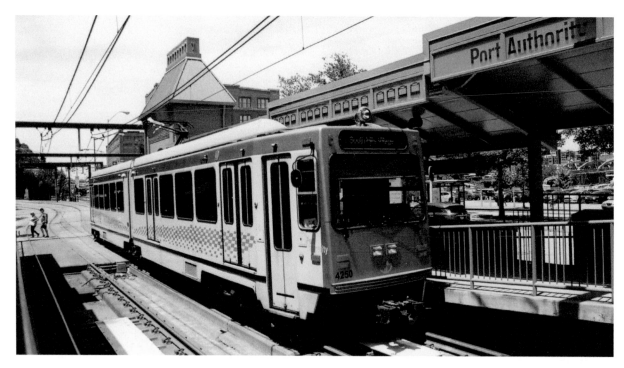

Station Square Station, named for the nearby Station Square development, is the location on June 12, 2019 of PAT light rail vehicle No. 4250 (originally No. 4150 built by Siemens Duewag, rebuilt by CAF, and renumbered 4250). Less than a year earlier on August 5, 2018, a Norfolk Southern Railway freight train derailed east of Station Square Station with derailed freight cars falling down the hillside and damaged 1,600 feet of PAT tracks, 4,000 feet of overhead electrical wires, and some of the concrete on the Panhandle Bridge. Two minutes before the derailment, a PAT light rail vehicle (LRV) had departed from the station. During the track restoration, the Mount Washington Transit Tunnel was closed and LRVs were rerouted via the Arlington–Warrington tunnel bypass trackage. Outbound LRV trackage reopened on August 23, 2018, and inbound LRV trackage reopened on August 25, 2018. (*Kenneth C. Springirth photograph*)

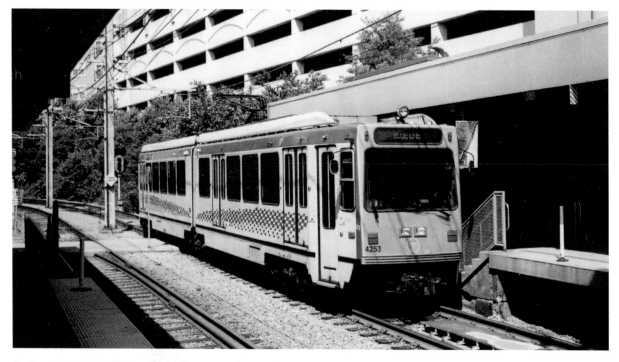

On June 12, 2019, PAT light rail vehicle No. 4253 (originally No. 4153 built by Siemens Duewag, rebuilt by CAF, and renumbered 4253) is at the South Hills Village Station in Bethel Park which is the southern terminus of the Blue and Red Lines. The station (located on the south side of the massive parking garage for suburban commuters that opened on May 1, 2005) is across the street from the South Hills Village shopping center. (*Kenneth C. Springirth photograph*)

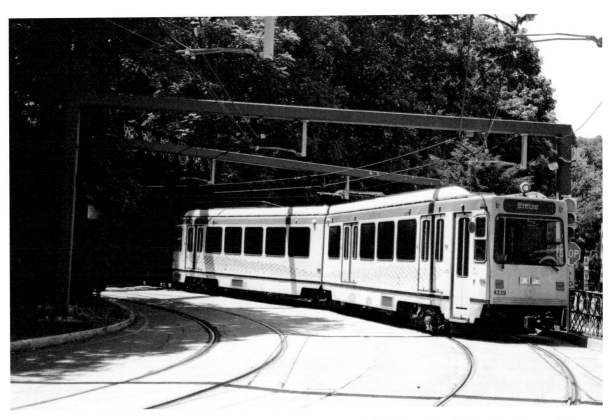

Blue Line (South Hills Village via Overbrook) light rail vehicle No. 4239 (originally car No. 4139 built by Siemens Duewag, rebuilt by CAF, and renumbered 4239) has just left Station Square Station and is turning to enter the Mount Washington Transit Tunnel on June 12, 2019. (*Kenneth C. Springirth photograph*)

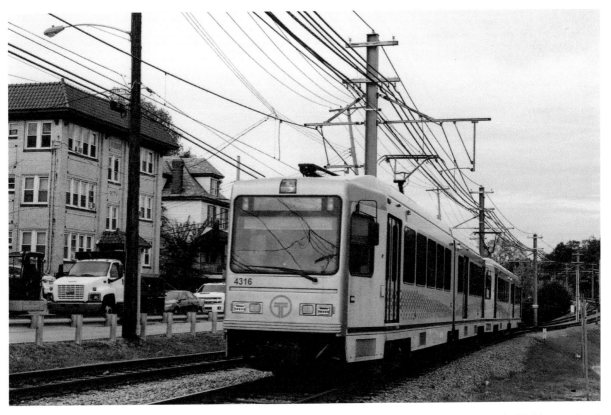

Northbound light rail vehicle No. 4316, built by CAF, is passing the Stevenson Station street level stop in the highly populated area of Dormont on its October 3, 2019 trip to downtown Pittsburgh. (*Kenneth C. Springirth photograph*)

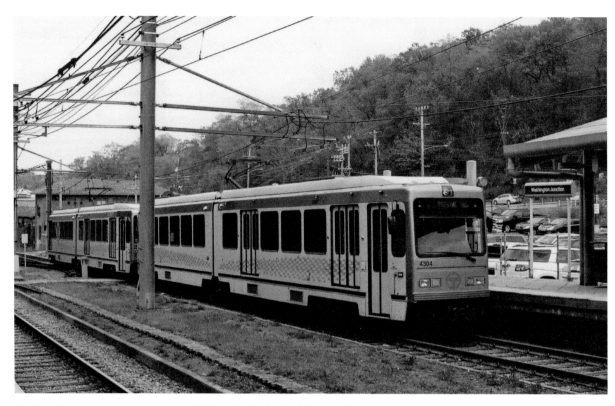

On October 3, 2019, a two-car train of light rail vehicles built by CAF from left to right No. 4302 and 4304 are at Washington Junction Station located in Bethel Park northbound for downtown Pittsburgh. This is a transfer station for passengers from the Library (Silver) Line to the Blue and Red Lines and is a commuter park and ride facility. (*Kenneth C. Springirth photograph*)

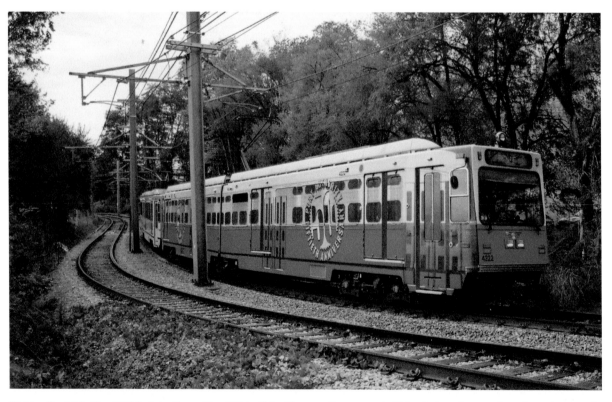

Light rail vehicle No. 4222 (originally car No. 4122 built by Siemens Duewag, rebuilt by CAF, and renumbered 4222), specially painted on October 5, 2014 to resemble the PCC cars that once served Pittsburgh and to commemorate the fiftieth anniversary of Port Authority Transit, which acquired Pittsburgh Railways in 1964, is at the end of a two-car train that has just left Dorchester Station for the South Hill Village Station on October 3, 2019. (*Kenneth C. Springirth photograph*)

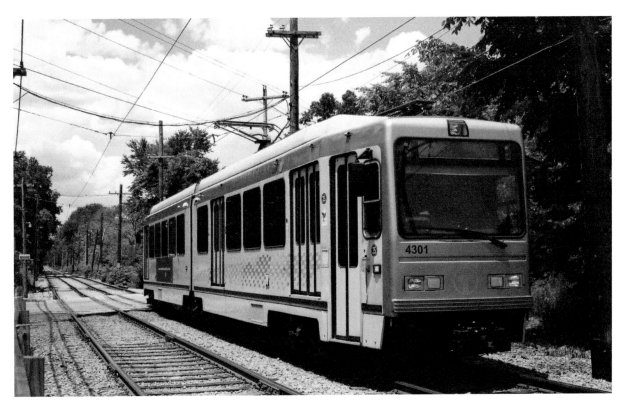

Northbound light rail vehicle No. 4301, built by CAF, has just left West Library Station on June 30, 2020. This station was established when Pittsburgh Railways opened their interurban line from Charleroi to Pittsburgh on September 12, 1903, and today is a park and ride stop. (*Kenneth C. Springirth photograph*)

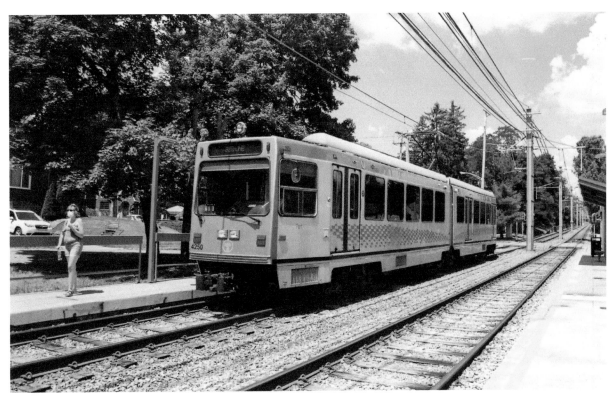

On June 30, 2020, southbound light rail vehicle No. 4250 (originally built by Siemens Duewag as No. 4150, rebuilt by CAF, and renumbered 4250) is at Poplar Station. The passenger who just came off the car is wearing a mask because of the coronavirus epidemic. This street-level stop is located in a Mount Lebanon residential area provides commuters convenient access to downtown Pittsburgh, South Hills, and Library. (*Kenneth C. Springirth photograph*)

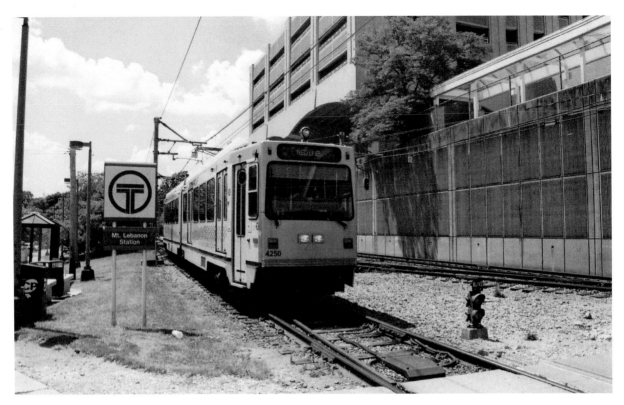

Mount Lebanon station is the location of light rail vehicle No. 4250 (originally built by Siemens Duewag as car No. 4150, rebuilt by CAF, and renumbered 4250) on June 30, 2020. With the completion of the Mount Lebanon Tunnel, this station opened for revenue service on May 24, 1987. In addition to its rail and bus connections, it has a parking lot with space for twenty-four vehicles. (*Kenneth C. Springirth photograph*)

On June 30, 2020, light rail vehicle No. 4317, built by CAF, is ready to cross South Park Road at the center of the road private right of way with Library Avenue on the left and Brightwood Road (that is not in the picture) on the right. (*Kenneth C. Springirth photograph*)

3

PAT Commuter Rail Service

In 1964, the Pennsylvania Railroad ended passenger service on its Pittsburgh commuter lines because of declining ridership. The Baltimore & Ohio Railroad (B&O) operated six weekday round trips from Pittsburgh to Versailles, and the Pittsburgh & Lake Erie Railroad (P&LE) operated one round trip from Pittsburgh to Beaver Falls. Port Authority Transit (PAT) began discussing with the B&O and P&LE about expanding railroad commuter service. With existing loses on the commuter service and declining ridership, both railroads could not justify expanding passenger service. PAT proposed taking over the B&O service. According to PAT, estimated capital costs for a three-year trial in 1974 would be $1.7 million plus $1.9 million in operating costs with an estimated per passenger subsidy of 95 cents. Capital costs would be shared equally between the state and county government to purchase two locomotives and nine coaches. Effective February 1, 1975, the service became PAT Train Mon Valley Commuter Rail operated by the Baltimore & Ohio Railroad and funded by Allegheny County and Pennsylvania Department of Transportation. Daily ridership increased from 300 to 1,400 by mid-1977; however, the per-passenger subsidy was

$2.77, which was almost three times the original estimated 95 cents. PAT renewed the agreement with the B&O plus obtained capital funding for new equipment and a new McKeesport Transportation Center which opened on December 21, 1981. New commuter parking lots were built at Braddock and Versailles plus a new stop was made at Port Vue. The mid-1979 schedule had eight trips in each direction between Pittsburgh and McKeesport of which five trips in each direction continued to Versailles. Although daily ridership reached 1,800 by 1981, it declined below 1,300 by 1983 that may have been caused by more commuters carpooling and economic problems in the Monongahela Valley. April 28, 1989 was the last day of this service. In 2021, PAT operates bus route 61C (McKeesport–Homestead) from downtown Pittsburgh to McKeesport Transportation Center connecting with bus route 60 (Walnut–Crawford Valley via McKeesport Transportation Center to Versailles). Bus route P7 (McKeesport Flyer) operates Monday to Friday except holiday rush-hour service from Pittsburgh via the East busway to the McKeesport Transportation Center.

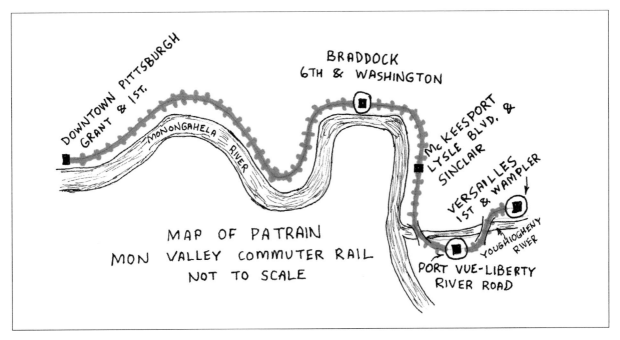

The above map shows the PATrain route with trains for Pittsburgh starting at Versailles crossing the Youghiogheny River via the Pittsburgh & Lake Erie (P&LE) Liberty Boro Bridge stopping at Port Vue-Liberty and crossing the Youghiogheny River again via the P&LE McKeesport Bridge to reach McKeesport. Trains then followed the north bank of the Monongahela River stopping at Braddock and continued west on the north side of the Monongahela River to reach the terminus at the B&O Grant Street at 1st Avenue (commuter-only station) station in Pittsburgh. B&O's intercity trains in the past used the P&LE Station on the opposite side of the river (today known as Station Square).

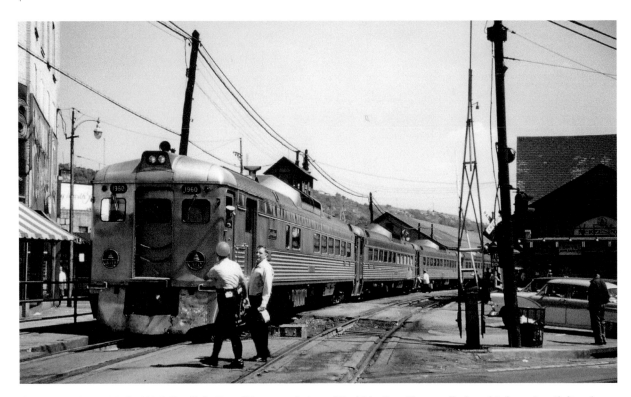

On August 26, 1962, the B&O *Daylight Speedliner* consisting of Budd built self-propelled multiple-unit rail diesel cars (RDC's) headed by No. 1960 model RDC-2 (baggage and passenger coach seating seventy passengers) is making a station stop at McKeesport, Pennsylvania. The *Daylight Speedliner* operated daily each way the 487.3-mile trip from Baltimore to Cleveland stopping at Washington, D.C., Silver Spring, Harpers Ferry, Martinsburg, Cumberland, Connellsville, McKeesport, Pittsburgh, New Castle, and Youngstown. According to the December 1962 *Official Guide of the Railways*, the B&O operated seven daily passenger trains in each direction stopping at Mckeesport and Pittsburgh on the Baltimore–Pittsburgh portion of the route. (*Kenneth C. Springirth photograph*)

At the Grant Street & 1st Avenue Pittsburgh B&O station, the 1:15 p.m. PATrain is awaiting departure time for its October 4, 1975 trip to McKeesport powered by B&O four-axle 1,750-horsepower type GP9 road switcher diesel electric locomotive No. 6604 (originally No. 751 built in April 1955 by Electro-Motive Division of General Motors Corporation [EMD]). This locomotive later became South Branch Valley Railroad No. 6604. (*Kenneth C. Springirth photograph*)

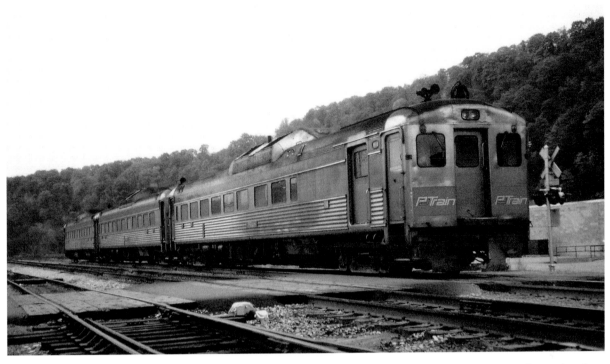

Starting February 1, 1975 the service became PATrain Mon Valley Commuter Rail, and the RDC units were relettered to show PATrain as noted by these cars at the Versailles, Pennsylvania, station on October 23, 1976. The B&O formerly operated twelve type RDC-1 and four type RDC-2 of these self-propelled rail diesel cars built by the Budd Company of Philadelphia. Each RDC had two, under the floor mounted compact diesel engines, which had torque converter drives to power the trucks at the front and back of the car. This made it possible for almost the entire car interior to be available for seats, restrooms, and luggage. (*Kenneth C. Springirth photograph*)

This is a close up view of the October 23, 1976 PATrain at Versailles shown in the top picture of this page with the PATrain logo shown on the side of the RDC. On level track, an RDC could accelerate to 44 miles per hour in sixty seconds, was fuel efficient, and had the ability for a single train to serve multiple destinations by dividing cars *en route*. The two compact General Motors model 110 engines used on the RDC reduced the time required to remove a motor. Even if one engine failed, an RDC can still run at reduced power. (*Kenneth C. Springirth photograph*)

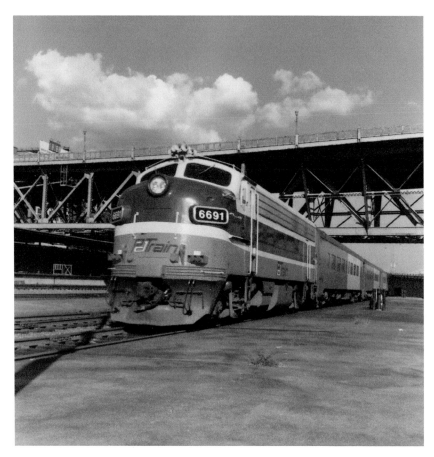

On July 30, 1981, PATrain headed by 1,500-horsepower type F7A diesel electric locomotive No. 6691 (originally built by EMD in May 1953 as No. 365 for the Texas & New Orleans Railroad which merged into the Southern Pacific Railroad on November 1, 1961 with the locomotive number unchanged) is at the Grant Street & 1st Avenue Pittsburgh B&O station. (*Kenneth C. Springirth photograph*)

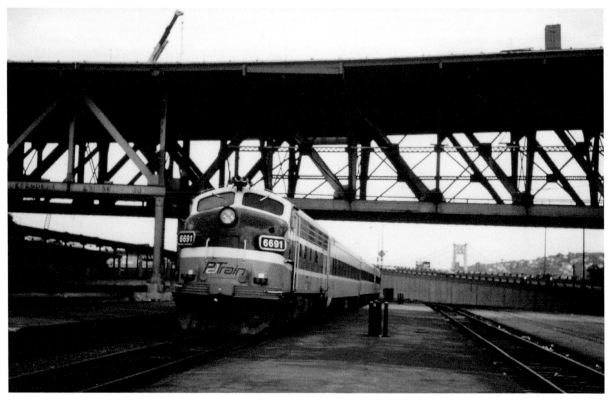

The Grant Street & 1st Avenue Pittsburgh B&O station is the location of PATrain powered by locomotive No. 6691 on June 2, 1983. While the locomotive was painted in an orange, brown, and cream paint scheme, the former Chesapeake & Ohio Railway coaches were painted orange with the upper car body in cream. (*Kenneth C. Springirth photograph*)

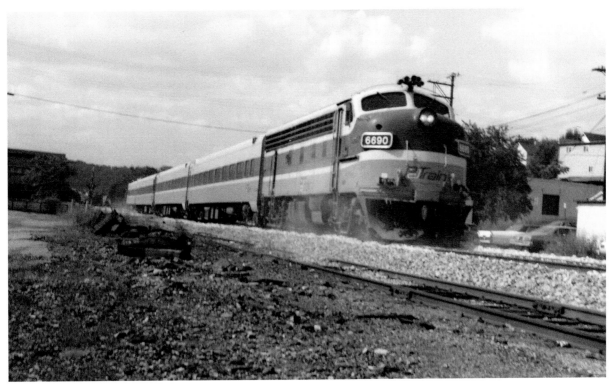

PATrain powered by locomotive No. 6690 type F7A built by EMD for the Southern Pacific Railroad in February 1953 is at the borough of Versailles in Allegheny County, Pennsylvania, on August 4, 1986. Versailles population peaked at 2,754 in 1970, and declined 44.99 percent to 1,515 in 2010 primarily as a result of the decline in steel production in the region. (*Kenneth C. Springirth photograph*)

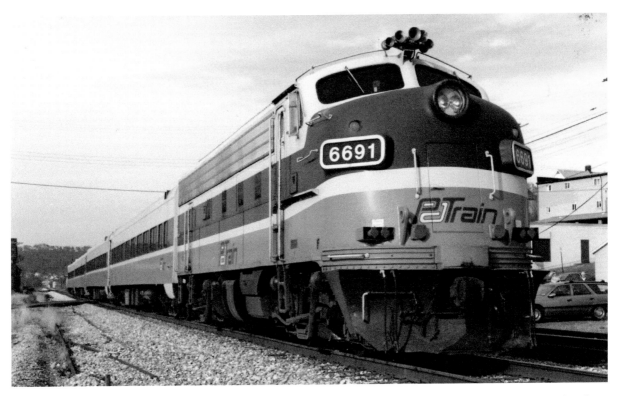

This is the 2:08 p.m. train No. 111, powered by EMD type F7A locomotive No. 6691, ready to leave Versailles for Pittsburgh on November 25, 1988. The April 1952 *Official Guide of the Railways* showed that the Baltimore & Ohio Railroad operated seven local passenger trains in each direction between Pittsburgh and Versailles daily except certain holidays. In addition, a morning commuter train from Connellsville stopped at Versailles on its westbound route to Pittsburgh and an afternoon commuter train from Pittsburgh stopped at Versailles on its eastbound route to Connellsville. (*Kenneth C. Springirth photograph*)

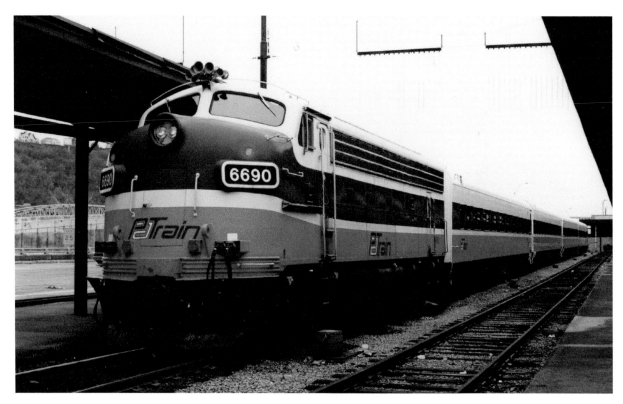

On March 24, 1989, a PATrain is awaiting departure time at the Grant Street and 1st Avenue Pittsburgh B&O station for the trip to Versailles, Pennsylvania, powered by type F7A locomotive No. 6690 built by EMD in February 1953 as No. 6443 for the Southern Pacific Railroad. It later became Wellsville Addison & Galeton Railroad No. 2200, and still later Port Authority of Allegheny County (PAT) No. 6690. (*Kenneth C. Springirth photograph*)

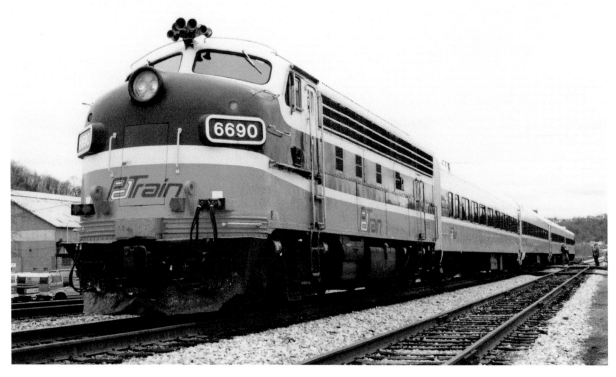

The PATrain in the above picture has completed its March 24, 1989 trip to Versailles, Pennsylvania. With a decline in ridership, April 28, 1989 was the last day of Pittsburgh–Versailles train service. The locomotive became Connecticut Department of Transportation No. 6690. (*Kenneth C. Springirth photograph*)

4
Pittsburgh's Inclines

Monongahela Incline (opened May 28, 1870) was Pittsburgh's first incline (built primarily to haul people, up and down "Coal Hill." which is today Mount Washington) is still in service today operating from its lower level station on 73 West Carson Street just west of the Smithfield Street Bridge to its upper level station at 5 Grandview Avenue at Wyoming Street. As industry in Pittsburgh expanded, there was a need for labor. With industry using most of the flat land along the river, the steep surrounding hillsides were available for housing; however, populating the hillsides was hindered by a lack of public transit. Many of the residents were German immigrants who lived on Coal Hill (today known as Mount Washington) who had steep pathways to ascend and descend the hills, and they proposed that the city build cable car or inclined planes like they had in their former homeland. However, because of the American Civil War, finances were tight. After the end of the Civil War, in 1865, it was proposed and accepted that the Monongahela Inclined Plane Company would build and operate a passenger incline between Monongahela Borough (today Carson Street in Pittsburgh) and Coal Hill (today Mount Washington). The charter was granted in April 1867. Civil engineer J. S. Kirk made the survey and selected two sites: one known as Southern near the Smithfield Street Bridge (later location for Monongahela Incline); the other called Western across from the Point where the Allegheny and Monongahela Rivers meet to form the Ohio River (later location of Duquesne Incline). Both of those locations proved to be excellent choices with both inclines surviving due to their excellent location. The Monongahela Incline was designed by John J. Endres (a civil engineer born in Prussia and brought in from Cincinnati, Ohio) who was assisted by his daughter Caroline Endres (one of the first female engineers in the United States). In addition, engineer Samuel Diescher, born in Hungary, assisted in the project. Jones & Laughlin (later known as Jones & Laughlin Steel Corporation) manufactured the iron rail track for the incline. Iron City Bridge Company built the iron bridge supporting the incline as it passed over railroad tracks (originally Pittsburgh, Virginia & Charleston Railway that merged into the Pennsylvania Railroad on April 1, 1905; became Penn Central Transportation Company on February 1, 1968; Consolidated Rail Corporation on April 1, 1976; and since June 1, 1999 Norfolk Southern Railway) near the lower station. Wire rope cable was designed by John A. Roebling. The incline (owned by the Monongahela Plane Company) opened on Saturday May 28, 1870 at 3 p.m., functioned perfectly, and operated free to the public until closure at 8 p.m.

According to the American Society of Mechanical Engineers May 11, 1977 *National Historic Mechanical Engineering Landmarks*, this incline (the oldest continuously running incline in the United States) is 640 feet long, elevation of 370 feet, grade of 38 degrees, track gauge of 5 feet, and operates at a speed of 6 miles per hour. Even though one car ascends while the other car descends, each car has a separate hoisting rope and drum. The cast-iron drums are 8.33 feet in diameter, and the crucible steel hoisting rope (having an average life of five to seven years) is 1.25 inches in diameter with a speed of approximately 600 feet per minute. A same size safety rope passes over a single large sheave at the top, from one car to another. The success of this incline resulted in the construction of other inclines in Pittsburgh.

As noted in *Pittsburgh Inclines* in ERA Headlights April 1956, the original steam engine power system was replaced by an Otis electrical system in 1935 "consisting of two 50 horsepower motors running on 120 volts DC driving one cable, with braking accomplished automatically on this cable when the power is shut off." Each passenger car weighs 7 tons and can carry about twenty-five total passengers. Since 1964, it has been owned and operated by Port Authority Transit (PAT), which operates Allegheny County's trolley and bus system. Free transfers can be made between this incline with PAT buses and light rail system. The Pittsburgh History and Landmark Foundation declared the incline a historic structure in 1970, and in 1977 the incline was added to the National Register of historic Places. In 1975, its ridership was 460,126. Original incline passenger cars were replaced in 1995. In 2015, the incline received a $3.5 million renovation with passenger cars refurbished, plus upgrades were made to the rails, ties, cable, and various lift components. With a one-way trip taking less than two minutes, this incline is the best way for many residents in the Mount Washington neighborhood of Pittsburgh to get to their jobs, shopping and entertainment plus it is a well-known tourist attraction. The lower-level station is a short distance from the PAT light rail system's Station Square Station plus the Station Square shopping complex. It should be noted that PAT operates the route 40 bus (a former trolley car route) that connects downtown Pittsburgh to both the Monongahela and Duquesne Inclines.

Monongahela Freight Incline (opened on March 31, 1884 and closed in 1935 due to a decline in business) was adjacent to and parallel to the Monongahela Incline serving Mount Washington. Designed by Samuel Diescher and John Endres (this incline built with a 10-foot track gauge that could handle vehicles and passengers) was parallel to the smaller original Monongahela Incline and was owned by the Monongahela Incline Plane Company.

Duquesne Incline (opened May 20, 1877), located about one mile west of the Monongahela Incline, is still in service today from its lower station at 1197 West Carson Street across the Monongahela River from the Point to its upper-level station (which houses a museum of Pittsburgh history) at 1220 Grandview Avenue between Oneida Street and Cohassett Street, which provides a magnificent view of the place where the Monongahela and Allegheny Rivers converge to form the Ohio River. This incline (owned by the Duquesne Incline Plane Company) was built to carry cargo up and down Mount Washington and later carried passengers. The incline structure was originally part wood and part iron and was rebuilt entirely by iron in 1888. Designed by Samuel Diescher, the 793-foot-long incline has an elevation of 400 feet, grade of 30 degrees, track gauge of 5 feet, and operates at a speed of 4.03 miles per hour. Like the Monongahela Incline, the Duquesne Incline passes over railroad tracks (originally Pittsburgh, Virginia & Charleston Railway that merged into the Pennsylvania Railroad on April 1, 1905 and since 1999 is the Mon line of the Norfolk Southern Railway) near the lower station. With a decline in passengers and a need for repairs, the incline closed in 1962. Residents of Pittsburgh's Duquesne Heights' neighborhood conducted a successful fundraiser, and the incline reopened on July 1, 1963 by the non-profit Society for the Preservation of the Duquesne Heights' Incline formed for its preservation and rents the incline for $1 a year from its owner PAT. The incline and its cars, built by J. G. Brill & Company, have been refurbished. Volunteer mechanics and engineers overhauled the incline machinery. Volunteer craftsmen refurbished the incline cars original hand-carved cherry panels with their maple trim and handsome hardware. Upper and lower incline waiting rooms were refurbished. In 1975, its ridership was 575,022. The Duquesne Incline provides residents and tourists a spectacular view of Pittsburgh.

Kirk Lewis Coal Incline/Hoist (1854–1870) was on Grandview Avenue near the present Duquesne Incline. It was named for Abraham Kirkpatrick Lewis a pioneer coal miner in Pittsburgh who made his living in coal mining and was the first to supply Pittsburgh coal to New Orleans. Coal came from a hillside mine and was lowered to the Pittsburgh, Cincinnati & St. Louis Railroad (PC&SL) at the lower level where it was transported via the PC&SL to many glass, steel, and iron plants along the Ohio River.

Cray & Company Coal Incline (late 1800s) had the upper station near Junius Street and Camden Street to lower station at Shaler Street in the West End Valley.

Clinton Iron Works Coal Incline (late 1800s) was on Hillside below Maple Terrace to West Carson Street near the present Station Square. It transported coal directly to the Clinton Industries located around the Monongahela River.

Jones & Laughlin Coal Incline (late 1800s) was a 1,300-foot-long incline in Pittsburgh that connected a coal mine to the J&L iron making facility. It operated from its lower level on Josephine Street between South 29th Street and South 30th Street to Sumner Street at its upper level.

Kneeling Coal Incline (1870–1928) was located on the South 12th Street–Southside slopes between the Mount Oliver and Knoxville Inclines. Coal was transported from a mine shaft to an upper loading platform. Then cable cars descended along tracks that went under Birmingham (today Brosville) Street and on an elevated platform where coal was dumped into coal cars of the Pittsburgh, Virginia & Charleston Railway (later Pennsylvania Railroad).

Knoxville Incline (Opened August 15, 1890 and closed December 3, 1960) was 2,644 feet long (longest incline track in Pittsburgh and also known as the Pittsburgh Incline, 11th Street Incline, or 12th Street Incline) with a track gauge of 9 feet and an 18-degree curve at its midpoint (designed by John H. McRoberts) operated from its lower station on Bradish Street between 11th and 12th streets in Pittsburgh's South Side neighborhood rising 375 feet up to its upper station at Warrington and Arlington Avenue in Pittsburgh's Allentown neighborhood. Both the Knoxville Incline and Nunnery Hill Incline had guide wheels along the curve to guide the cables. This incline carried people and freight, and along with the Mount Oliver Incline enabled land development in Allentown and surrounding neighborhoods. Each incline car weighed about 10 tons, seated twenty passengers in a heated section, and could carry two vehicles.

Mount Oliver Incline (opened in 1871 and closed on July 6, 1951 at 7 p.m.), also known as the South Twelfth Street Incline, operated from its lower station on Freyburg Street near 12th Street in Pittsburgh's South Side up to Warrington Avenue in Mount Oliver. The incline had a length of 1,600 feet, a rise of 380 feet, and a track gauge of 5 feet laid with 20-pound rail.

Fort Pitt Incline (opened in 1882 and closed on November 7, 1900) operated from its lower level from 2nd Avenue near the north end of the Tenth Street Bridge to its upper level at Bluff and Magee Streets near Mercy Hospital in the Bluff neighborhood of Pittsburgh on the north side of the Monongahela River southeast of Pittsburgh's central business district. Designed by Samuel Diescher and owned by the Fort Pitt Incline Plane Company, this incline was 350 feet long with a vertical rise of 135 feet and a track gauge of 10 feet.

Penn Incline (also known as the 17th Street Incline opened on March 1, 1884 and closed on November 30, 1953 at 6 p.m.) operated from its lower-level station on 17th Street between Penn and Liberty Avenues (in Pittsburgh's Strip District) over Liberty Avenue, Bigelow Boulevard, Pennsylvania Railroad to its high level on Arcena (today Ridgeway) Street near Ledie Street in Pittsburgh's Hill District. The incline was 840 feet long and had a track gauge of 10 feet. At the upper level, an entertainment hall was built called the Penn Incline Resort to boost business. Initially popular, it went into decline and the building was destroyed by fire in 1892. Designed by Samuel Diescher to hoist 20-ton loads of coal to the hilltop, the coal traffic did not meet expectations; however, railroad and business activity in the Strip District provided enough customers to keep the incline in operation until the end of World War II when business declined to fifty customers per day. Incline service was reduced to three hours in the morning and four hours in the afternoon. Pittsburgh Railways, the incline's last owner, asked the Pennsylvania Public Utilities Commission for permission to abandon it. There was no opposition,

and the incline shut down on November 30, 1953. Demolition of the incline was completed on October 1, 1956.

St. Clair Incline (opened on March 5, 1888 closed in 1932) owned by the St. Clair Incline Plane Company (also known as the South 22nd Street Incline) operated from its lower level near the intersection of South 22nd Street and Josephine Street and travelled 1,372 feet with a rise of 370 feet to the upper level on Salisbury Street between Fernleaf Street and Sterling Street. Designed by engineer J. H. Mc Roberts, the 2,060-foot-long incline had a vertical rise of 361 feet. It became increasingly steeper towards the top like a parabolic arc.

Bellevue and Davis Island Incline (1887–1893) owned by the Bellevue & Davis Island Incline Plane Company operated from its lower-level steel outdoor elevator (in Bellevue Borough northwest of downtown Pittsburgh near the Bellevue Station of the Pittsburgh, Fort Wayne & Chicago Railroad) that carried passengers about 85 feet to the top of the bluff. From this spot, an electric street railroad took passengers on a twisting uphill ride and then along a straight stretch of Sherman Avenue (today South Jackson Avenue) to the upper-level station at Lincoln Avenue.

Nunnery Hill Incline (opened June 23, 1888 and closed September 13, 1895) owned by the Nunnery Hill Incline Plane Company operated from Federal Street at Henderson Street in the North Side up to Catoma Street near Meadville Street in the Fineview neighborhood of Pittsburgh. Designed by Samuel Diescher, it was 1,100 feet long, featured a 250-foot radius curve, and had a 5-foot track gauge.

Troy Hill Incline (opened on September 20, 1888 and closed in fall 1898) owned by the Troy Hill Incline Plane Company operated from its lower level on Ohio Street near end of the 30th Street Bridge and climbed Troy Hill to its high-level terminus on Lowrie Street at Ley Street on the crest of Troy Hill on the north side of Pittsburgh. The incline was 370 feet long with a 47-percent gradient. Not very profitable, it shut down in 1898.

Ridgewood Incline (opened on December 16, 1886 and closed on May 30, 1887) owned by the Ridgewood Incline Plane Company operated from its lower level on Charles Street North near Nixon Street and made a steady rise travelling 331 feet to its high level on Ridgewood Street at Yale Street in the Perry South (also known as Perry Hilltop) neighborhood in Pittsburgh's North Side. This was Pittsburgh's shortest-lived incline having been destroyed by a May 30, 1887 fire that destroyed the incline's engine house, office and about 30 to 40 feet of track.

Clifton Incline (opened 1895 and closed November 10, 1905 after an accident in which an empty passenger car broke loose, went down the track, and smashed in a home on Sarah Street with no casualties) operated from its lower-level Sarah Street (later Strauss Street) and Myrtle Street on the North Side (north of the Allegheny and Ohio River in what is today the Perry Hilltop also known as the Perry South neighborhood of Pittsburgh) up to its upper level at Clifton Park and was owned by the Clifton Avenue Incline Plane Company. The incline was cofounded by businessman William McCreery to improve access to a residential neighborhood. This incline had only one passenger car that was operated by a single operator handling the duties of operator and conductor. The other car was used as a counterbalance.

Pittsburgh & Castle Shannon Coal Incline operated from Carson Street to about Lava Street. Passenger service began around 1872 using the Coal Incline and Tunnel. Castle Shannon Inclines No. 1 and No. 2 replaced the Coal Incline and Tunnel by 1892.

Castle Shannon Incline No. 1 (opened August 26, 1890 and closed June 21, 1964) operated from its lower station on East Carson Street just west of Arlington Avenue to the upper station at Bailey Avenue just west of Haberman Avenue in Mount Washington. Unable to handle the weight of large freight and passenger cars, the original machinery was replaced, and the repaired incline reopened on March 7, 1891. It had a track length of 1,375 feet and a track gauge of 10 feet. This was part of the Pittsburgh & Castle Shannon Railroad (P&CS) route from Pittsburgh to Castle Shannon. P&CS steam railroad passenger service was replaced by Pittsburgh Railways electric trolley cars that operated through the Mount Washington tunnel in 1909. Development of a residential area on the top of Mount Washington kept No. 1 in operation longer than No. 2.

Castle Shannon Incline No. 2 (opened August 20, 1892 and closed 1914) operated from its lower station at Warrington Avenue to its top station at Bailey Avenue (adjacent to the Castle Shannon Incline No. 1) in Mount Washington. It had a track length of 2,562 feet and a track gauge of 3 feet 4 inches.

Norwood Incline (opened September 7, 1901 and closed 1923) operated from the lower station on Island Avenue near Adrian Street just outside of Pittsburgh in McKees Rocks to its upper station on Desiderio Avenue between McKinnie Avenue and Highland Avenue in Stowe Township. In its first two years, free rides were given to entice new residents to hillside lots available around McKees Rocks. After that two-year period, a 1 cent fare was charged.

Kund and Eiben Incline (opened in 1915 and closed in 1929 after Saw Mill Run Boulevard was completed) was a short incline along Saw Mill Run in Bon Air owned by the Kund and Eiben Manufacturing Company that operated a wood planing mill alongside a creek near Bausman Street. The top level of the incline was next to the Pittsburgh & West Virginia Railroad (P&WVRR) tracks on a hillside high above the creek. A hoist moved materials to and from P&WVRR freight cars on that hill. The incline carried raw and finished wood products and later materials for a concrete fabrication plant. This incline was dismantled in 1929 after completion of Saw Mill Run Boulevard.

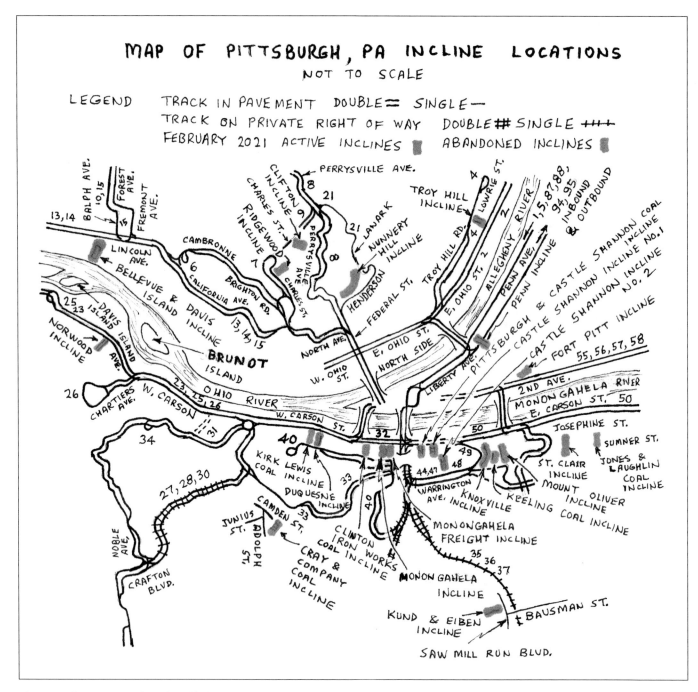

This map shows many of Pittsburgh's former inclines including access by former Pittsburgh Railways trolley car routes. Bellevue & Davis Island Incline was served by trolley Routes 10, 13, 14, and 15. Ridgewood Incline was served by Route 7. Clifton Incline was served by Route 9. Nunnery Hill Incline was served by Routes 8 and 21. Troy Hill Incline was served by Routes 2 and 4. Penn Incline was served by Routes 1, 5, 87, 88, 94, and 95. Norwood Incline was served by Routes 23 and 25. Fort Pitt Incline was served by Routes 55, 56, 57, and 58. St. Clair Incline and Jones & Laughlin Coal Incline were served by Route 50. Knoxville Incline was served by Routes 48 and 49. Keeling Coal Incline and Mount Oliver Incline were served by Route 48. Pittsburgh & Castle Shannon Coal Incline and Castle Shannon Incline No. 1 were served by Routes 49 and 50. Castle Shannon Incline No. 2 was served by Routes 44, 47, 48, and 49. Kirk Lewis Incline, Duquesne Incline, Clinton Iron Works, Monongahela Incline, and Monongahela Freight Incline were served by Route 40 on the upper level and numerous routes on the lower level. Kund & Eiben Incline was served by Routes 35, 36, and 37. Cray & Company Coal Incline was served by Route 33. In 2021, only the Duquesne Incline and Monongahela Inclines remain in operation.

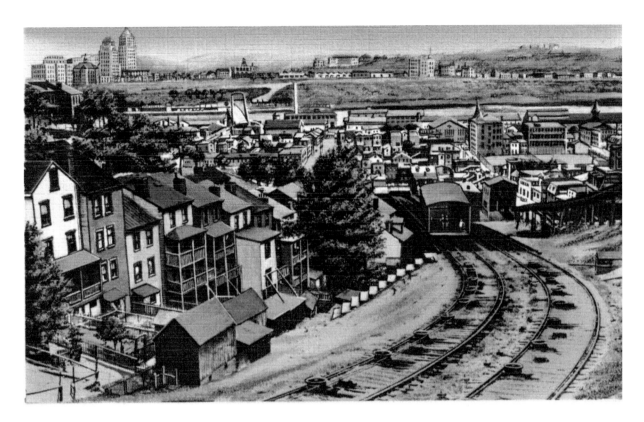

Above: In this early postcard view of the Knoxville Incline also known as the Pittsburgh Incline, 11th Street Incline, and 12th Street Incline, this was an important means of transportation for workers to get from their hillside homes to industrial plants located along the river valley in Pittsburgh when opened August 15, 1890. A large percentage of Pittsburgh's labor force was from Germany which had many cable car systems in their mountainous areas. Many of these residents suggested that inclines should be built.

Right: Shown in this postcard, the Knoxville Incline was Pittsburgh's second incline built with a curve and served the South Side while the Nunnery Hill Incline, on Pittsburgh's northside Fineview neighborhood, was Pittsburgh's first incline built with a curve. Inclines yesterday and today are good for topographical challenges. They can be an effective feeder system plus close hard to fill gaps in transit systems.

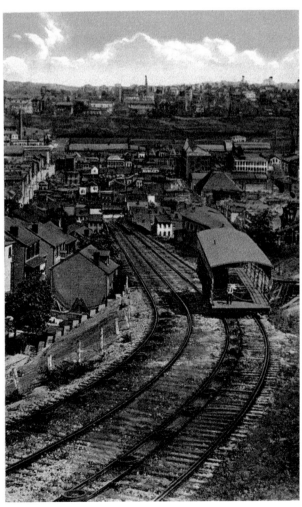

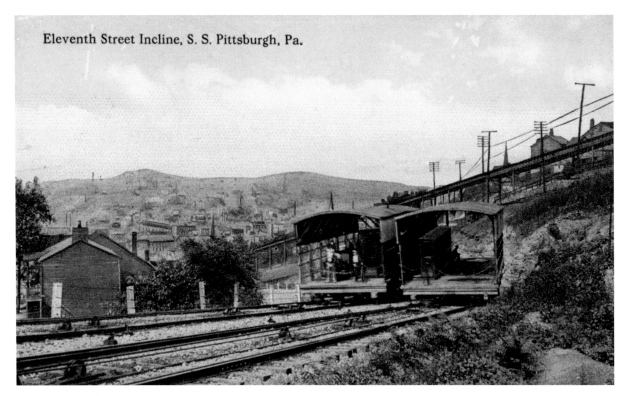

Two large incline cars (designed to handle both passengers and freight) are passing in this postcard view in this vintage postcard view of the Knoxville Incline. In addition to its curve, this incline once took part in the annual Memorial Day parade with the parade forming on the South Side, participants took the incline to the top of the hill, and regrouped to march to the South Side Cemetery.

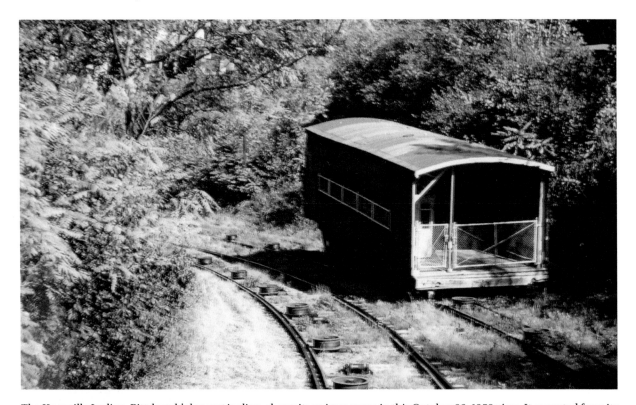

The Knoxville Incline, Pittsburgh's longest incline, shows its unique curve in this October 26, 1959 view. It operated from its lower station on Bradish Street between 11th and 12th Streets in Pittsburgh's South Side neighborhood to its upper station at Warrington and Arlington Avenue in Pittsburgh's Allentown neighborhood. Its December 3, 1960 closure left only the Monongahela and Duquesne Inclines in Pittsburgh. (*Kenneth C. Springirth photograph*)

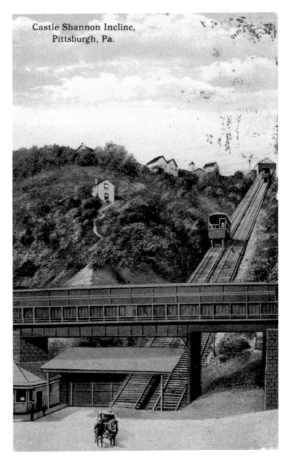

In this postcard postmarked March 14, 1913, a horse-drawn vehicle is on East Carson Street at the front of the Castle Shannon Incline No. 1 in Pittsburgh.

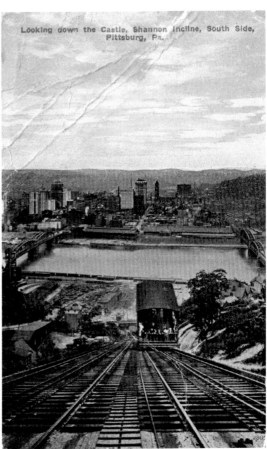

At the upper level, the postcard postmarked July 24, 1913 shows a view looking down the Castle Shannon Incline No. 1 as a car goes down with the Monongahela River and Pittsburgh skyline in the background.

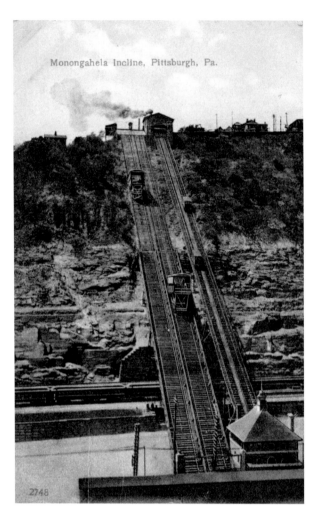

Monongahela Incline, Pittsburgh, Pa.

Left: In this postcard postmarked October 15, 1908, the larger cars of the Monongahela Freight Incline are on the left and parallel to the smaller cars of the Monongahela Incline on the right used for passenger service. Both inclines passed over the Pennsylvania Railroad whose passenger cars are in view. The Pennsylvania Railroad became part of the Penn Central Transportation Company on February 1, 1968, which became part of Consolidated Rail Corporation on April 1, 1976, and part of Norfolk Southern Railway on June 1, 1999. While the freight incline closed in 1935, the passenger incline continues to daily operate between its lower station at 73 West Carson Street and upper station at 5 Grandview Avenue.

Below: A car of the Monongahela Freight Incline is coming up with the structure of the Monongahela Incline parallel and to the left in this postcard postmarked February 10, 1913. In the upper right of the picture is the Smithfield Street Bridge over the Monongahela River and the tall building is the Pittsburgh & Lake Erie Railroad (P&LE) passenger station, which served its last passenger train on July 12, 1985. The Monongahela Incline, P&LE passenger station, and Smithfield Street Bridge were awarded Pittsburgh History & Landmarks Foundation plaques in 1970.

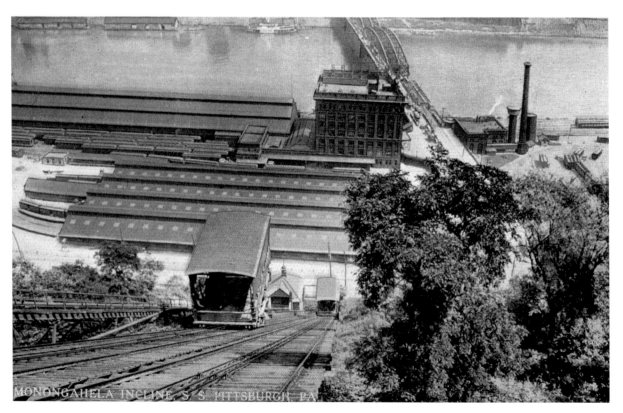

MONONGAHELA INCLINE, S. S. PITTSBURGH, PA.

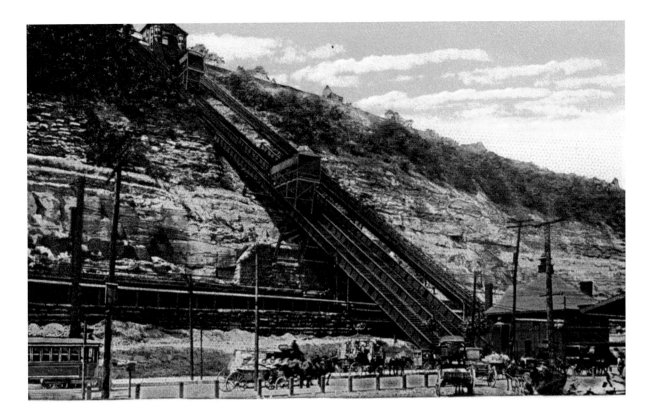

Above: In this postcard scene of the Monongahela Freight Incline alongside the Monongahela Incline, a portion of a Pittsburgh Railways Route 50 (Carson Street) trolley car is operating on East Carson Street near Smithfield Street. Passengers riding the Monongahela Incline from Mount Washington had excellent east and west trolley car connections on Carson Street plus numerous trolley car connections on Smithfield Street north across the Monongahela River to downtown Pittsburgh and south to a variety of Pittsburgh neighborhoods and the interurban lines to Washington, Charleroi, Roscoe, and Donora.

Right: The large car is at the top of the Monongahela Freight Incline (built to provide efficient transport of goods) while two smaller incline cars of the parallel Monongahela Incline (used for passenger service) are shown in this postcard view taken from the lower level on Carson Street. From Smithfield Street and Carson Street, this postcard provides a nice view of the Monongahela Freight Incline and the Monongahela Incline. This portion of Smithfield Street was served by Pittsburgh Railways trolley car Routes 35 (Library), 36 (Drake), 37 (Shannon), 38 (Mt. Lebanon), 39 (Brookline), 40 (Mt. Washington, 42 (Dormont), 43 (Neeld Avenue), 44 (Knoxville), 47 (Carrick via Tunnel), 48 (Arlington), 49 (Beltzhoover, and 50 (Carson St.).

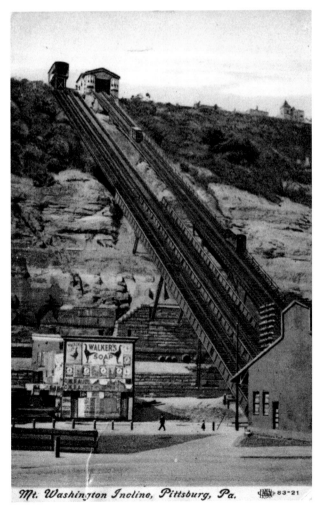

Mt. Washington Incline, Pittsburg, Pa.

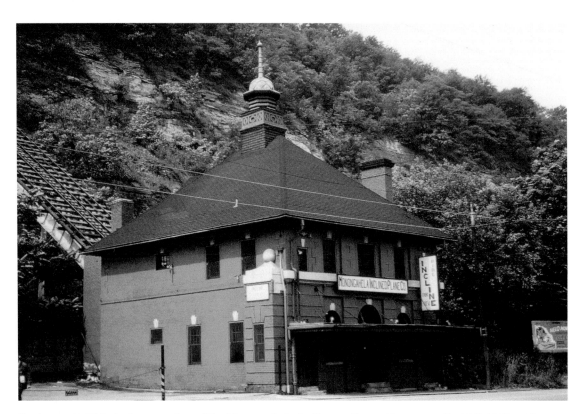

On August 3, 1963, the lower station of the Monongahela Incline on Carson Street near Smithfield Street is a two story Second Renaissance Revival-style building with a four-sided roof, and the front of the building has an arch above the door and first floor windows. With the steep incline behind it makes it easy to understand why this incline continues to be popular with residents who live in Mount Washington as well as tourists who visit Pittsburgh to see its unique attractions. (*Kenneth C. Springirth photograph*)

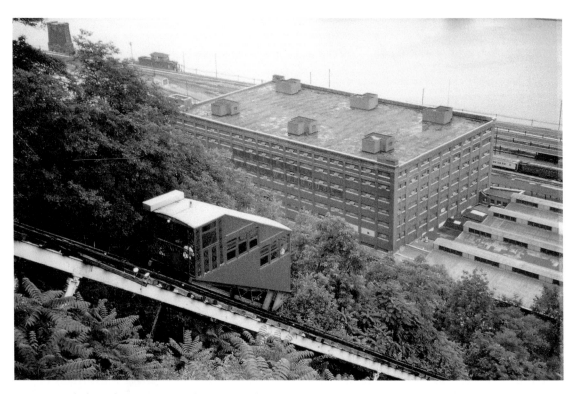

A Monongahela Incline car is providing a smooth, quiet, and quick ride connecting the lower level at Carson Street with the upper level at Grandview Avenue in this August 3, 1963 scene. The view at the top has contributed to making this a very desirable Pittsburgh neighborhood. (*Kenneth C. Springirth photograph*)

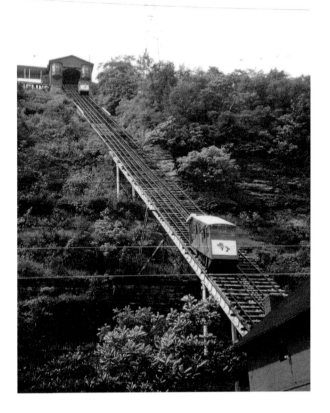

Right: On August 3, 1963, one car is approaching the bottom station while the other car is approaching the top station on the 38-degree angle of the Monongahela Incline. Built at a cost of $50,000, this incline has transported millions of people since it opened on May 28, 1870. It opened up Mount Washington enabling residents to live hundreds of feet above the city and have excellent access to businesses and factories along the river. (*Kenneth C. Springirth photograph*)

Below: The red and cream paint scheme of the Monongahela Incline cars of the top-page picture has been superseded by a cream and light brown paint scheme in this June 12, 2019 view looking up from the Carson Street station. According to the American Public Transportation Association (APTA), Pittsburgh's incline ridership increased 10.73 percent from 1,132,000 in 2011 to 1,253,500 in 2012. However, as a result of the coronavirus epidemic, ridership decreased 15.77 percent from 1,202,600 in 2018 to 1,013,000 in 2019. (*Kenneth C. Springirth photograph*)

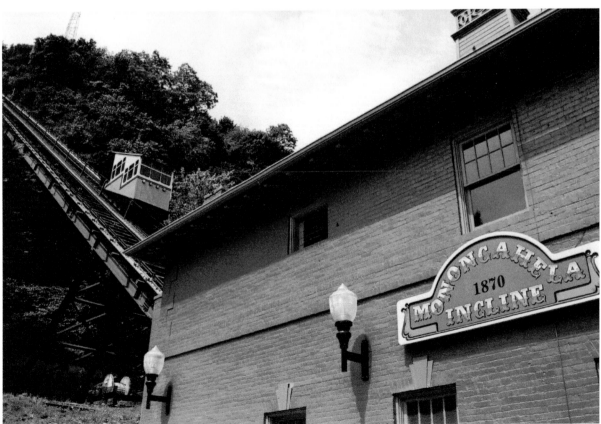

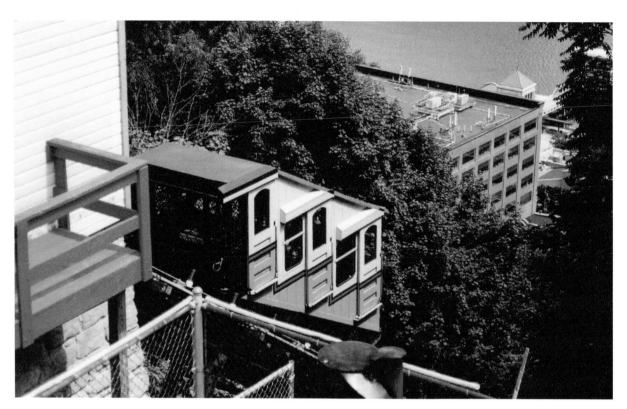

On a sunny June 12, 2019, the Monongahela Incline car displays its three-level compartment design. Each of the three-level compartments is horizontal. The two lower compartments are closed and the upper compartment is open. (*Kenneth C. Springirth photograph*)

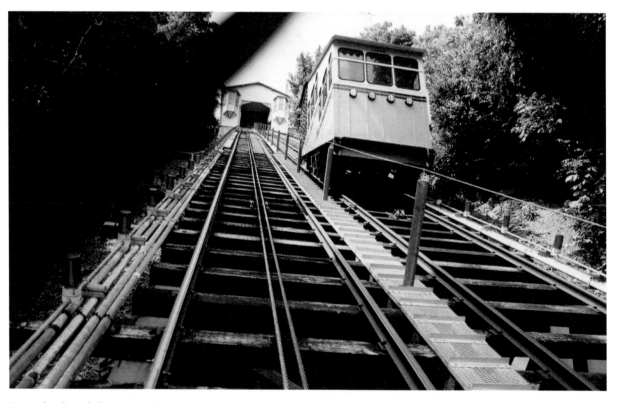

From the downhill Monongahela Incline car with one of the three levels open, the upward car passes on June 12, 2019. In 1935, electrical equipment replaced steam engines. During 1982 and 1983, the structure, lower station, and cars were rehabilitated. The upper station was restored, motor plus braking systems were rebuilt, and the cars became wheelchair accessible in 1994. (*Kenneth C. Springirth photograph*)

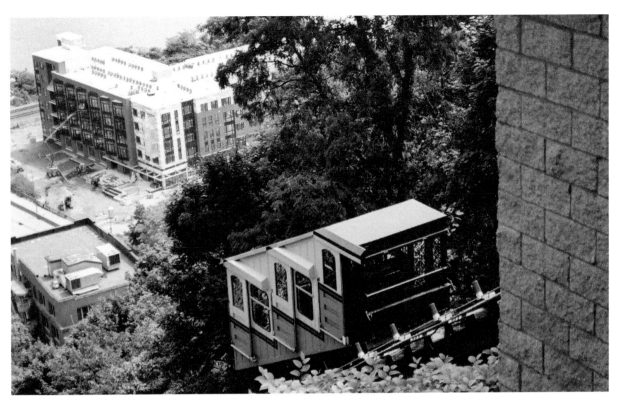

From the Grandview Avenue upper level of the Monongahela Incline, a car is heading downward in this June 12, 2019 scene looking down at the Monongahela River. (*Kenneth C. Springirth photograph*)

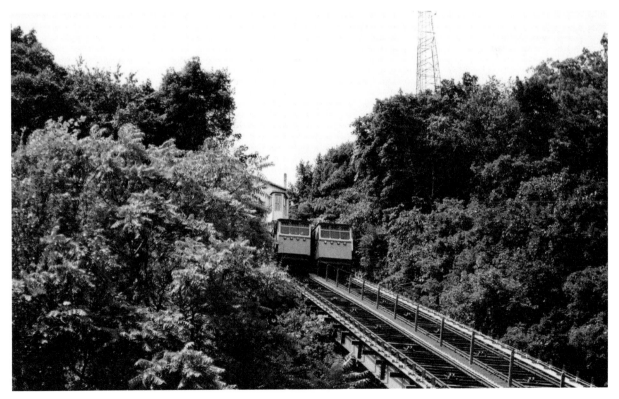

On June 12, 2019, two Monongahela Incline cars are passing each other amid the dense foliage on both sides of the incline. (*Kenneth C. Springirth photograph*)

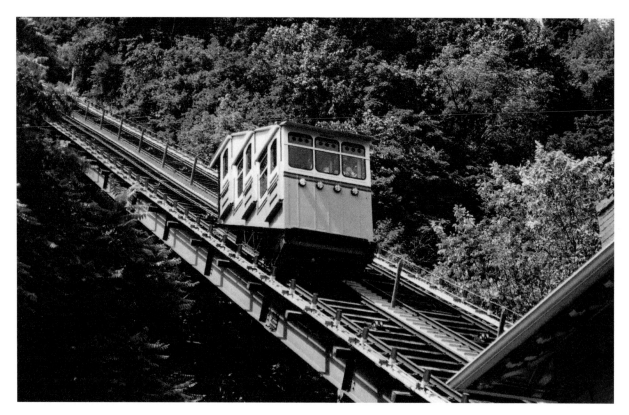

It is a thrill to ride the 640-foot-long Monongahela Incline climbing 370 feet on a 38-degree angle on June 12, 2019. This view shows the three different level compartments with one having an open area. Car capacity is twenty-five passengers. (*Kenneth C. Springirth photograph*)

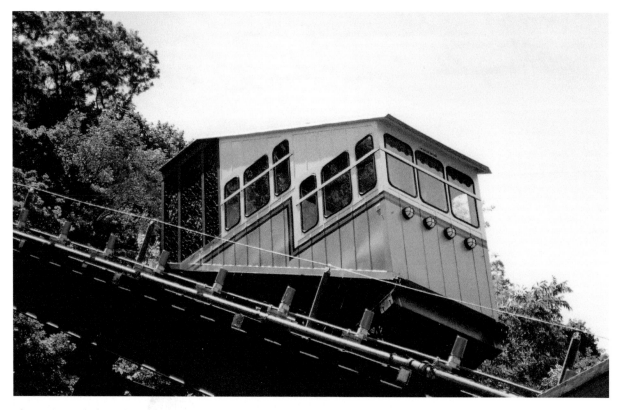

The Monongahela Incline continues to be popular not only for those living at the top of Mount Washington but also for those passengers inside the car in this June 12, 2019 view to look out the car windows and be in awe of an ever-changing view of Pittsburgh's skyline. (*Kenneth C. Springirth photograph*)

Right: The upper station of the Monongahela Incline is located on Grandview Avenue at Wyoming Street in this June 12, 2019 view providing a splendid view of downtown Pittsburgh. (*Kenneth C. Springirth photograph*)

Below: Following the May 23, 1870 successful opening of the Monongahela Incline, about a mile west of it, the Duquesne Incline opened on May 20, 1877 to serve the growing community on Mount Washington. It was a treat to ride the 793-foot-long Duquesne Incline, which rose 400 feet at a 30-degree angle shown in this postcard postmarked October 8, 1916. (*Kenneth C. Springirth photograph*)

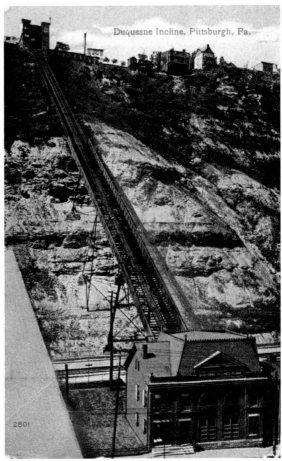

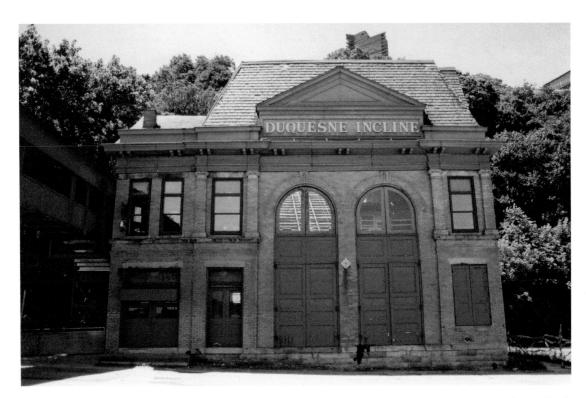

This is a June 12, 2019 view of the lower-level Duquesne Incline station on Carson Street. As more roads were built on Mount Washington, incline ridership declined, and with major repairs needed, the Duquesne Incline closed in 1962. Duquesne Heights' residents launched a successful fundraiser, and the incline reopened on July 1, 1963. Since 1964, this incline has been operated by the Society for the Preservation of the Duquesne Heights' Incline and is owned by the Port Authority of Allegheny County. (*Kenneth C. Springirth photograph*)

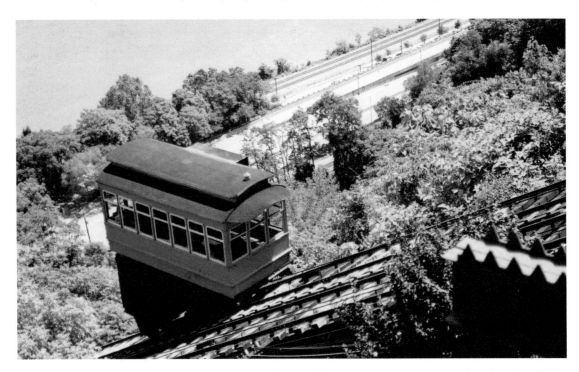

The Duquesne Incline car is heading up as seen from the Grandview Avenue upper station with a nice view of West Carson Street and the Monongahela River on June 12, 2019. During 1888, the incline was completely rebuilt with an all steel structure. In 1932, electrical equipment replaced the steam engine. Since 1963, the incline has been completely refurbished. The ornate cars originally built by J. G. Brill & Company of Philadelphia were restored, and an observation deck was built at the upper station level. (*Kenneth C. Springirth photograph*)

Right: In this June 12, 2019 Duquesne Incline scene, the car at the top is coming down, and the lower car is going up. In 1962, the Duquesne Incline, owned by the Duquesne Incline Plane Company (DIPC), closed to repair worn parts; however, a high-cost estimate resulted in permanent closure. A dedicated group of Duquesne Heights' residents met with the DIPC owner. Agreement was reached that if the residents could raise the $15,000 repair cost, DIPC would repair and reopen it. In six months, the residents raised the money, repairs were made, and the Duquesne Incline reopened on July 1, 1963. (*Kenneth C. Springirth photograph*)

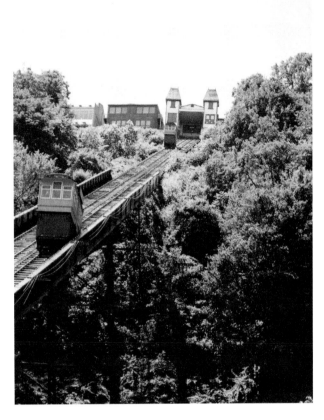

Below: The Duquesne Incline cars in the above picture are about to pass each other. In 1964, Port Authority Transit (PAT) purchased the Duquesne Incline. Since the incline was not economically viable, PAT leased it to the Duquesne Heights residents for $1 a year. Each year, PAT has returned that dollar as a donation to the Duquesne Incline. A Society for the Preservation of the Duquesne Heights' Incline was formed in 1964. Only conductors, operators, and a maintenance staff are paid. Daily supervision plus additional work is done by unpaid volunteers. (*Kenneth C. Springirth photograph*)

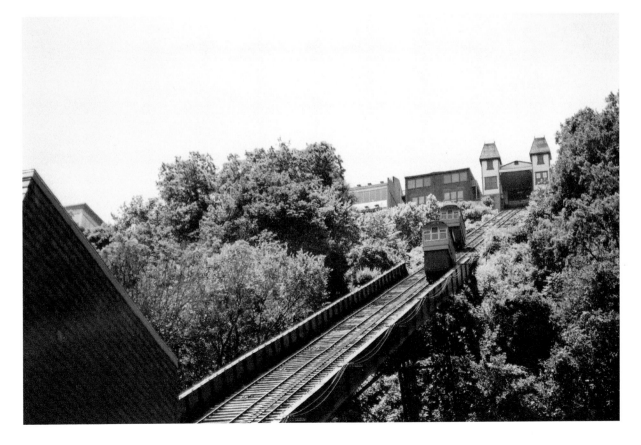

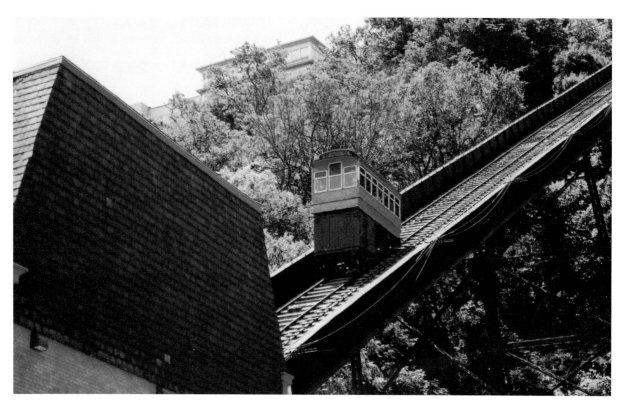

An incline car is coming down to the Duquesne Incline lower-level Carson Street Station on June 12, 2019. PAT reimburses the Duquesne Incline for PAT riders who use passes, tickets, or transfers to ride it. The Duquesne Incline operates entirely on fares collected, membership fees, donations, and gift shop sales. (*Kenneth C. Springirth photograph*)

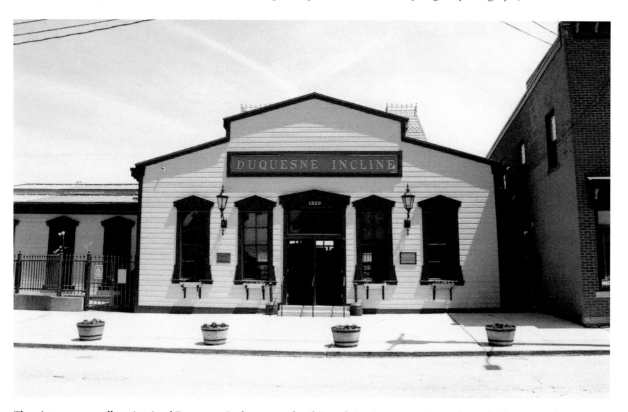

The picturesque well-maintained Duquesne Incline upper level Grandview Avenue station exists today because of a visionary group of residents who had the guts, grit, and great determination to keep it in operation. The Duquesne Incline has never received a direct subsidy from any city, county, state, or federal government. This incline operates every day of the year including holidays. (*Kenneth C. Springirth photograph*)